IMAGES
of Rail

ALTOONA AND LOGAN VALLEY ELECTRIC RAILWAY

THE CITY PASSENGER RAILWAY COMPANY
GOOD ONE FIVE CENT FARE FOR
J.J. Lancaster GEN'L MGR.
205673

ALTOONA & LOGAN VALLEY ELECTRIC RY CO.
GOOD FOR ONE ZONE FARE
PRESIDENT
041690

ALTOONA & LOGAN VALLEY ELECTRIC RY. CO.
EMPLOYEE'S FREE TICKET
Not Good If Detached
Pres. & Gen. Mgr.
037986

ALTOONA & LOGAN VALLEY ELECTRIC RY. CO.
Good For ONE SEVEN CENT FARE
PRESIDENT
34617

ALTOONA & LOGAN VALLEY ELECTRIC RY. CO.
SPECIAL EMPLOYEE'S PASS
Pres. & Gen. Mgr.
13092

ALTOONA & LOGAN VALLEY ELECTRIC RY CO.
GOOD FOR ONE TEN CENT FARE
PRESIDENT
A09073

ALTOONA & LOGAN VALLEY ELECTRIC RAILWAY CO.
SCHOOL TICKET
GOOD ONLY 7 A. M. to 5 P. M.
PRESIDENT
18000

ALTOONA & LOGAN VALLEY ELECTRIC RAILWAY COMPANY
Good for ONE FARE
Form 200
PRESIDENT
000500

ALTOONA & LOGAN VALLEY ELECTRIC RAILWAY CO.
SCHOOL TICKET
GOOD ONLY 7 A. M. to 5 P. M.
PRESIDENT
203936

ALTOONA & LOGAN VALLEY ELECTRIC RY. CO.
MAIL CARRIER'S TICKET
PRESIDENT

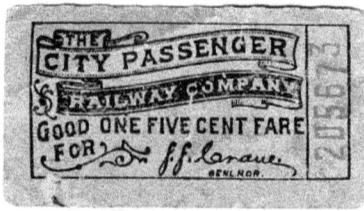

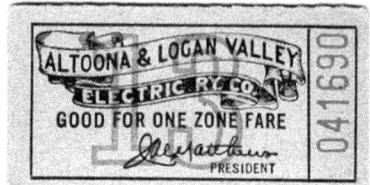

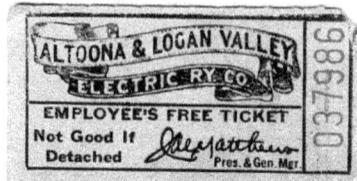

ALTOONA AND LOGAN VALLEY ELECTRIC RAILWAY COMPANY
CHILDREN'S SCHOOL TICKET
ALTOONA
TO
LAKEMONT
GOOD FOR ONE FARE
This Day Only—June 6th, 1908

LAKEMONT PARK
ALTOONA, PA.
REDUCED RATE
RIDE TICKET B 547126

Lakemont Park
ADULT SWIM
021120
NATIONAL TICKET CO., SHAMOKIN, PA

Over the years, Logan Valley issued many tickets for traveling and for the park, which it owned. Shown here is a sampling of tickets.

IMAGES
of Rail

ALTOONA AND LOGAN VALLEY
ELECTRIC RAILWAY

Leonard E. Alwine and David W. Seidel

ARCADIA
PUBLISHING

Published by Arcadia Publishing
Charleston, South Carolina

Library of Congress Catalog Card Number: 2005931402

For all general information contact Arcadia Publishing at:
Telephone 843-853-2070
Fax 843-853-0044
E-mail sales@arcadiapublishing.com
For customer service and orders:
Toll-Free 1-888-313-2665

Visit us on the Internet at www.arcadiapublishing.com

*The authors offer this work in dedication to the many men
and women who were former employees of the Altoona and Logan
Valley Electric Railway and its predecessor companies, as well as those
of the Logan Valley Bus Company, most of whom are deceased.
Their service to Blair County is remembered and held in high regard
as are the employees (past, present, and future) of the successor
transit service, Amtran.*

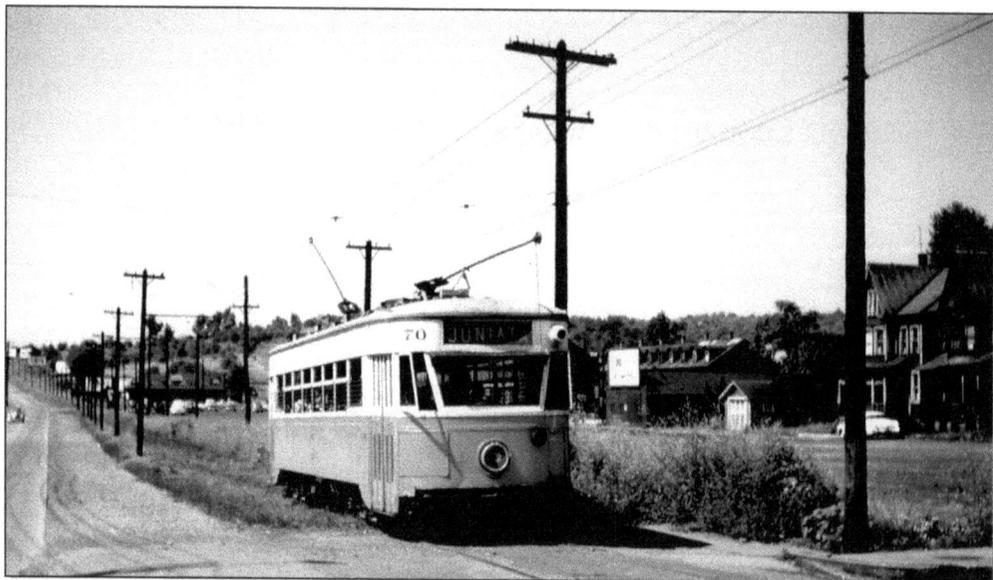

Osgood-Bradley car No. 70 is eastbound in the Juniata section of Altoona. This car operated on the Eldorado line and will soon reverse direction to retrace the 10-mile route. The Pennsylvania Railroad's massive locomotive shop complex is on the left, just out of view. While the locomotive shops remain under Norfolk Southern Railroad today, the Altoona and Logan Valley Electric Railway right of way is now part of a four-lane express thoroughfare.

CONTENTS

ACKNOWLEDGMENTS

Photographs used in this publication are from the collections of the authors. These have been assembled over many years with the help of individuals and groups who willingly shared their photographs in an effort to preserve history. Many pictures were purchased at train shows and from individuals or clubs and organizations. In many instances, the identity of the actual photographer is unknown.

That said, very special thanks go to Paul W. Westbrook Jr., deceased, the past president of Horseshoe Curve Chapter, National Railway Historical Society (NRHS), whose photograph collection of the Logan Valley's last run motivated the authors to further research the company history; Francis X. Givler, current president of Horseshoe Curve Chapter, NRHS; Joe Harella, current vice president of Horseshoe Curve Chapter, NRHS (and Amtran bus driver); Richard Heiler; Tim VanScoyoc of the Blair County Historical Society; Marie Wright, North Jersey Chapter, NRHS; Thomas D. Jones and Ken McNelis Jr., Motor Bus Society; Lehigh Valley Chapter, NRHS; New England Electric Railway Historical Society; Railways to Yesterday, Inc.; Amtran (Altoona Metro Transit) historical files; John Davis, deceased; George Badwey, deceased, the last trolley operator to be hired (1945); Herman Darr, deceased; Bob Leidy, Lakemont Park Historical Museum, Inc.; Charles Houser Sr., deceased; Charles Houser Jr.; Jody Kinsel; Tony Branda; Jim Snyder of Blair County Genealogical Society; Jake Dolheimer; and John Conlon, Altoona historian.

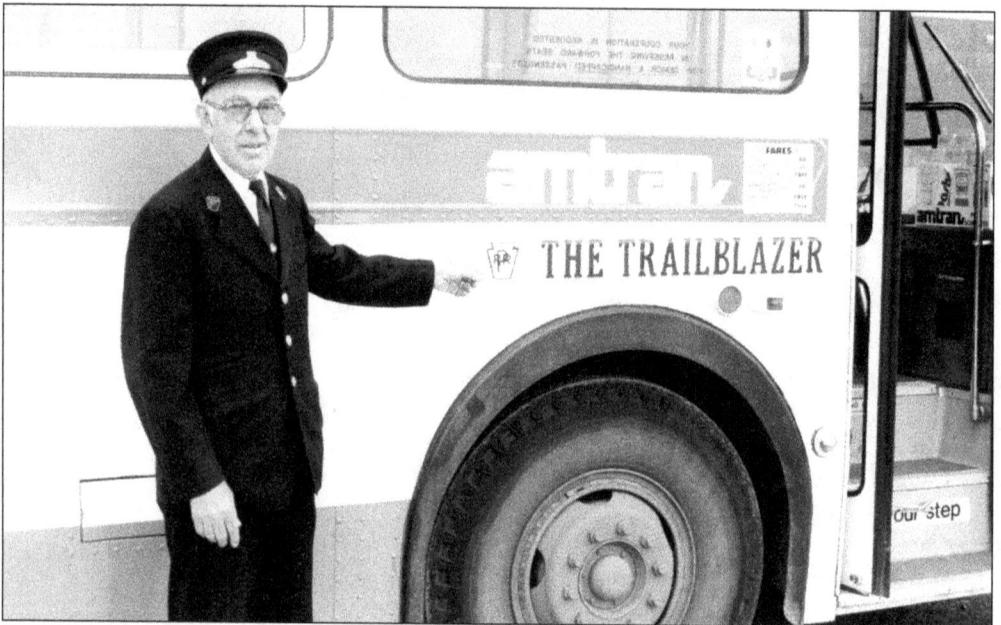

Paul W. Westbrook Jr. is shown here on September 21, 1980, on the occasion of the grand opening of the Railroaders Memorial Museum in Altoona. For the occasion, Amtran (Altoona Metro Transit) renamed buses for famous passenger trains of the Pennsylvania Railroad.

INTRODUCTION

Mention Altoona, Pennsylvania, and most railroad enthusiasts would have visions of the Pennsylvania Railroad (PRR) shops and yards, building, maintaining, and operating hundreds of steam locomotives and freight and passenger cars on a routine daily basis.

In this book another Altoona railway will be chronicled, a railway that helped build the PRR by hauling thousands of people to and from these railroad shops and yards on a daily grind. A railway that all but disappeared halfway through the 20th century in 1954. That railway was the Altoona and Logan Valley Electric Railway, locally known as the Logan Valley.

Logan Valley's beginnings were very humble. Operations began as the City Passenger Railway, incorporated March 10, 1882. That first railway was a horsecar line, and, following construction of a three and a half mile loop through downtown Altoona, service began on July 4, 1882. Nine years later, on July 4, 1891, the City Passenger Railway began transporting passengers with electric-powered cars.

The year 1891 saw another railway chartered in Altoona—the City and Park Railway, which had plans to build a seven and a half mile line from Lakemont, the planned location for an amusement park, into South Altoona. By October 1891, several miles of this route were in operation, but the park did not officially open until 1894.

In December 1891, City Passenger—fearing competition—purchased a large tract of land in South Altoona and built a new carbarn. They also purchased enough City and Park Railway stock to gain control and operated it as a subsidiary.

On December 12, 1892, a third railway, the Altoona and Logan Valley Electric Railway Company, was chartered and purchased most of the City Passenger Railway stock, thereby gaining control of it as well as the City and Park Railway. This was done to gain access to Altoona city streets, as Logan Valley planned to build routes from Lakemont to Hollidaysburg and from Altoona to Juniata and Bellwood.

During 1892, yet a fourth railway, the Tyrone Electric Railway, was chartered in Tyrone (13 miles north of Altoona) as part of the Home Electric Company to provide city routes in Tyrone and interurban routes to Bellwood and Nealmont. Construction of these lines was not completed until July 3, 1902.

On August 5, 1903, American Railways purchased enough stock in all four companies to be able to control them, subsequently merging them into one entity and retaining the name Altoona and Logan Valley Electric Railway. The railway now had a total of 50 miles of routes, all in and around Altoona and Blair County.

By the 1920s, this trackage increased to 55 route miles, and most of the private right of ways were now double-tracked. In 1923, the Logan Valley Bus Company was formed to provide feeder routes to the trolleys from the more sparsely populated areas outside the city limits.

As part of the late-1920s rebuild program, most every mile of track was rebuilt and 18 new cars were purchased. Logan Valley employed over 300 people, and management was planning even more expansion for the future. The cars and buses were traveling a collective 7,220 miles a day to cover all routes and were transporting 11.5 million passengers per year leading into the Depression.

But, following receivership in early 1931, the route miles were reduced to about 25, and buses replaced the trolleys on the night runs.

Between 1947 and 1954, Logan Valley purchased 41 General Motors (GM) diesel buses to replace the remaining trolleys. June 2, 1954, was the last revenue day of electric operations on regular routes, coinciding with the summer vacation shutdown for the Pennsylvania Railroad shops. An official last ride was held on August 7, 1954, on the three remaining routes: Juniata, Eldorado, and Hollidaysburg. The trolleys, track, and overhead were sold for scrap in January 1955. Logan Valley continued to use buses until October 29, 1959, when the very first transit authority in Pennsylvania was created to take over operations.

The great Logan Valley all but disappeared from Altoona and the Blair County area. Close scrutiny will reveal small traces of it, but most people today would never know that Altoona had a railway other than the renowned PRR and its successors: Penn-Central, Conrail, and, now, Norfolk Southern.

The purpose of this book is to acknowledge the history that contributed to the development of Altoona and Blair County in the industrial age, a time when all problems of the day could be easily solved, or at least forgotten, by a simple trolley ride to an amusement park.

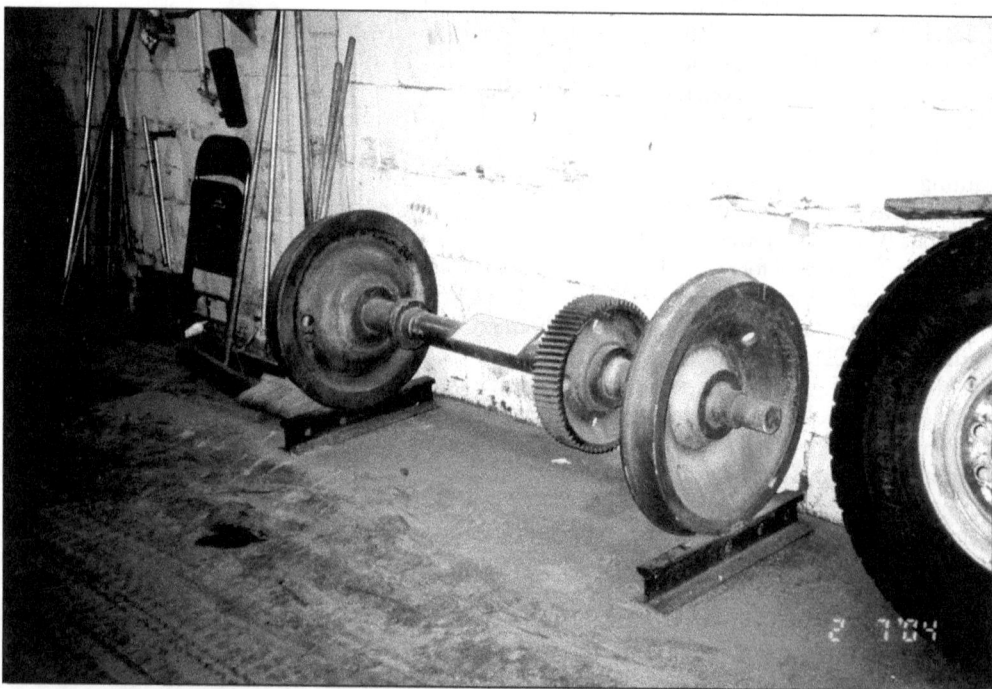

At the Amtran bus garage (former carbarn), a set of drive wheels from car No. 51, the last trolley to operate in Altoona, awaits restoration in February 2004. The end of trolley service in Altoona and the return of this wheel set to the carbarn encompass a half century.

One

THE CITY PASSENGER RAILWAY
1882–1891

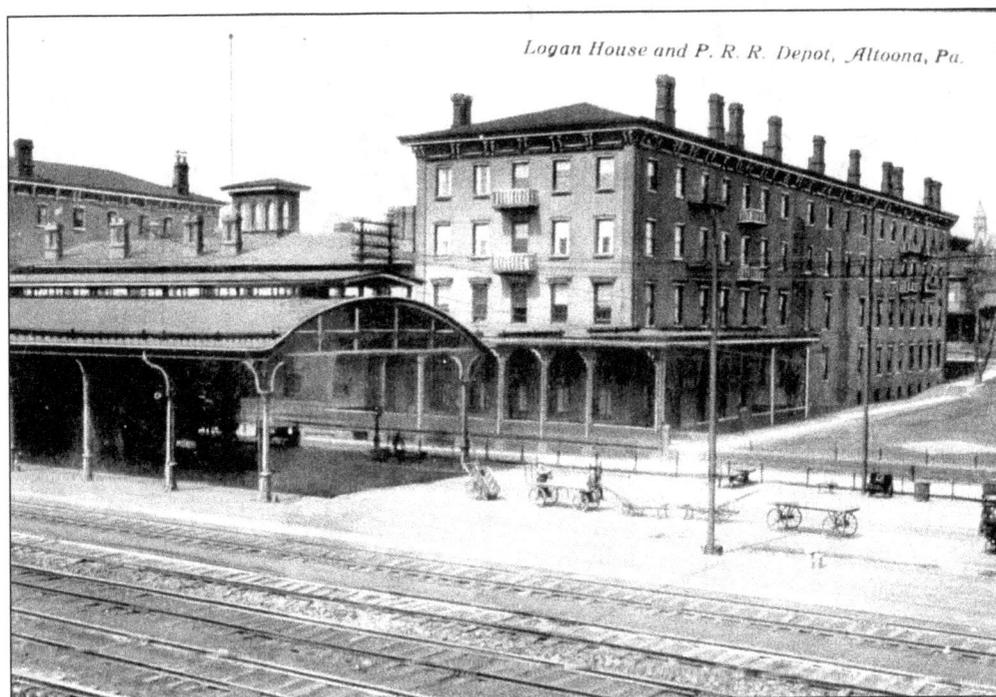

Logan House and P. R. R. Depot, Altoona, Pa.

On February 18, 1882, a group of local men met in the Logan House (Pennsylvania Railroad Hotel) in downtown Altoona to discuss creating a horse-powered railway for the growing city. On March 10, 1882, the City Passenger Railway was incorporated to build a horsecar line through downtown Altoona, crossing the railroad main line at Seventeenth Street and parallel to downtown on Eighth Avenue. A turntable would reverse cars for the return trip.

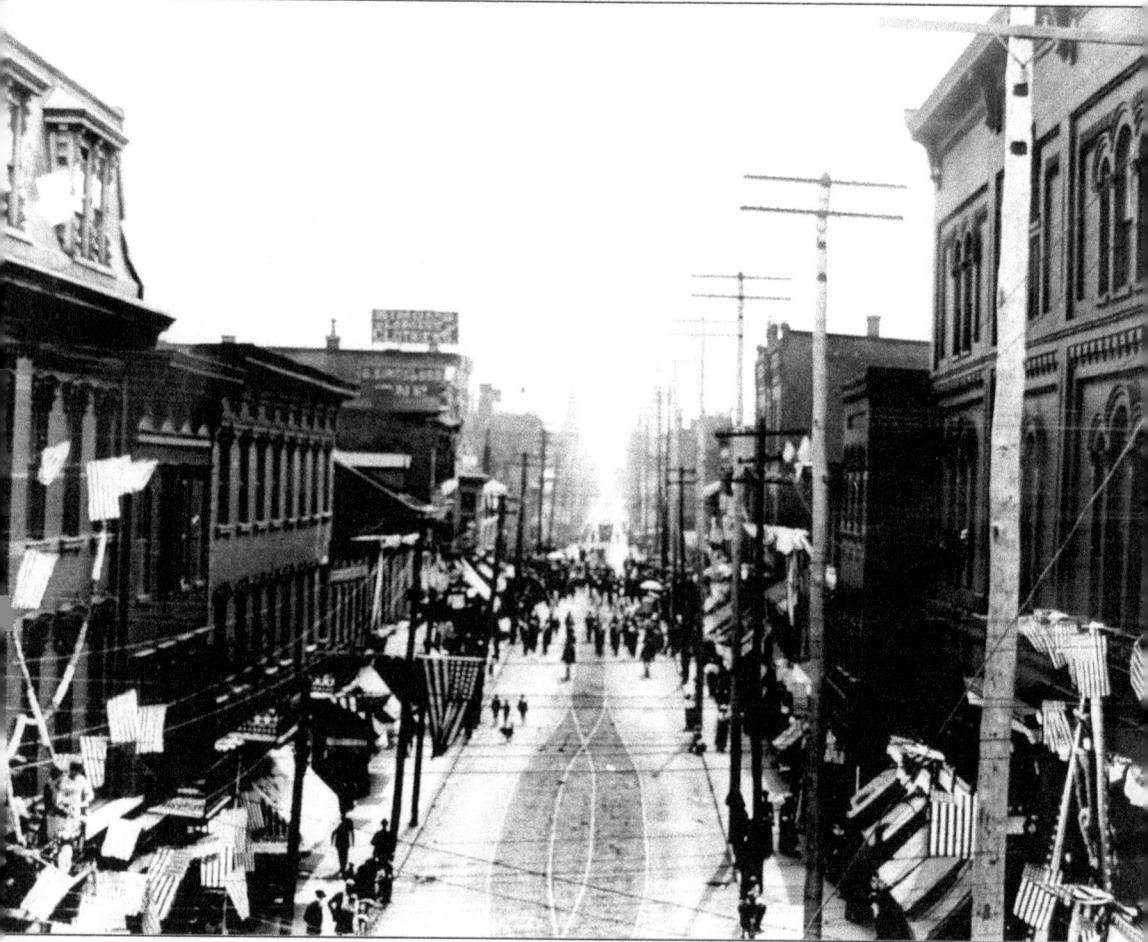

The first little horsecar operated for the first time on July 4, 1882. This photograph was possibly taken that day or on another holiday due to the number of flags. This view is westward from Eleventh Street. At the extreme right is the former Eleventh Avenue opera house, which was destroyed by fire c. 1907. A horsecar can be seen in the distance. The double-track area is a passing track arrangement for when two cars meet.

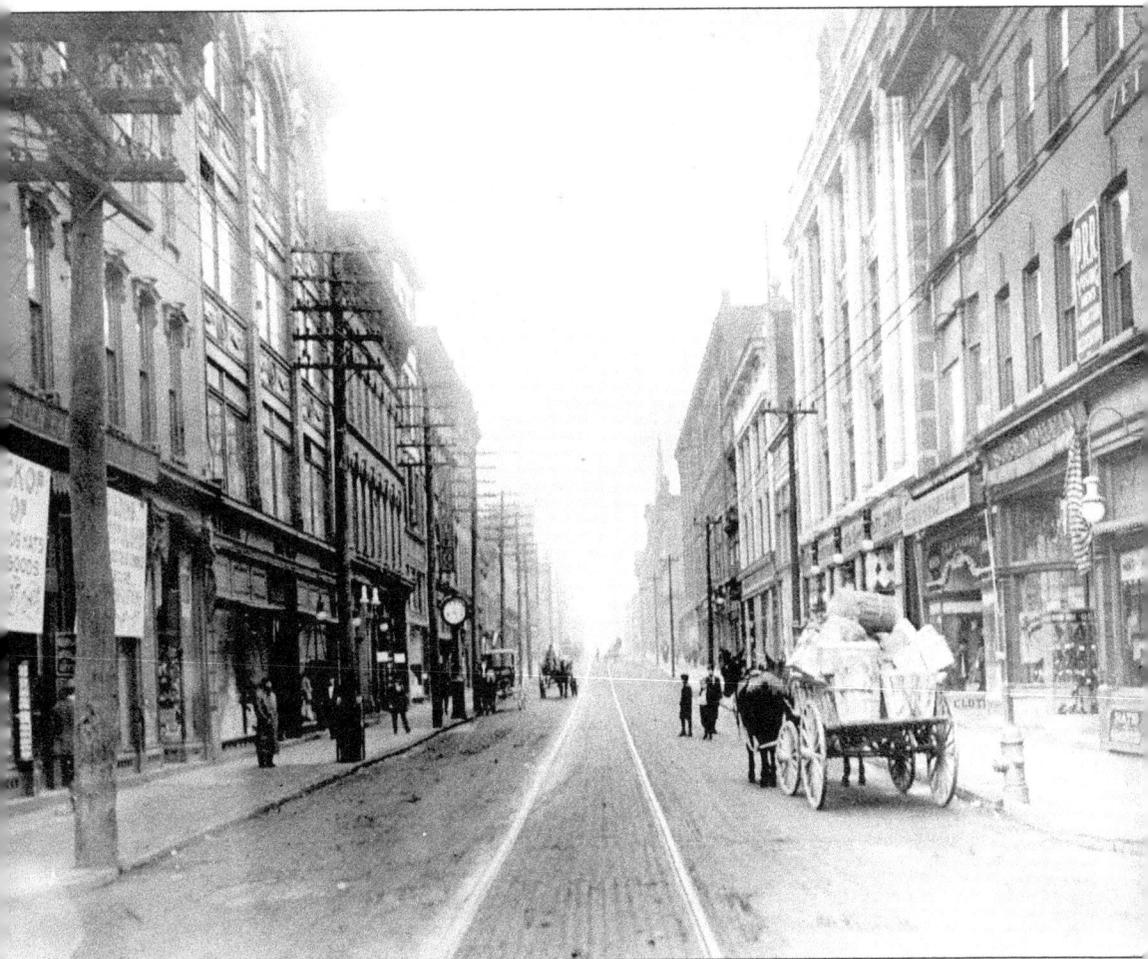

In this view, the trolley tracks and overhead wire are seen on Eleventh Avenue in a westerly view from Thirteenth Street. By this time, the right of way was brick-paved. The mode of transportation is still primarily horse and wagon even with the advanced electric trolley line.

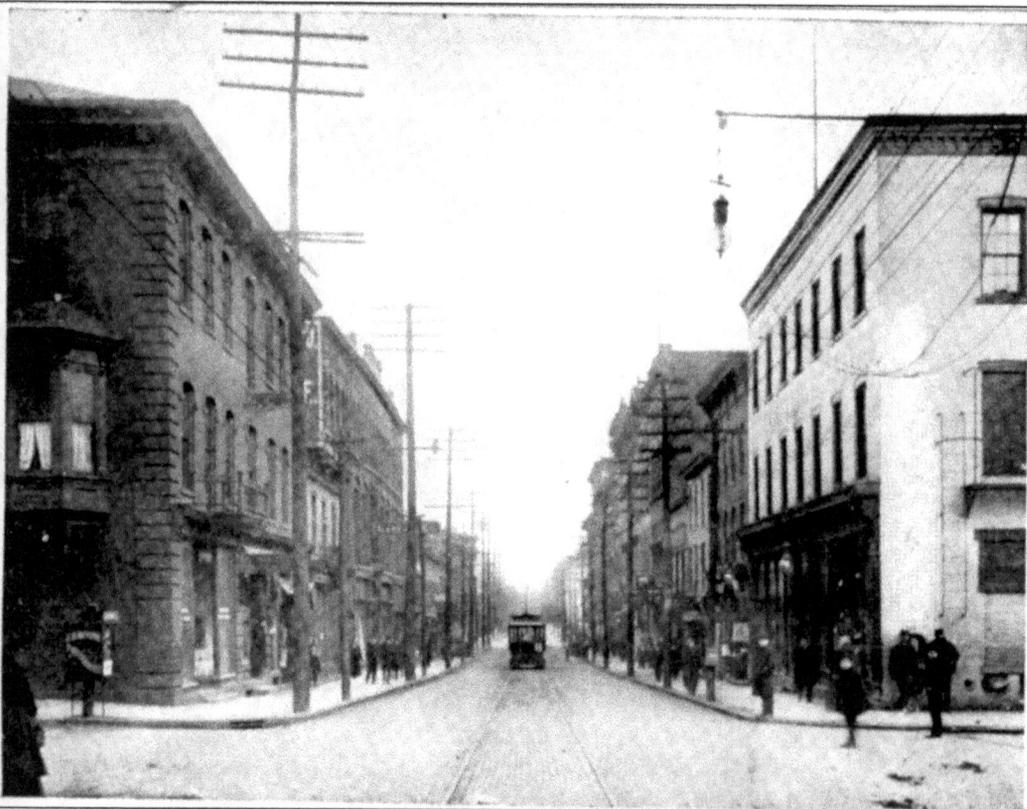

An easterly view from Fourteenth Street, this is a postcard of Eleventh Avenue that shows an early electric car. The No. 8 on the front of the car indicates it will later travel over the Eighth Avenue line. City Passenger Railway's carbarn was located further east at Chestnut Avenue and First Street, near the PRR roundhouse. A spur track connected the carbarn with the downtown loop.

Two

THE EARLY ELECTRIC
YEARS
1891–1903

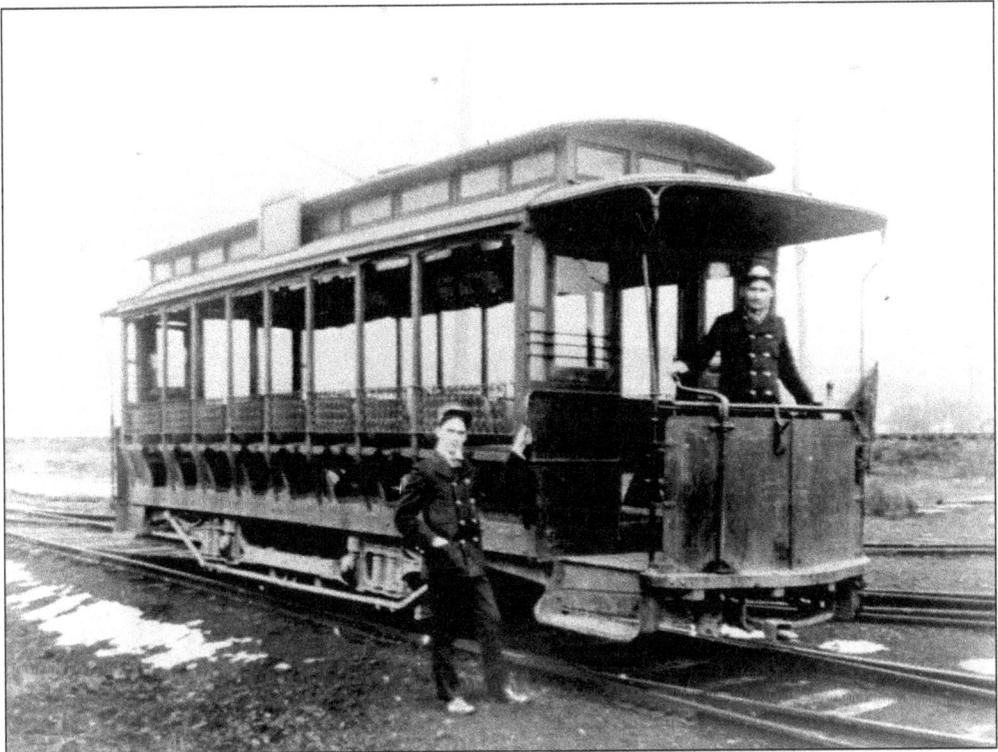

The City Passenger Railway also had open cars for the summer travelers. These cars provided natural air-conditioning on hot summer days. Car No. 26, shown here, was actually a semi-convertible, as the sides slide up into the roof sections in the summertime but could be put back down in winter months.

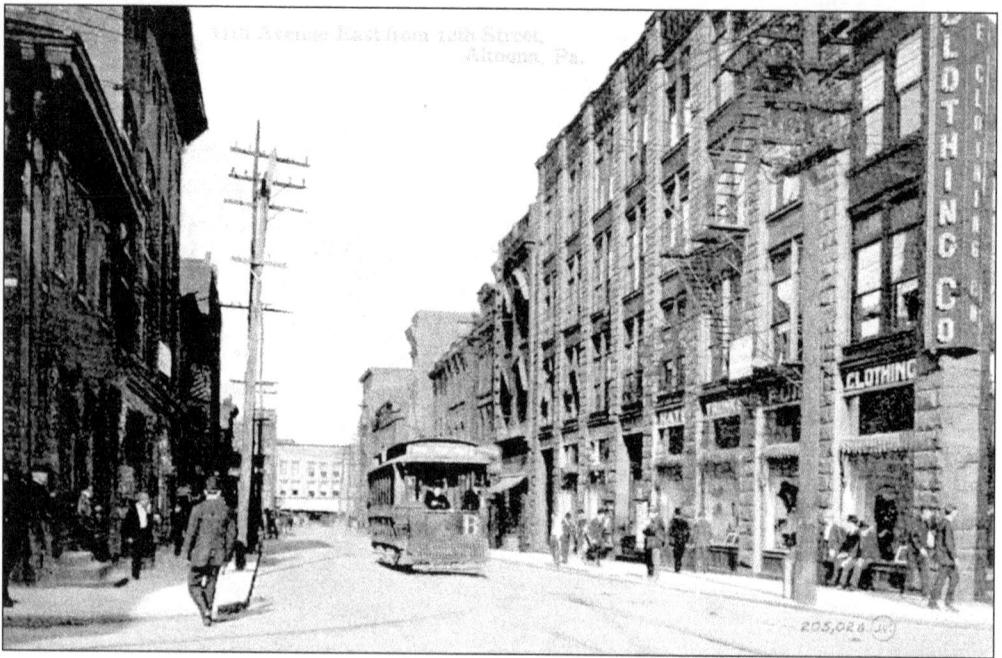

This shows a postcard view of another City Passenger Railway open car on Eleventh Avenue approaching Twelfth Street and serving the Broad Avenue line. Eleventh Avenue was the primary commercial district. The Goldschmidt Building is on the immediate right.

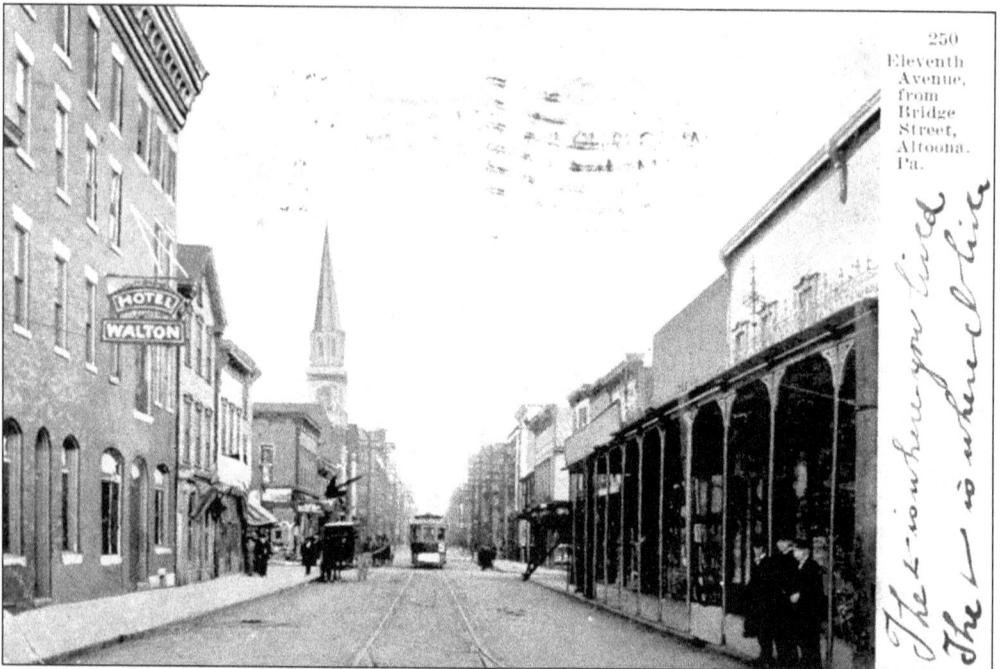

Here is another view of Eleventh Avenue easterly from Bridge Street (Seventeenth Street). Approaching the photographer is a car destined for the Eighth Avenue line. On the left is the Hotel Walton. The steeple belongs to the First Baptist Church, which was later destroyed by fire on February 4, 1912.

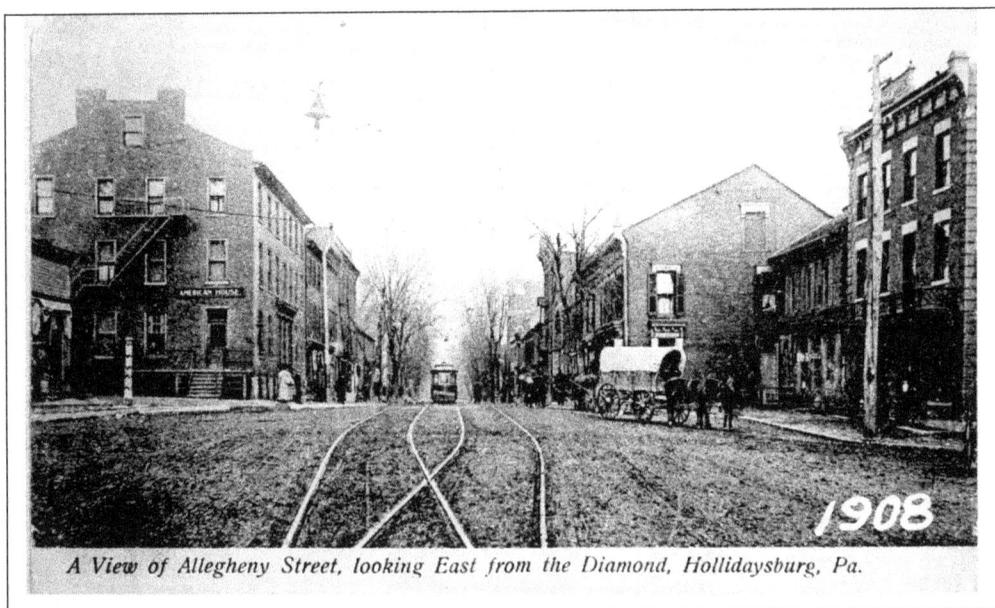

A View of Allegheny Street, looking East from the Diamond, Hollidaysburg, Pa.

An easterly view of the Diamond in Hollidaysburg, Pennsylvania, around 1908, this photograph shows an early Logan Valley electric car approaching the double-tracked passing tracks on the Diamond. Note the early dirt street of the time. The Diamond is the town square of Hollidaysburg.

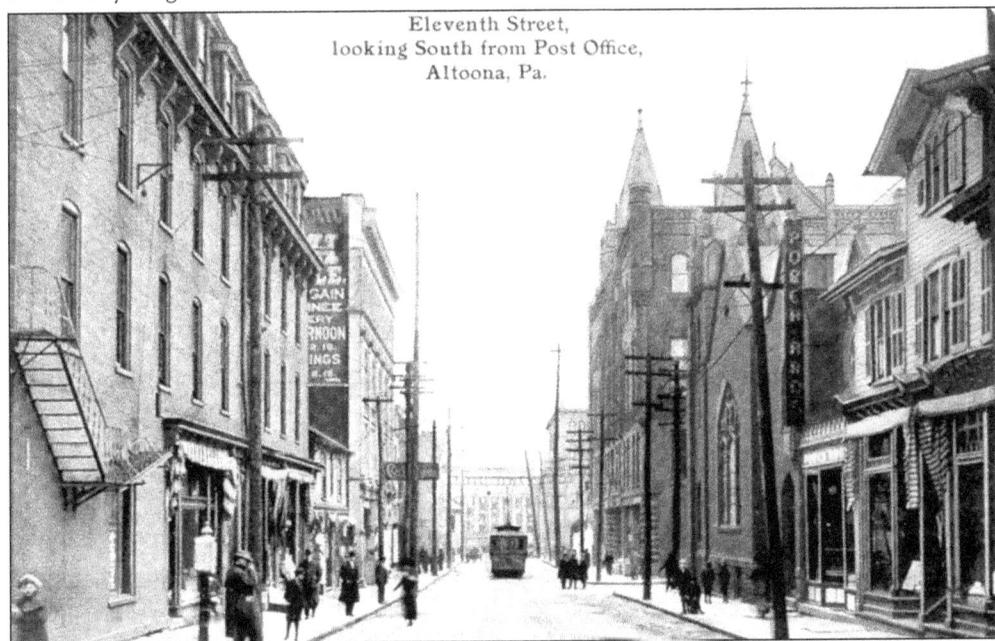

Eleventh Street, looking South from Post Office, Altoona, Pa.

This early view of downtown Altoona on Eleventh Street shows the eastern edge of the business district. The federal courthouse and post office were behind the photographer, and to the south were the PRR shops in the distance. The prominent structures on the right are the Grace Lutheran Church and the Masonic temple. Opposite the Masonic temple is the former Lyric Theater, which was destroyed by fire on February 24, 1907, and later rebuilt, though owned and operated under different names.

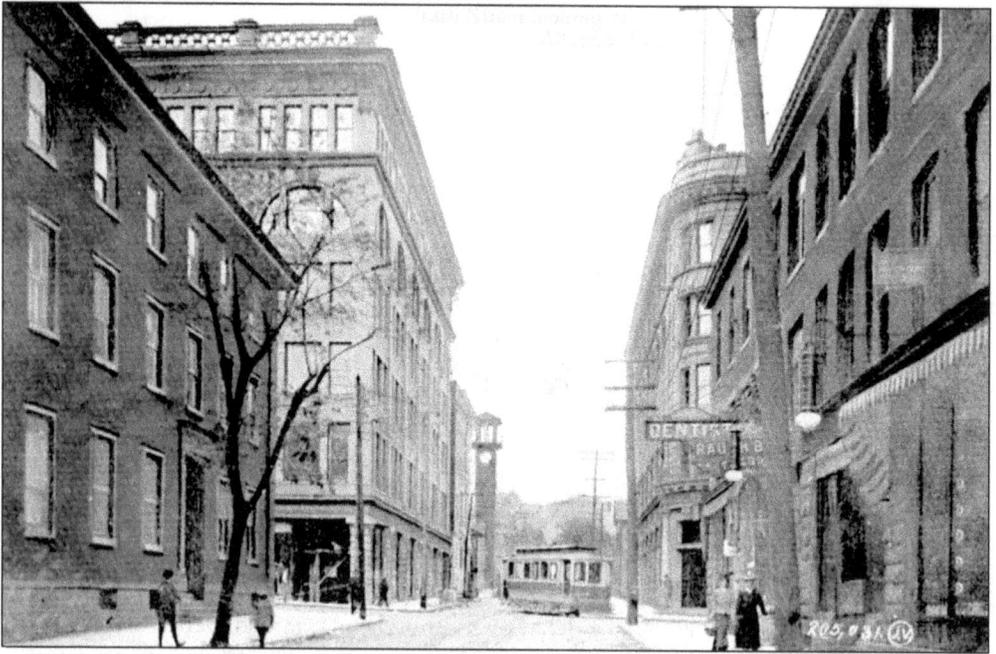

A short wheelbase trolley is turning the corner in this northerly view on Twelfth Street from Eleventh Avenue to Twelfth Avenue and beyond. This car served the Fairview section of Altoona, known for its steep grades suitable for this type of car. The PRR office building stands to the immediate left. The larger structure (left) is the former Rothert's Department Store, which was destroyed by fire on October 18, 1906, but was immediately rebuilt. The clock tower in the distance is city hall, and the prominent structure on the right is the Altoona Trust Company.

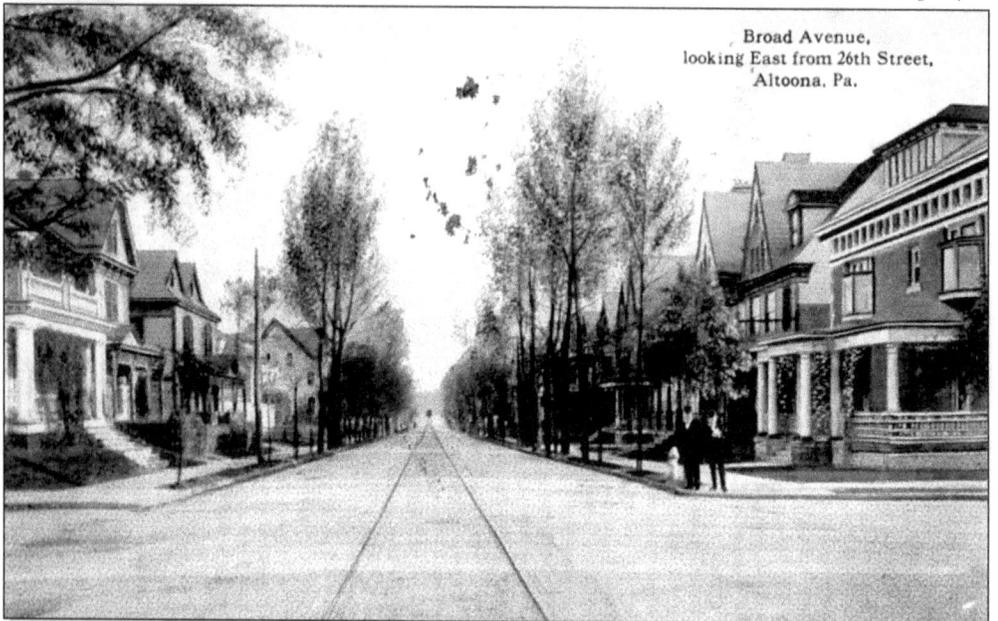

Away from downtown, the trolley lines went to residential neighborhoods. Broad Avenue was an upscale section with many large homes. In this easterly view, a distant trolley traverses Broad Avenue in this view from Twenty-sixth Street.

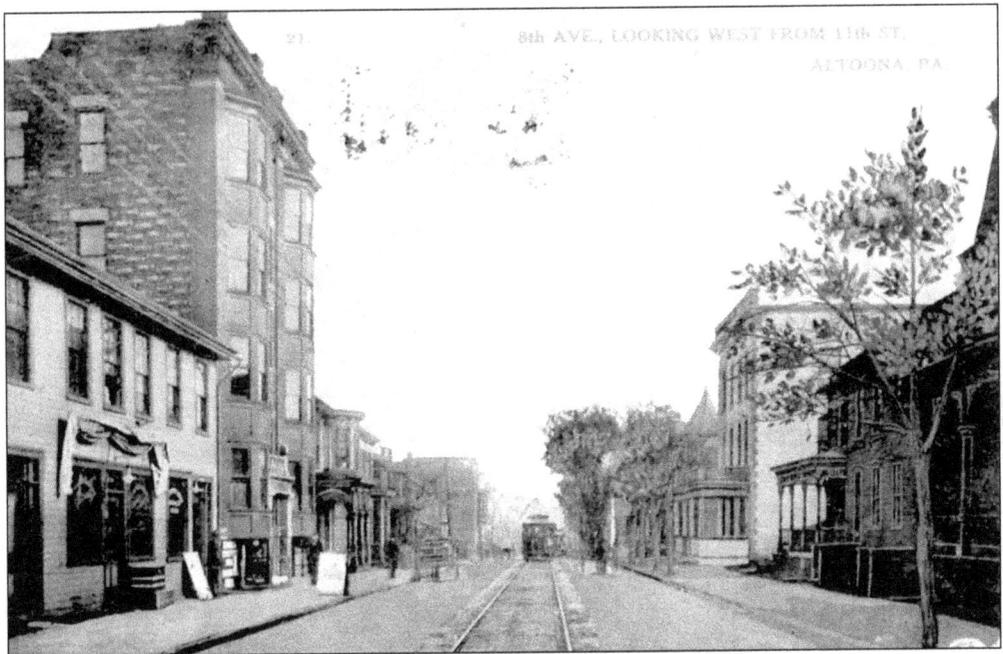

The Eighth Avenue line paralleled downtown Altoona on the opposite side of the PRR main line railroad. This trolley served an area once known primarily as the Italian community, shown westerly from Eleventh Street.

This westerly view in the Juniata section of Altoona, once a separate borough, shows the double-tracked right of way in the business district. The tall rectangular building in the distance on the left was the PRR YMCA for crews. The building now serves as Park Furniture Store. Juniata was adjacent to the PRR locomotive shops and yards.

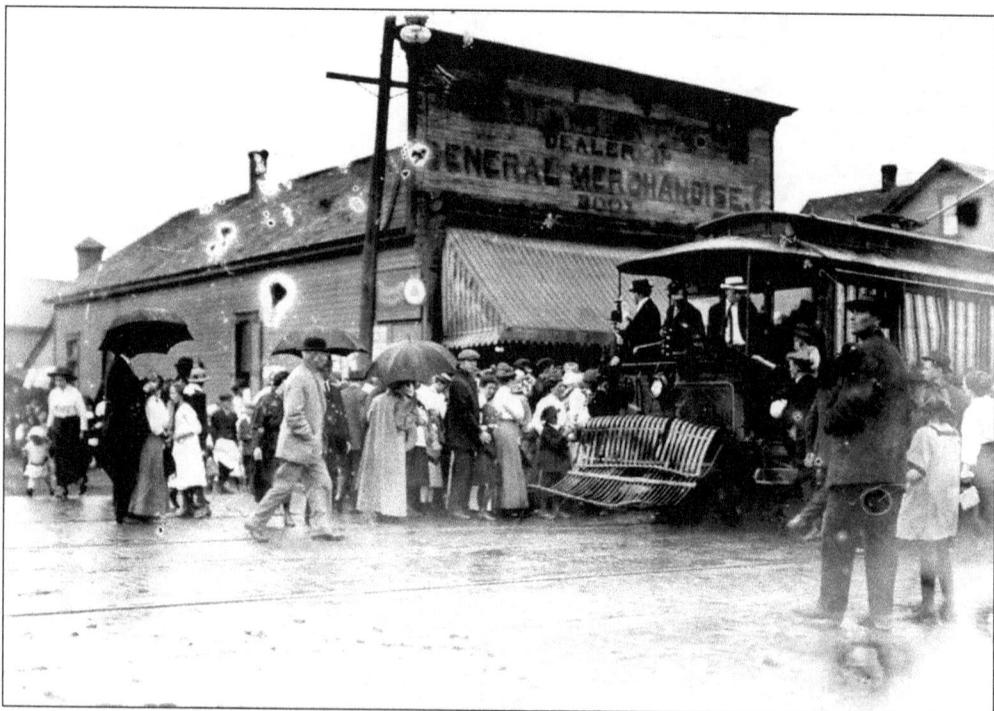

Another railway chartered in 1891 was the City and Park Railway, started by Sylvester C. Baker to build a line from Lakemont, south of the city line into town. City and Park planned to build an amusement park in Lakemont. By year-end, several miles of track were laid and in use. With the curtains down on a rainy day, car No. 27 takes passengers to Lakemont Park.

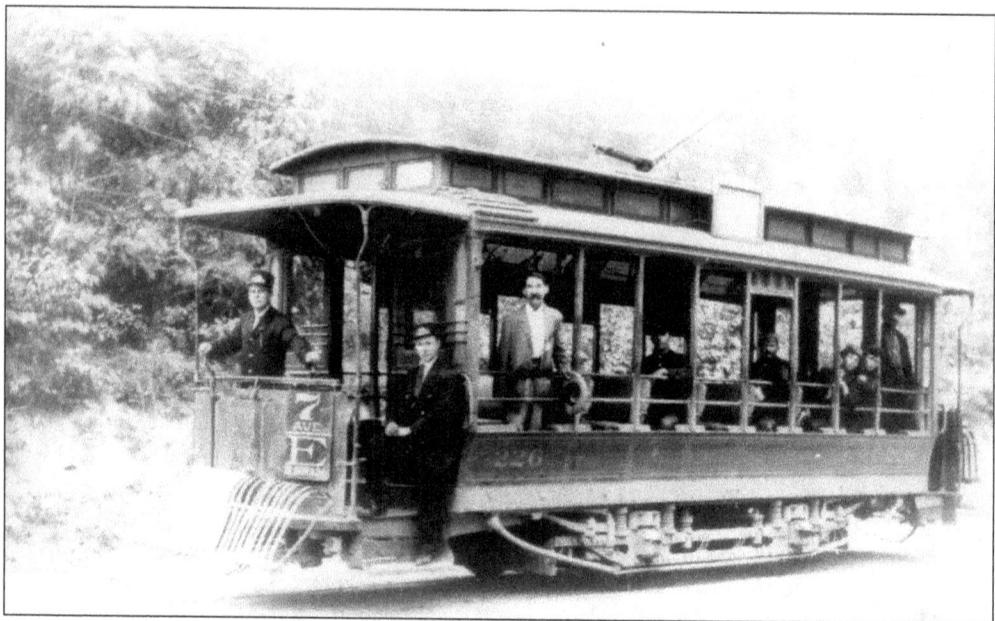

Conductor Ralph Clapper and motorman Herman Cain appear with City and Park Railway car No. 226 around 1904. No. 226 (St. Louis Car Company 1893) is seen here on the Eldorado line.

18

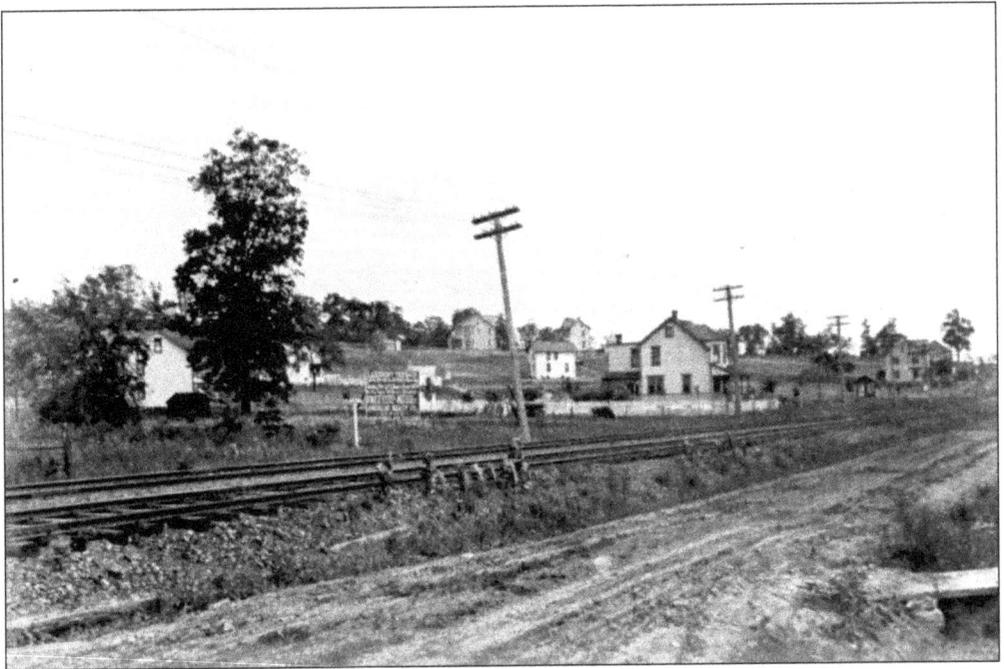

The line from South Altoona to Lakemont was almost flat for most of the distance that traversed Llyswen and Lakemont Terrace to Park Hill. The area at Lakemont Terrace was a new community, and the sign advertises the sale of lots.

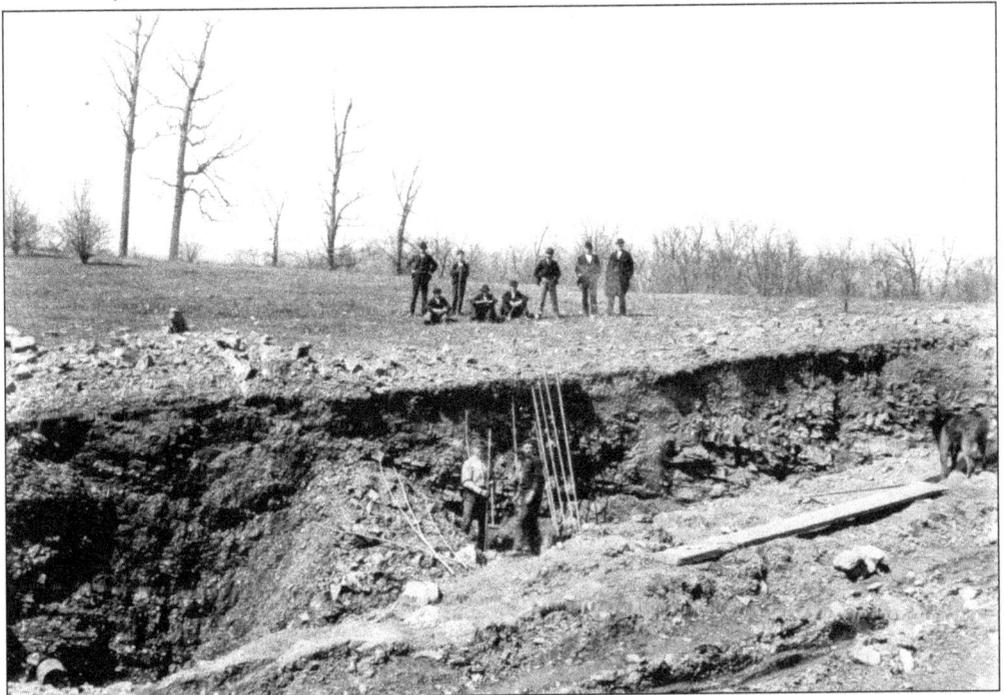

From Park Hill into Lakemont was a steep grade southbound. Much excavating was required to descend the hillside into Lakemont. In the 1890s, this labor was done by hand with pick and shovel as can be seen in this view.

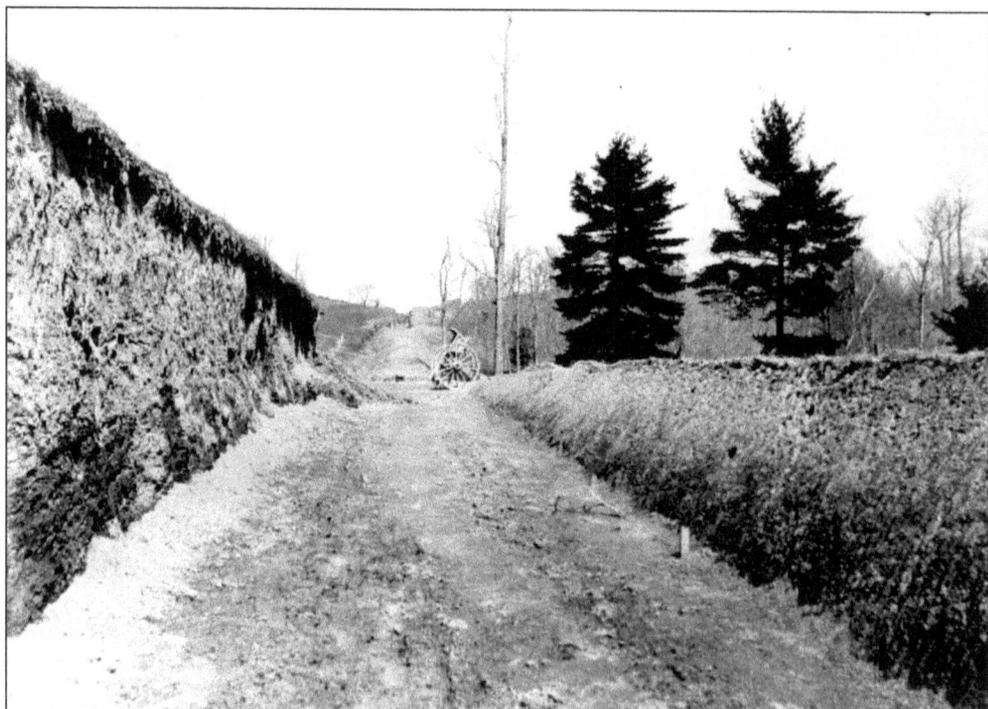

This northerly view at the bottom of the grade at Lakemont Park shows the grading required for the trolley right of way. The grading is almost complete, and most of the fill had to be hauled away by oxcarts as shown here.

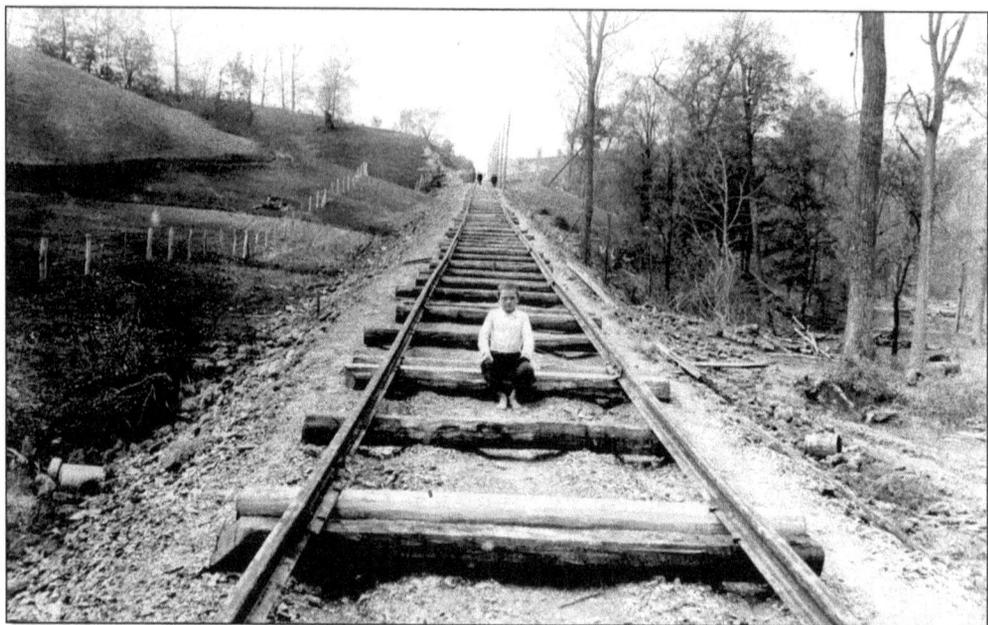

Nearing completion, the roadbed is ballasted and the ties and track are laid down. Near the top of the hill, the poles are being installed, and soon trolley wire will be hung. Today this roadbed is part of the four-lane Route 36, with Interstate 99 bridging at the apex of the hill. The identity of the young boy is unknown.

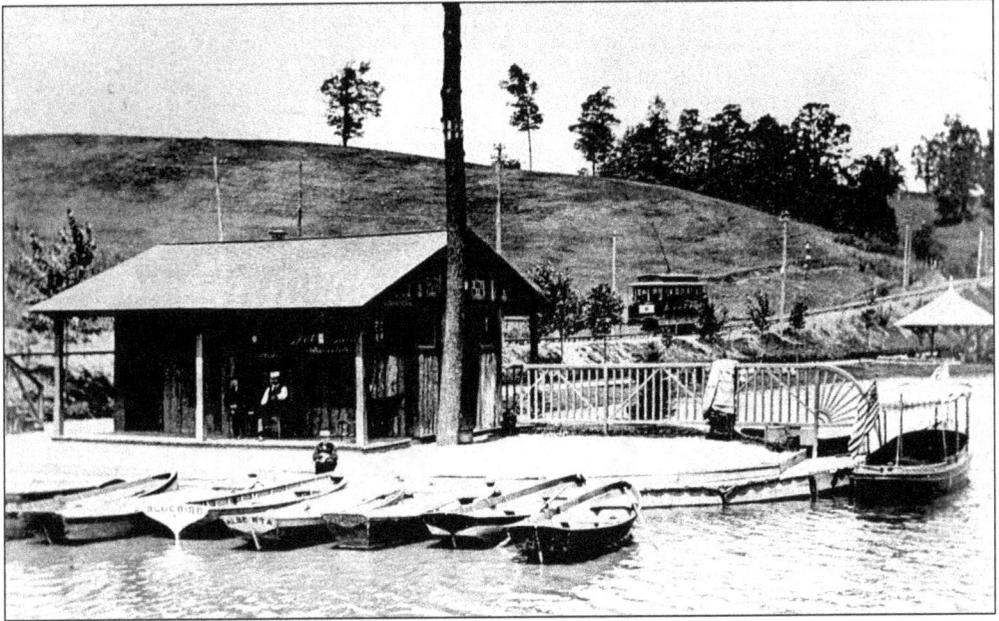

By 1894, Lakemont Park was open and the tracks were completed. In this view, an open car starts up Park Hill in the background. It has just departed the Lakemont station, which was to the left of the boathouse. The boat to the right with the American flag is the electric launch, which could be chartered for a romantic ride on the lake.

Near the end of 1891, City Passenger Railway purchased City and Park Railway and built a new powerhouse and carbarn complex in South Altoona along Fifth Avenue at Thirty-third Street. This new complex was quite large. This photograph shows the paint shop, which maintained trolleys in bright paintwork. This building was also utilized for the bus garage for a number of years.

Opposite the paint shop on Fifth Avenue was the new carbarn, built in 1902 after a second fire destroyed an earlier version. The new barn was quite large with nine stalls. The track to the right is Fifth Avenue today but was just a trolley right of way at that time. Several open cars are seen on the lead tracks.

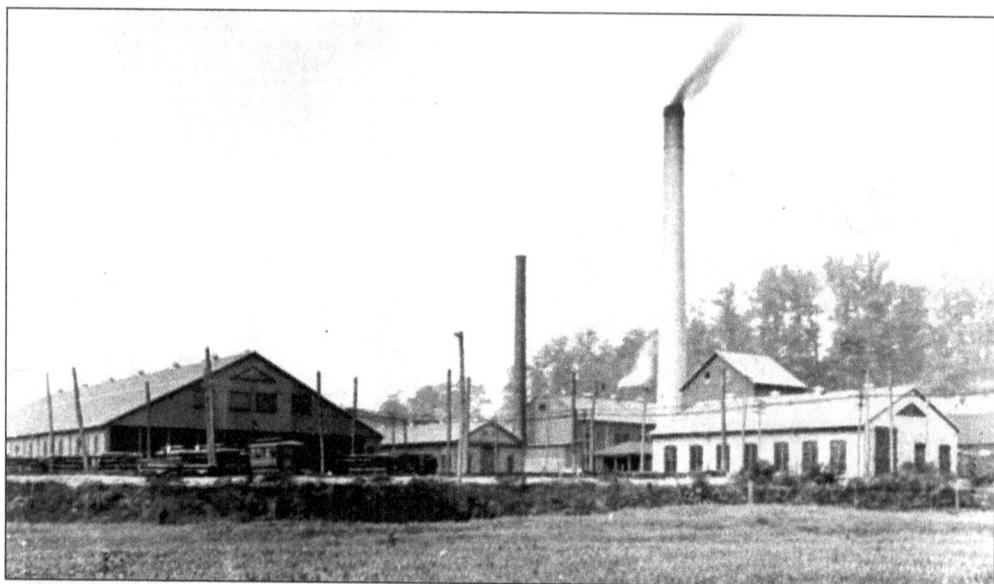

This photograph shows a good view of the entire carbarn complex. The powerhouse and smokestack are behind the older carbarn, which was rebuilt into a carpenter shop, and a machine shop is in the rear. The high building near the smokestack is the coal tipple.

22

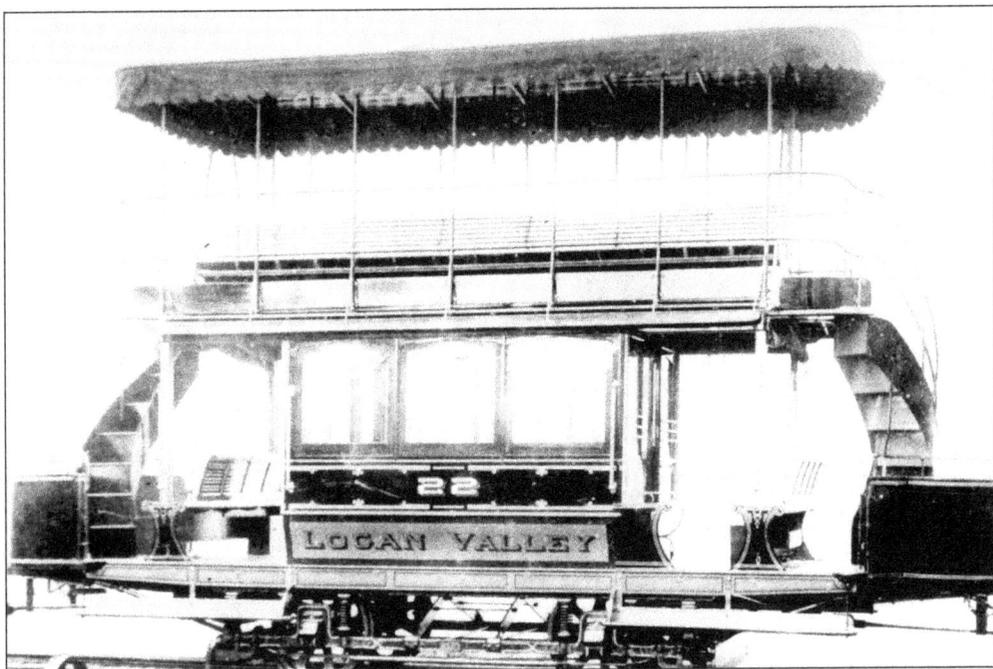

In December 1892, the Altoona and Logan Valley Electric Railway was chartered to build lines from Lakemont to Hollidaysburg and from Juniata to Bellwood. To connect the lines and have access to Altoona, they purchased City Passenger and City and Park Railways, respectively, in April 1893. Six Brill double-deck trailer cars, represented here by No. 22, were purchased to transport passengers to Lakemont Park.

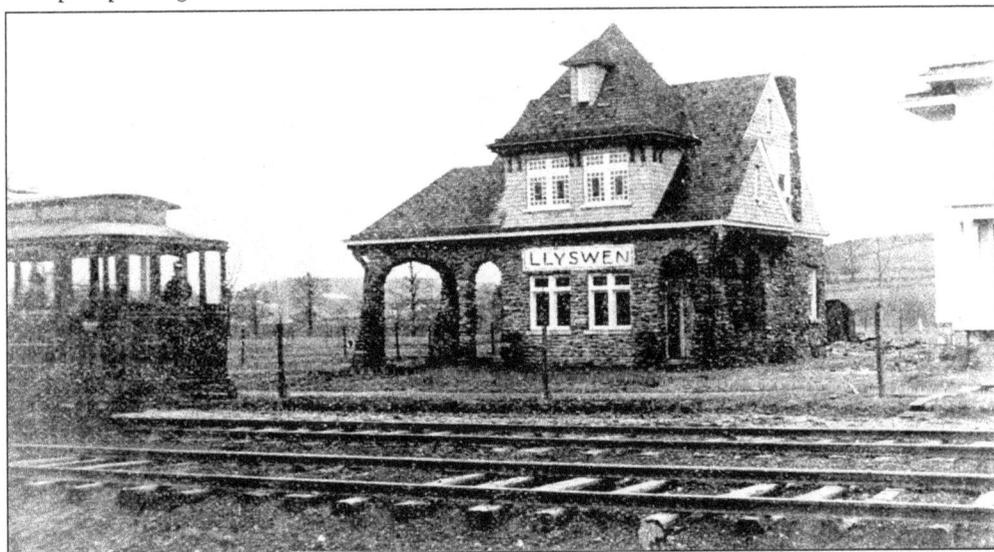

The Logan Valley developed suburban communities through their subsidiary Altoona Suburban Home Company, especially in the new Llyswen section of Altoona. Shown here is the Llyswen trolley station, constructed 1895–1896 by noted architects Michael and Louis Beezer, both of whom constructed twin, Queen Anne-style cottages one block away on lots received as payment for the design of the station. This station was constructed from irregularly coursed, smooth brookstone. This structure survives today without significant modification.

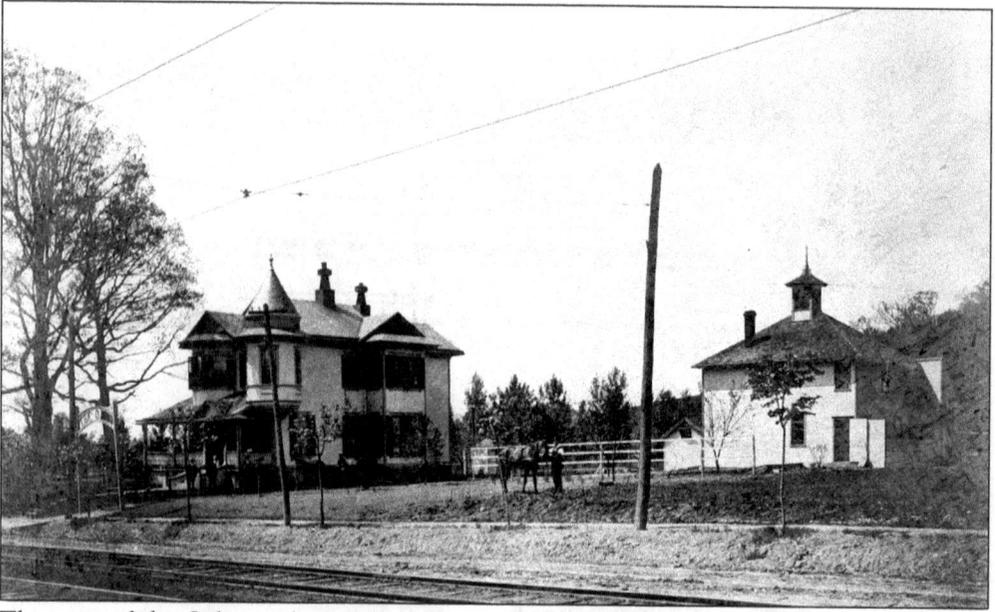

This view of the Oaks on the northwest corner of Logan Boulevard and Holmes Avenue, in the Llyswen area, developed by Logan Valley's Altoona Suburban Home Company, shows the double-tracked line to Lakemont Park. Constructed in 1896 by dentist J. B. Keefer, this residence survives today in well-maintained condition. Twin oak trees, seen in this view, also survive over 100 years later.

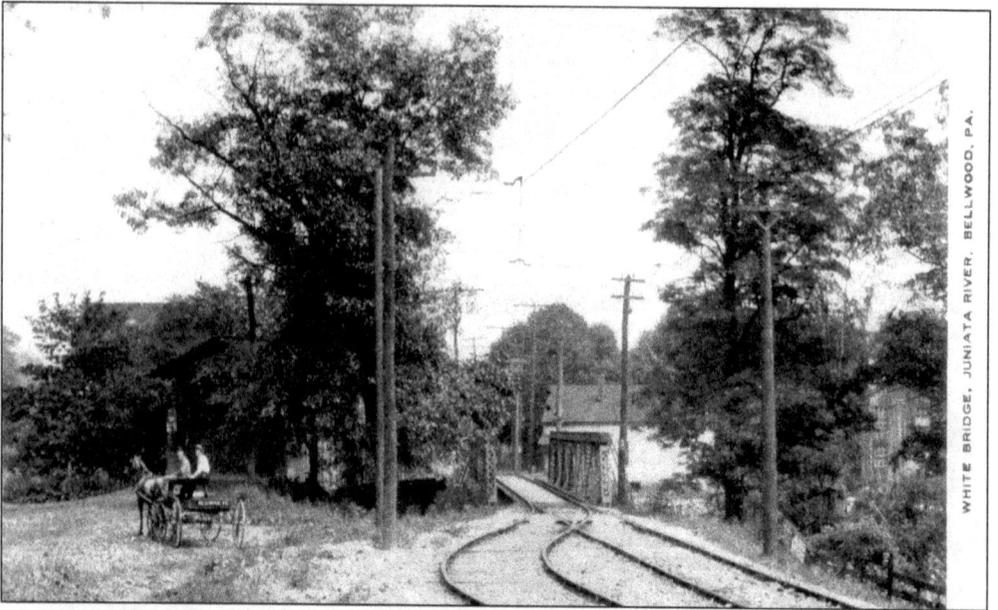

The Logan Valley lines extended northerly from Juniata to Bellwood, approximately seven miles, in 1894. This was a rural trolley line with passing sidings in several places. This view depicts the line crossing the Juniata River at White Bridge prior to arrival in the village of Bellwood. For several years the line into Bellwood from Altoona to the south and from Tyrone to the north were unconnected. They were separated for six blocks due to a lack of approval by the Bellwood council. Between 1901 and 1903, passengers were required to walk those six blocks.

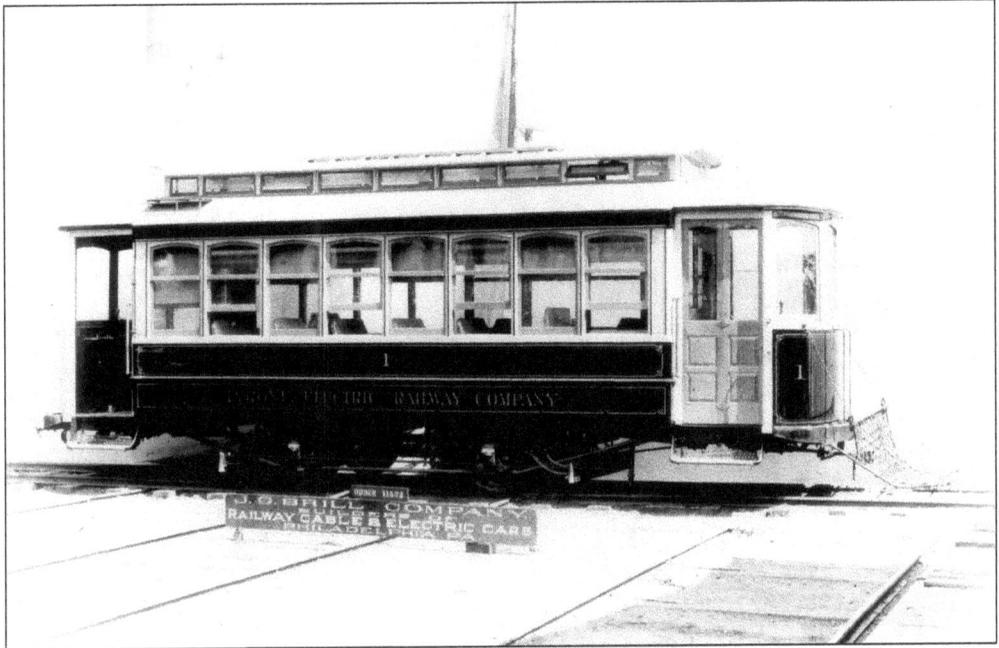

In June 1892 a fourth railway, the Tyrone Electric Railway Company, was chartered by Home Electric and Steam Power Company of Tyrone—about 12 miles north of Altoona—to build local lines as well as lines to Nealmont and Bellwood. This is Tyrone Electric car No. 1, manufactured by Brill.

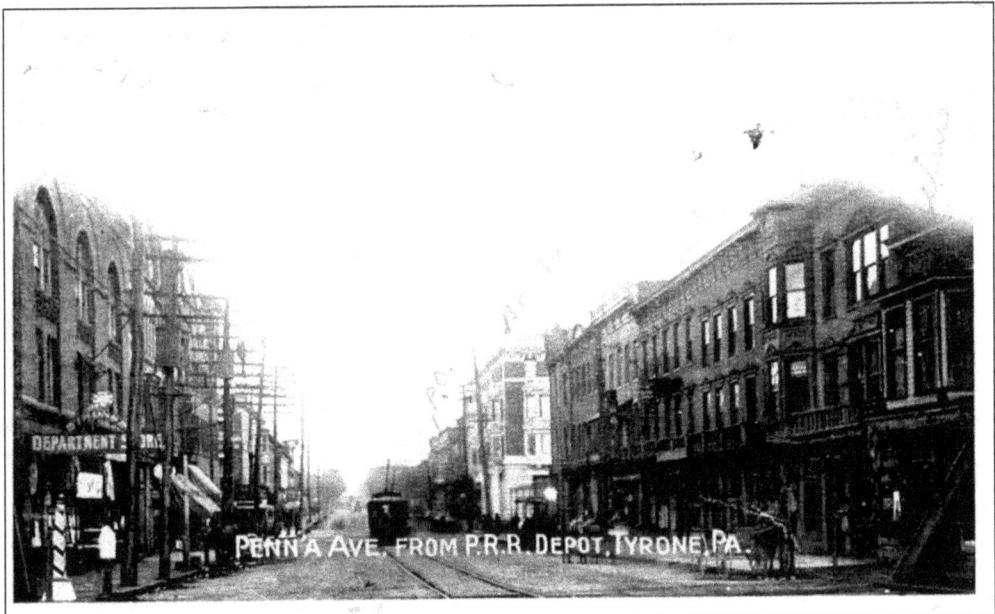

An early car on Pennsylvania Avenue in Tyrone moves toward the PRR station. From the station, the cars either went north about two miles to Nealmont or south to Bellwood, which was about six miles.

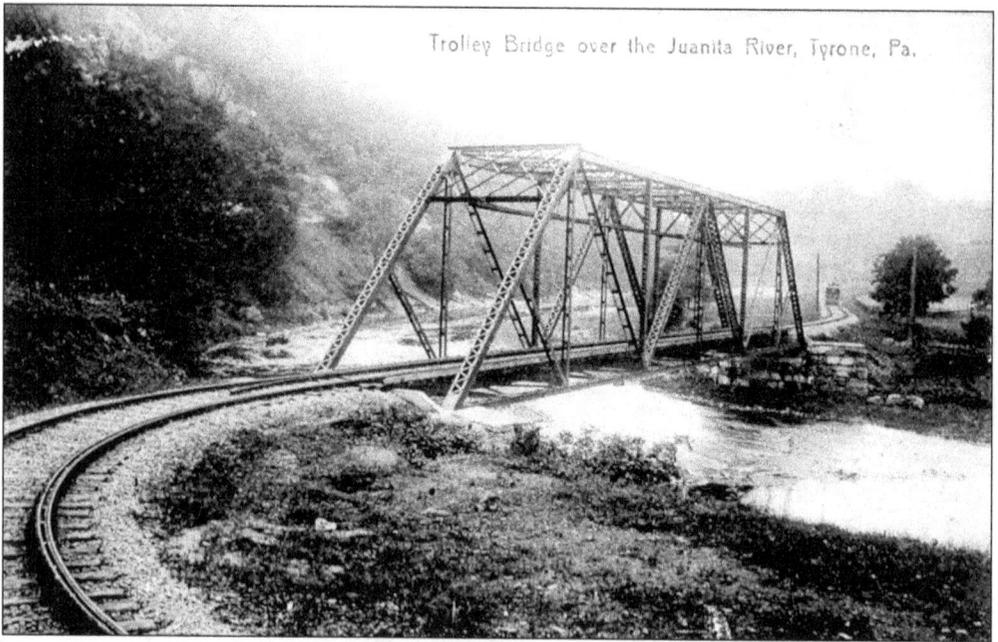

Trolley Bridge over the Juanita River, Tyrone, Pa.

The route from Tyrone to Bellwood was very rural and crossed the Juniata River near Tyrone. These early bridges had to be rebuilt when heavier cars came to the system in the 1900s.

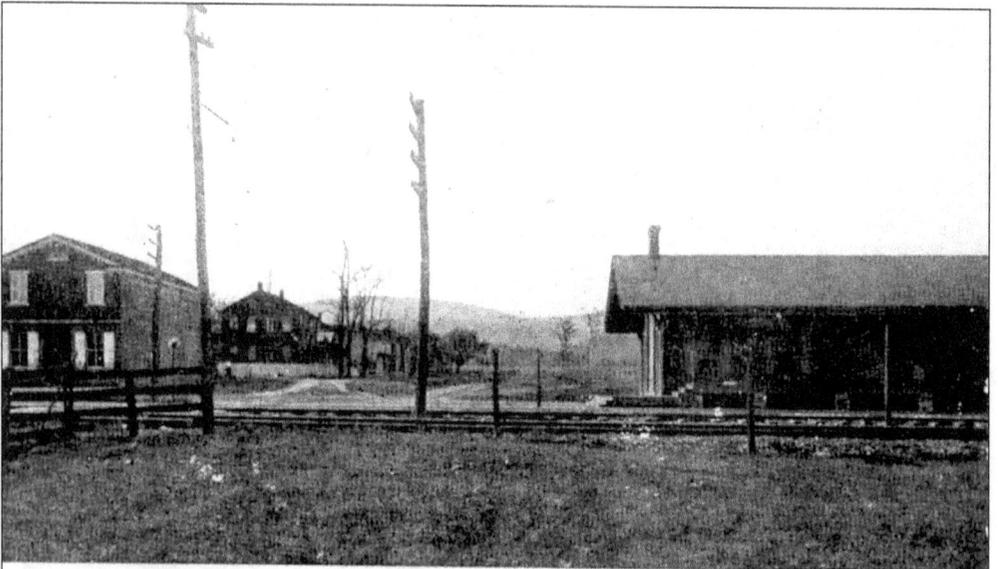

Pub. by J. A. Gardner, Tyrone, Pa. TIPTON, Pa.

In Tipton, Pennsylvania, between Tyrone and Bellwood, a rather large station was built. This station was possibly shared by the PRR, as the trolley tracks paralleled the PRR main line. Tipton was a popular destination because of the Altoona Motor Speedway located there.

Three

LOGAN VALLEY GROWING YEARS
1904–1930

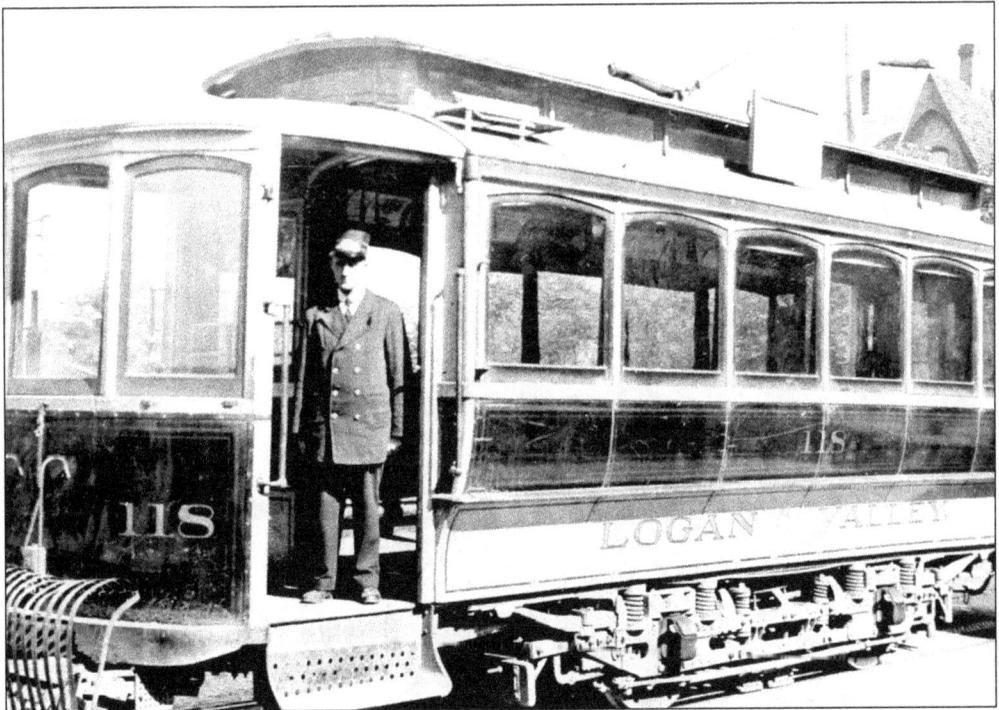

On August 5, 1903, American Railways merged the four local trolley lines into the Altoona and Logan Valley Electric Railway. The line through Bellwood was connected, and passengers could now ride from Nealmont to Hollidaysburg. The cars were repainted orange and ivory and lettered Logan Valley, similar to car No. 118 shown here.

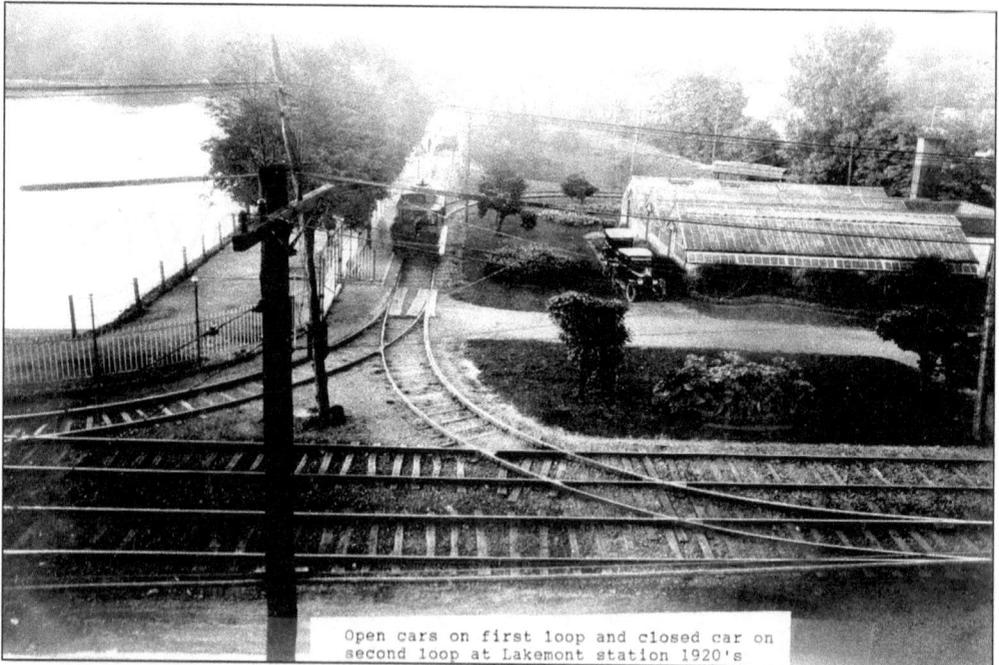

Open cars on first loop and closed car on second loop at Lakemont station 1920's

To handle the large crowds coming to Lakemont Park, the famous trolley loops were installed on the breast of the dam. To do so, more than half the station was razed. Shown here are two open cars on the first loop around the greenhouses and a closed car on the second loop opposite the spillway. The greenhouses were destroyed in a major flood on St. Patrick's Day in 1936.

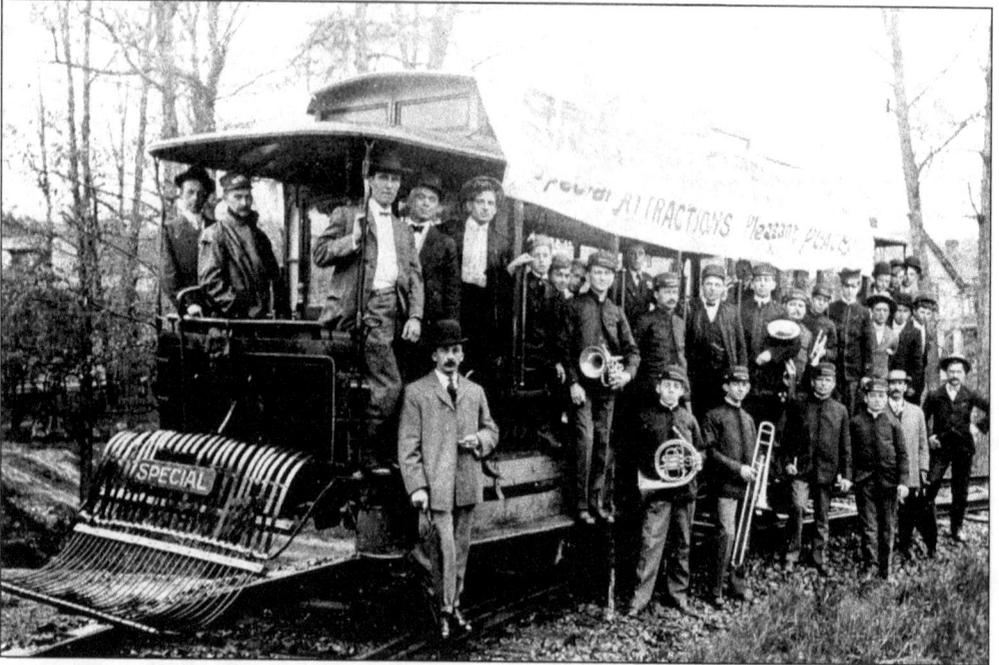

On the second loop, open car No. 206 arrives with a band to celebrate the grand opening of Sylvan Lodge in Lakemont. The early cars had large metal baskets to keep people and animals from falling under them.

Carrying more people and keeping on schedule was hard for the little single-truck cars with hand brakes. Logan Valley was operating a collective 2.5 million miles a year and carrying over 11 million passengers, so accidents were bound to happen. This car lost its brakes on Allegheny Street hill in Hollidaysburg, stopping in the Juniata River near the PRR station. This area is known locally as Gaysport for the former terminus of the Pennsylvania Canal nearby, which joined with the Allegheny Portage Railroad.

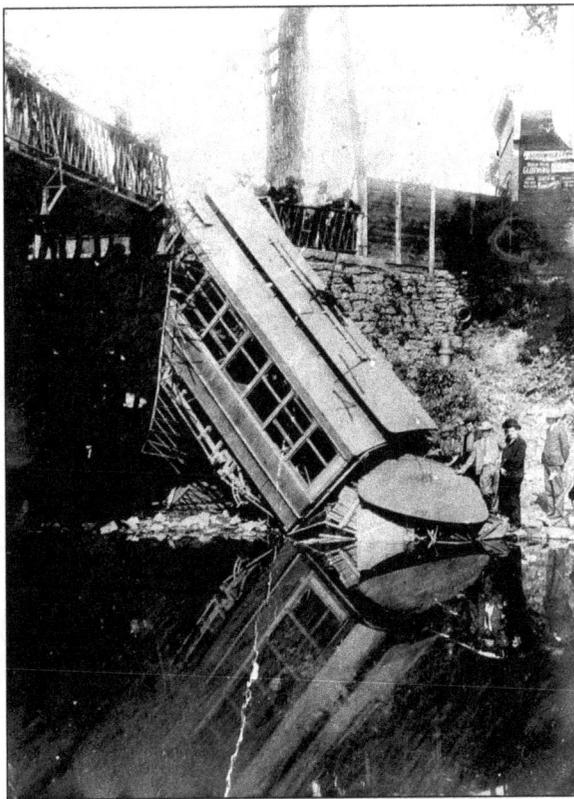

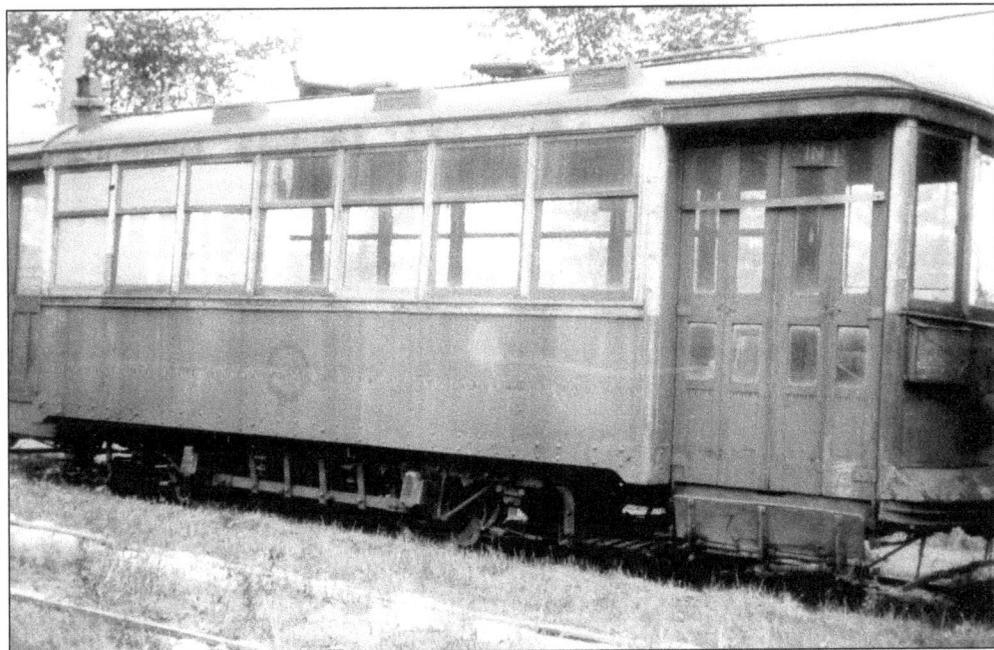

Newer cars arrived in 1911 when Cincinnati Car Company delivered cars No. 135 to No. 139, which had better controls and air brakes and more power. This photograph of car No. 139 was taken in the late 1940s after many years of service.

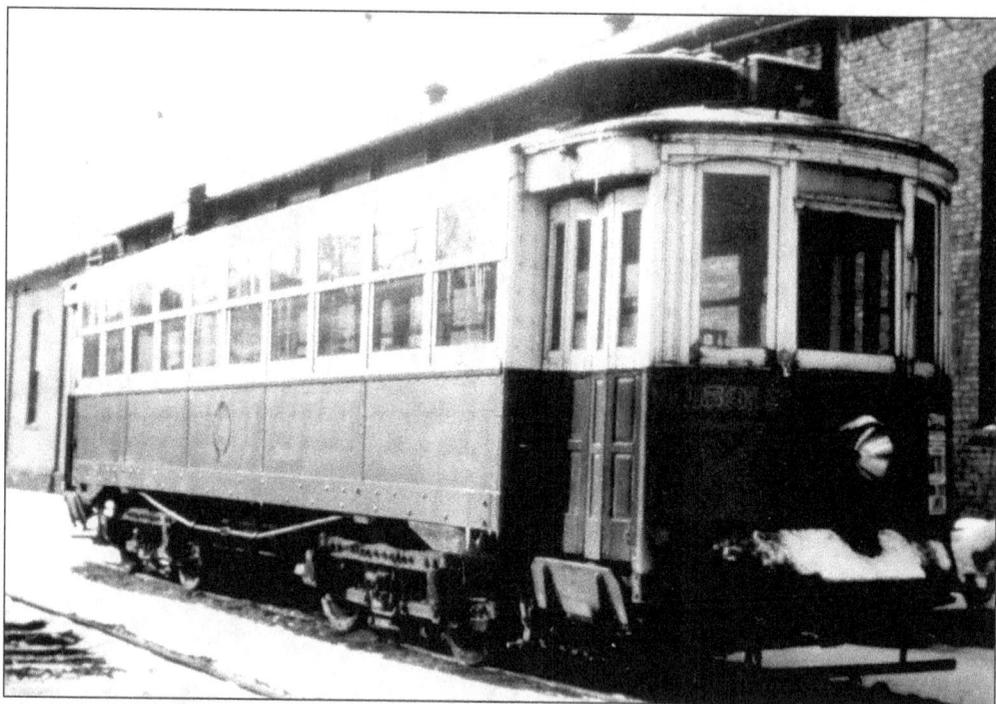

Logan Valley streetcar No. 159 (Stephenson 1903) is shown at the carbarn area awaiting another assignment in this winter scene.

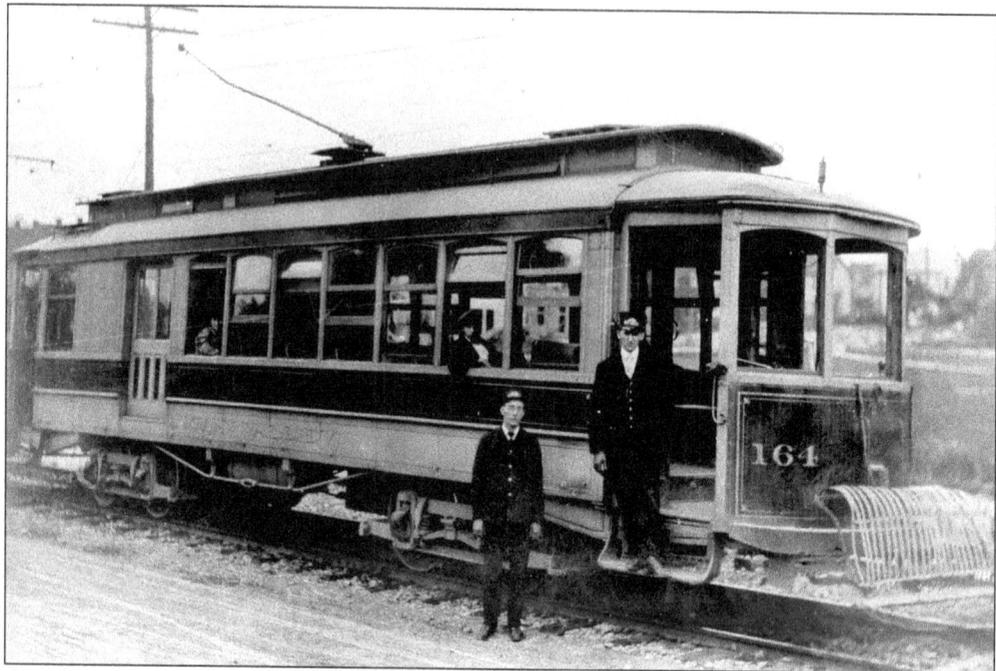

Logan Valley also had combination cars. They held No. 162 to No. 164, which were former Tyrone Electric cars. These were used to haul freight and produce between Altoona, Tyrone, and Hollidaysburg. One of these cars could even be rented to use for that last ride to a local cemetery such as Rose Hill.

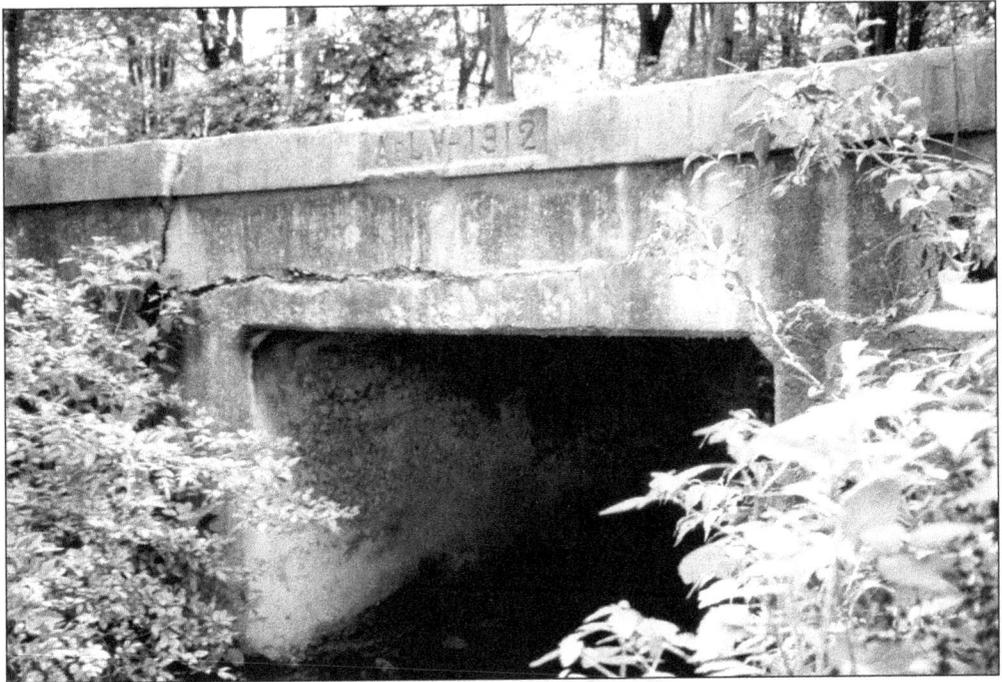

In 1912, the year the Titanic sank, the Logan Valley began building bridges to carry the heavier cars. This concrete bridge still exists at Bellwood but carries automobiles and a soon-to-be-constructed rail trail.

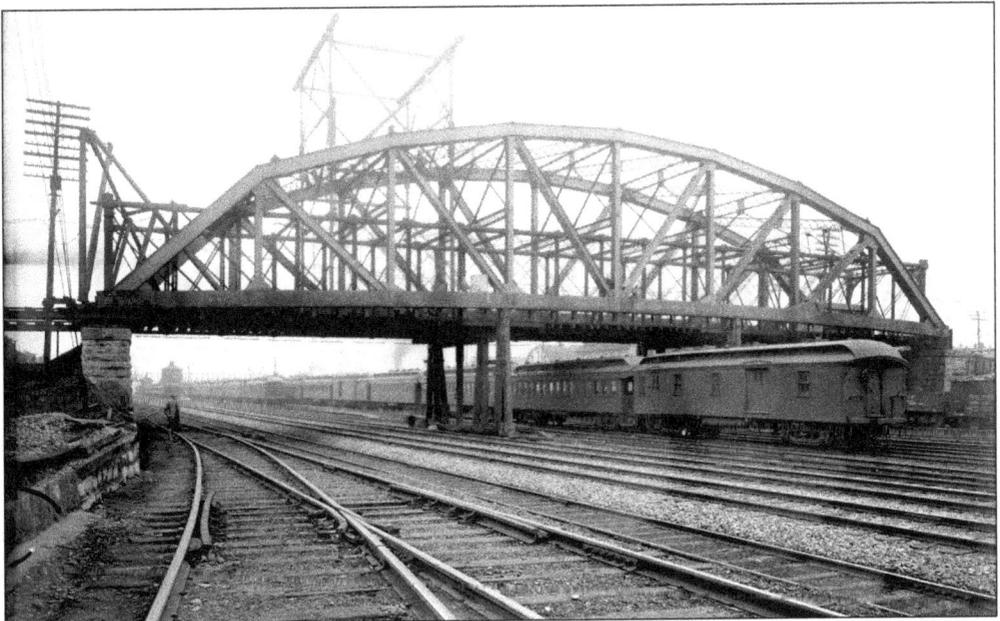

Another larger capital project in Altoona was a joint effort between the Logan Valley, the City of Altoona, and the PRR to build the Seventh Street Bridge. The old bridge was used as scaffolding to build the new bridge, then it was torn down. Once completed in 1913, the trolleys now had two ways to cross the PRR main line in Altoona. Seventh Street and Seventeenth Street formed the full circle serving the two sides of town.

EMPLOYEES OF T

ALTOONA & LOGAN VALLEY EL

1915

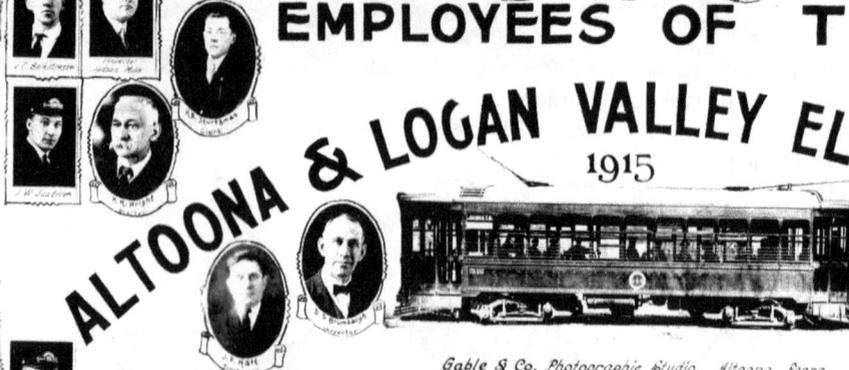

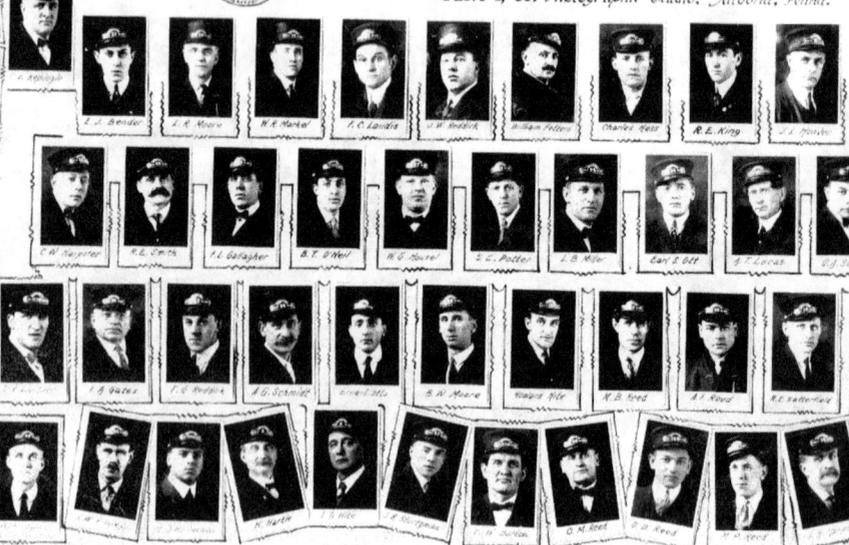

Gable & Co. Photographic Studio, Altoona, Penna.

32

In 1915, Logan Valley had an employee roster photograph prepared. J. M. Harpster (16th from left, second row from top) was step-grandfather to co-author David Seidel.

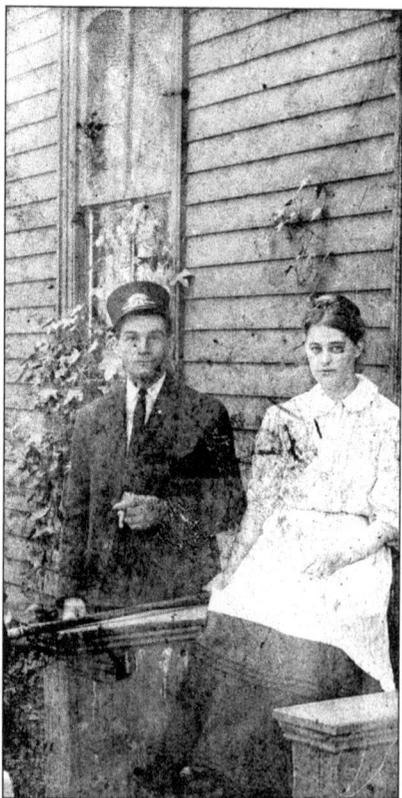

Altoona and Logan Valley Electric Railway employee F. C. Landis is shown here with a lady friend. It is not known if Landis was a motorman or conductor. The identity of the young lady is unknown.

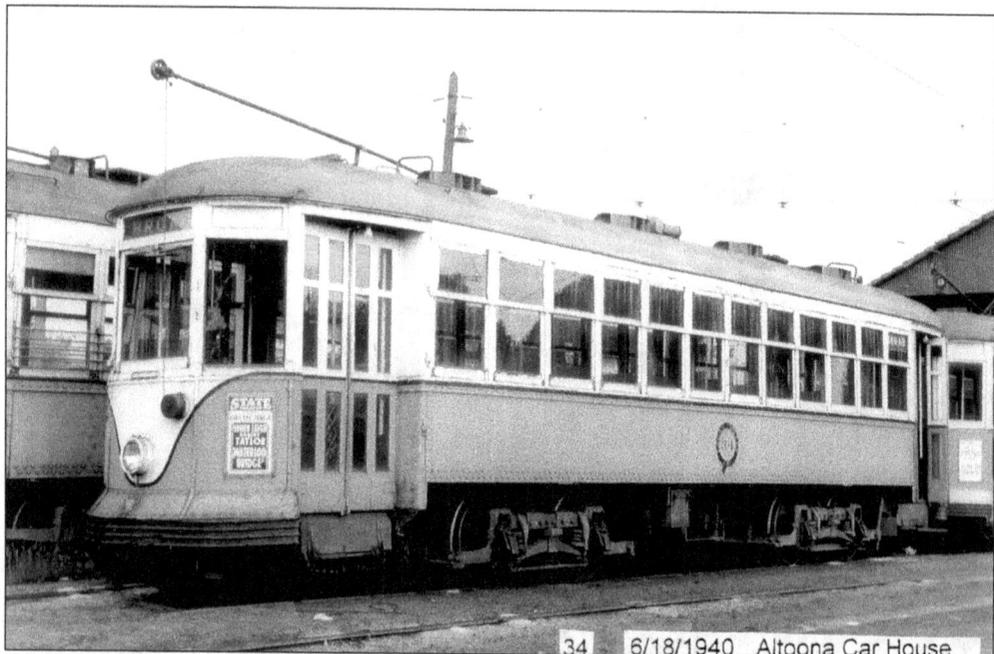

Logan Valley streetcar No. 34 (Brill 1914) is seen here at the Logan Valley carbarn on June 18, 1940. The advertising placard is promoting *Waterloo Bridge*, the latest film of actress Vivian Leigh and actor Robert Taylor, which was featured at the State Theater in downtown Altoona.

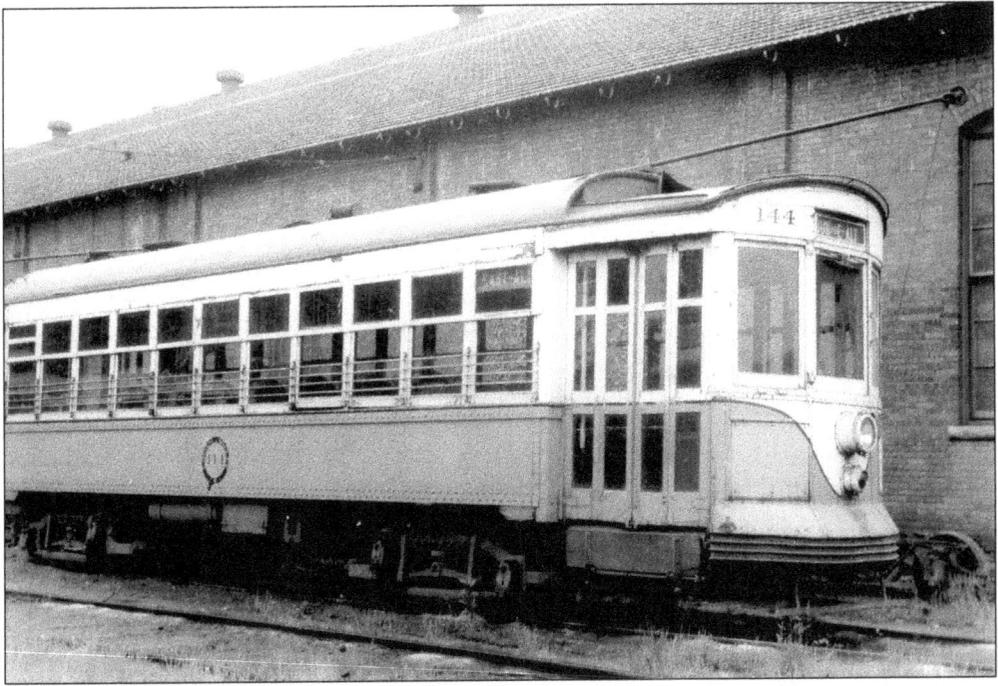

In 1914, Logan Valley purchased several new double-truck cars from the Brill Company. They became numbers 140 through 144 and are represented here by car No. 144 sitting at the carbarn. These cars were used mainly on the East Juniata and East Altoona PRR shops' shuttle lines.

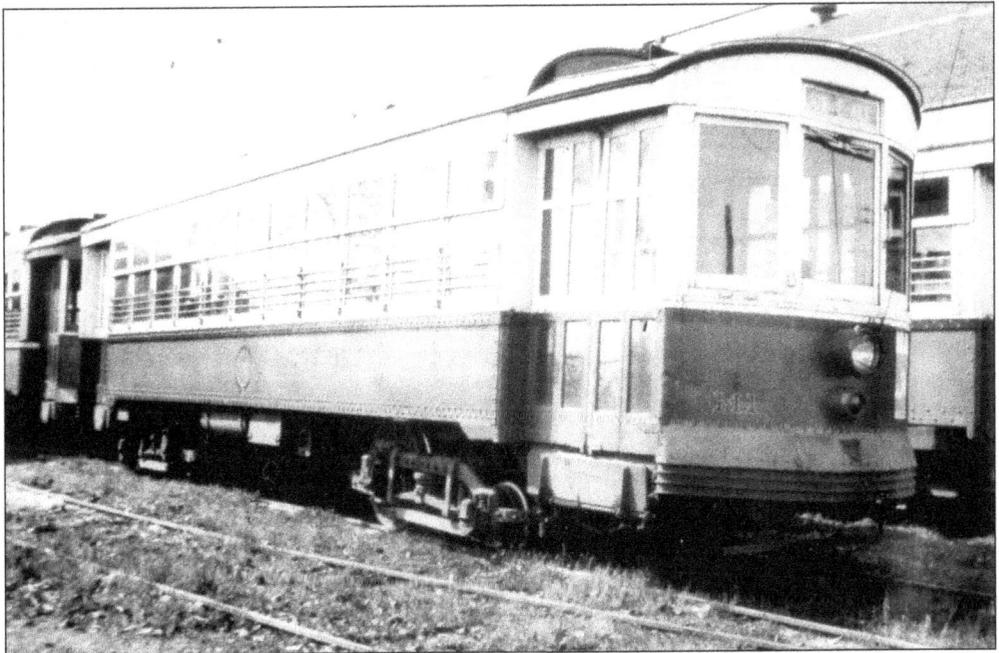

Logan Valley car No. 141, similar to the preceding image, is seen at the carbarn between runs. This car, also a Brill from around 1914, is signed for Juniata and East Altoona to service PRR shops and facilities. East Altoona was the location of the PRR's famous "world's largest roundhouse" for steam locomotives.

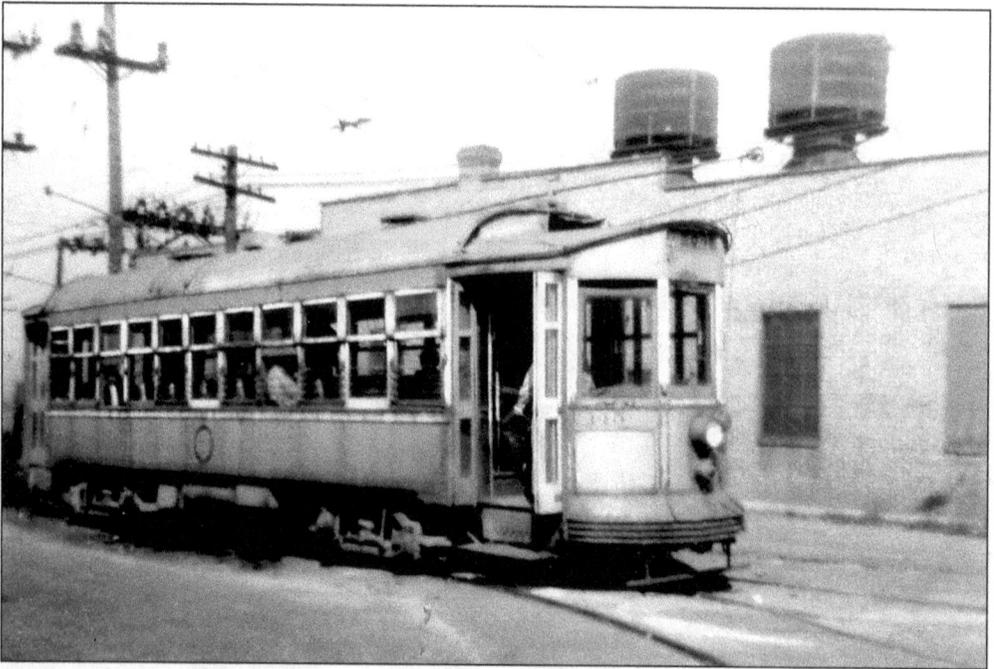

In 1916, another order of these Brill cars arrived numbered 145 through 149. Car No.145 has just traveled across Red Bridge from Juniata to Hutchisons Crossing at Sixth Avenue. By now the cars are wearing the Logan Valley belt symbol with the car number inside. Red Bridge derived its name from the red oxide paint used on the bridge trusses.

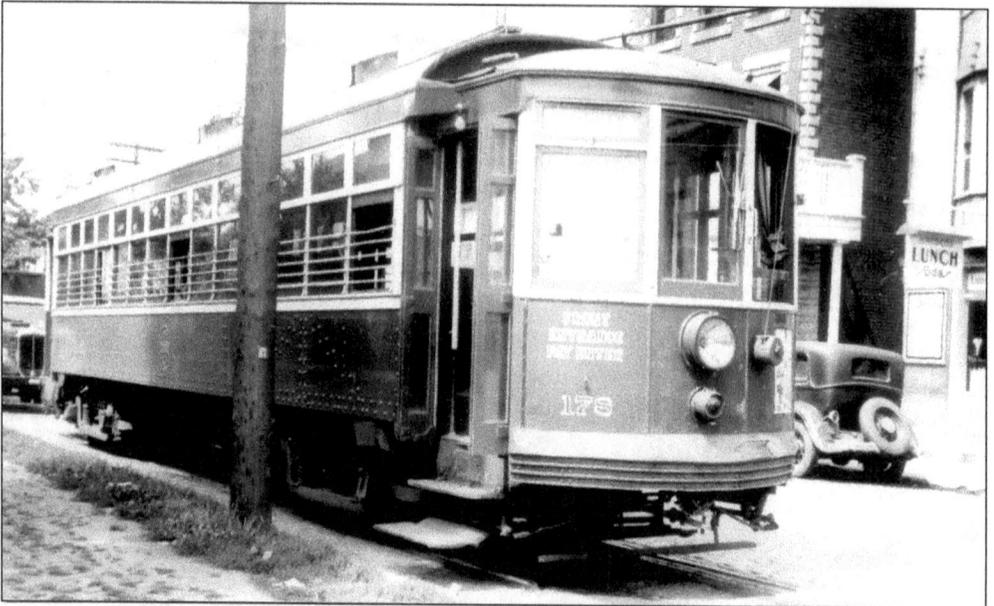

In 1918, Logan Valley purchased eight used cars from the Ohio Valley Electric Railway. They became numbers 173 through 180 and were built in 1913 by the St. Louis Car Company. Car No. 178 is shown here in the early paint scheme, which had very little ivory color. Later repaints would make the cars ivory from the belt rail up to the roof. Car No. 178 is shown on Broad Street, Hollidaysburg, at the PRR station, ready for a return trip to Altoona.

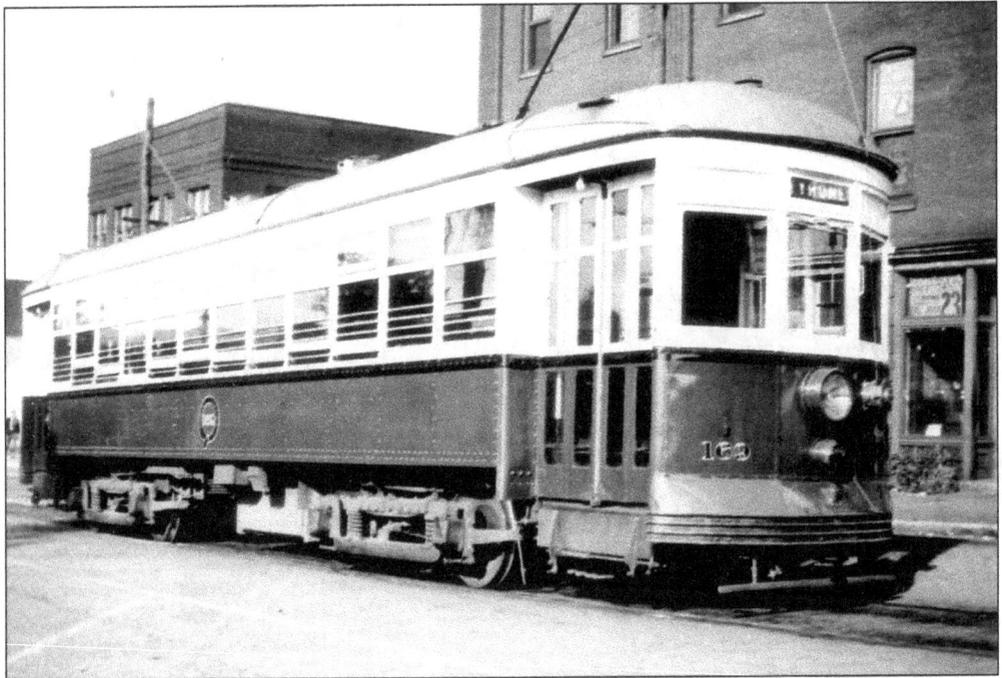

The second order of Brill cars received in 1914 were larger cars for use on the Tyrone line. They became numbers 169 through 172. These cars looked massive and could travel very smoothly at speed. Car No. 169 has just arrived at the PRR station in Tyrone, and the trolley wire pole is being changed for the return trip to Altoona.

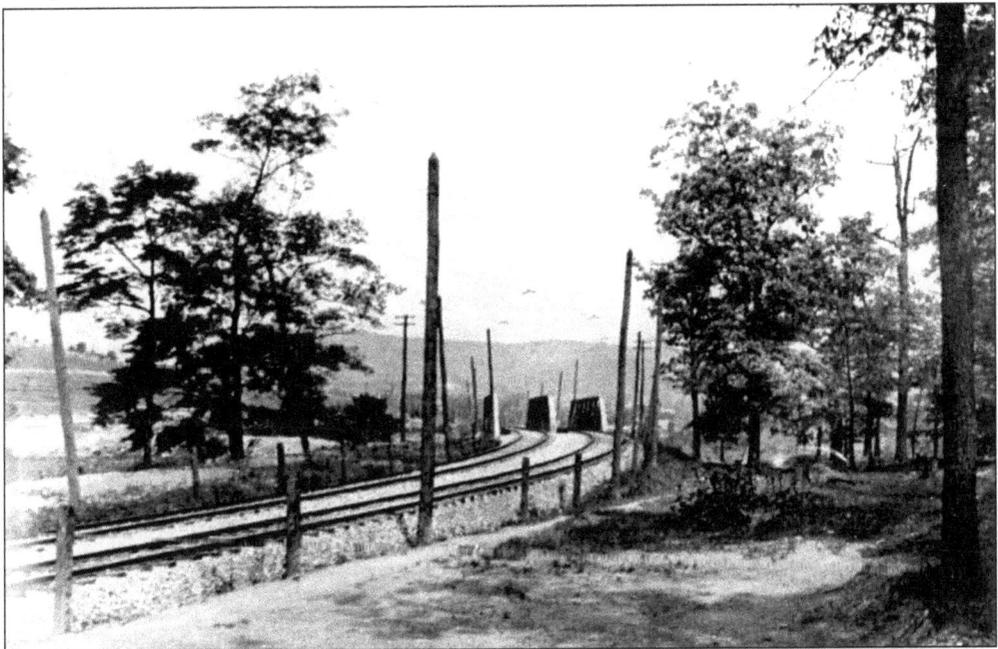

This view of the private right of way, departing Broad Avenue southward to Hollidaysburg, illustrates the line at peak condition with a well-ballasted roadbed. The trestle crosses the (then) PRR branch line. Today this is a four-lane highway.

Along the route to Hollidaysburg, the dirt road to the left is now Pennsylvania Route 36 south, and the trolley right of way is Route 36 north between Altoona and Hollidaysburg, comprising a four-lane highway.

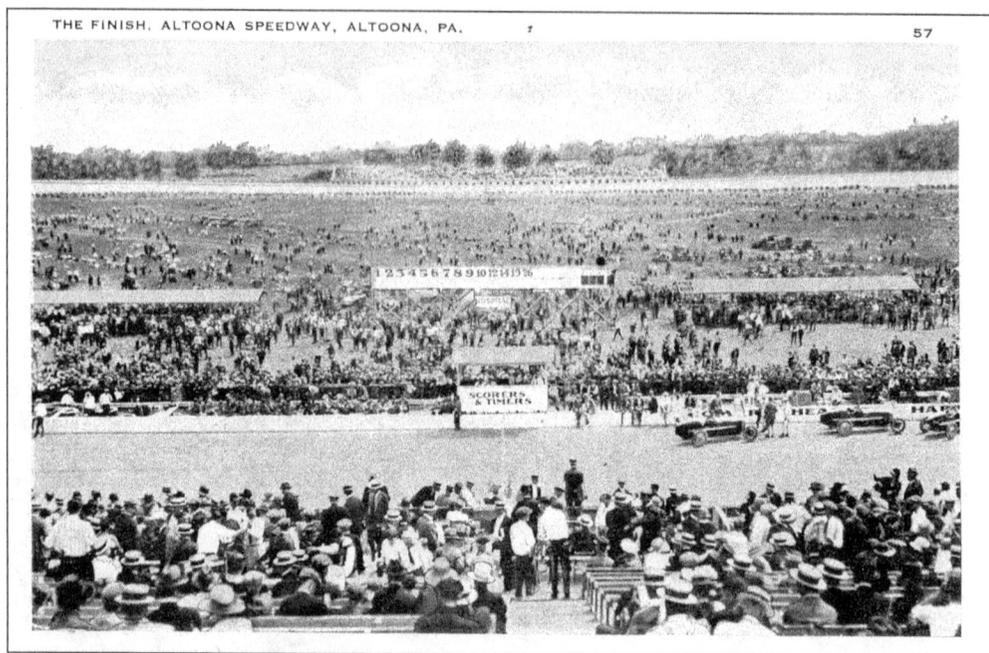

THE FINISH, ALTOONA SPEEDWAY, ALTOONA, PA. 57

A major attraction on the Bellwood-Tipton-Tyrone line was the Altoona Motor Speedway, popular from 1923 to just prior to World War II. This line paralleled the PRR main line. The motor speedway was a one-time rival to Indianapolis and very popular during the summer months. The construction of the oval speedway was unusual as the track was entirely made from lumber.

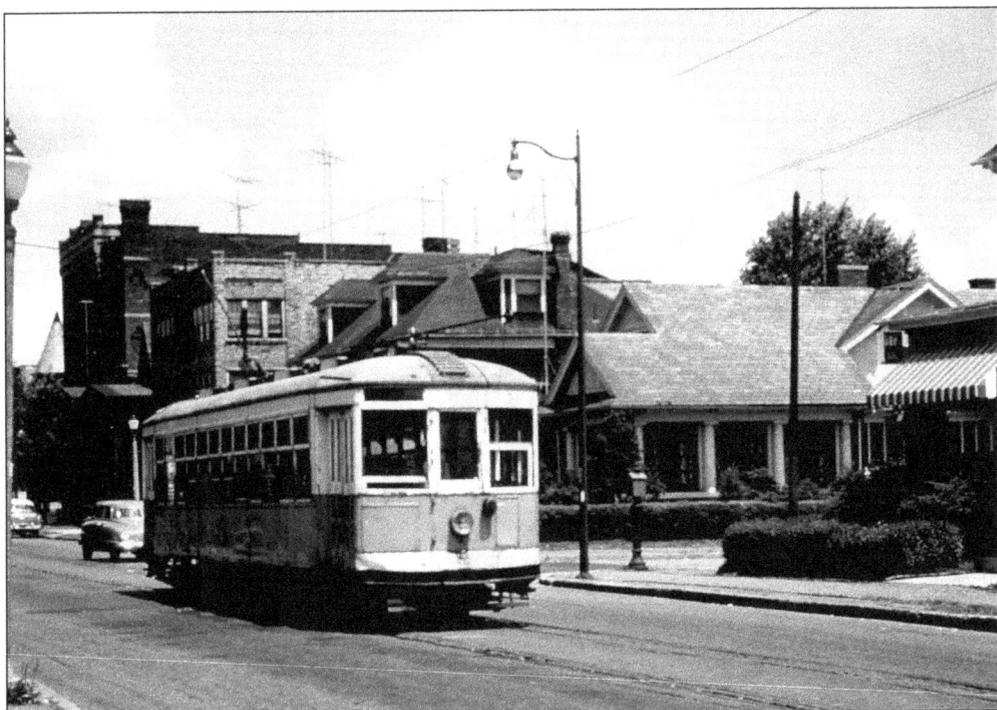

As part of the rebuild program, Logan Valley purchased 13 Osgood-Bradley cars in 1925. These cars took over most of the routes in Altoona. They were numbered 50 through 62 and cost $14,950 each. Here is car No. 51 on Broad Avenue in front of the Jaffa Mosque when vehicle traffic was two-way. Car No. 51 eventually became the very last streetcar operated in Altoona.

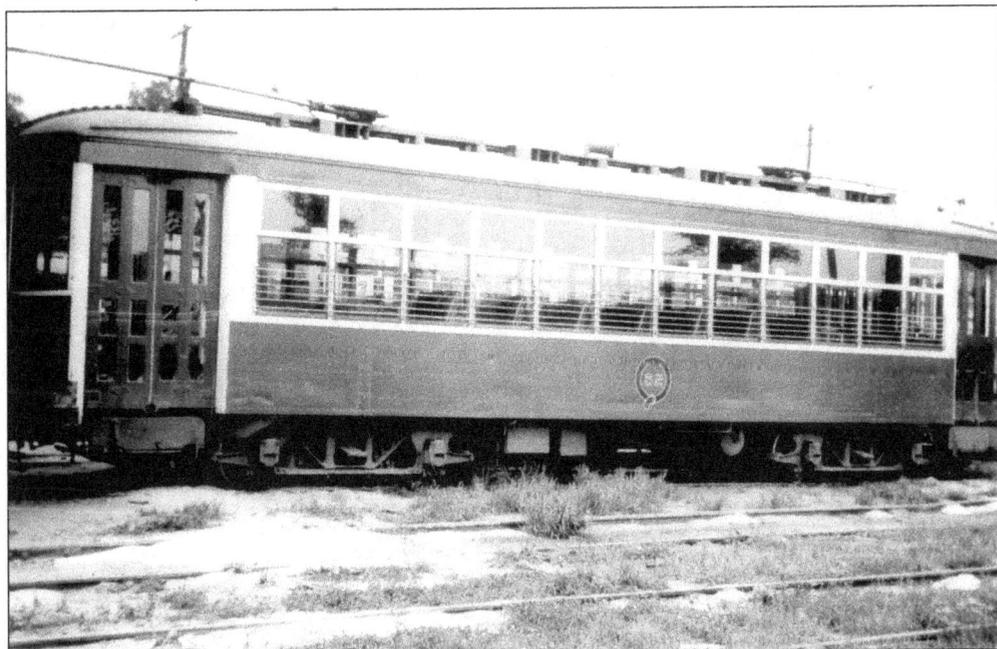

Another 1925 Osgood-Bradley was car No. 52, shown here in an earlier paint scheme with less ivory color. It sits near the carbarn.

EMPLOYEES

ALTOONA & LOGAN VALLEY

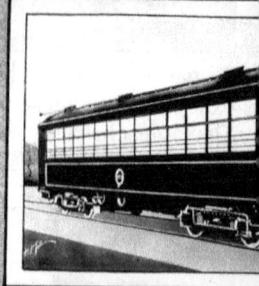

Wm. F. GABLE

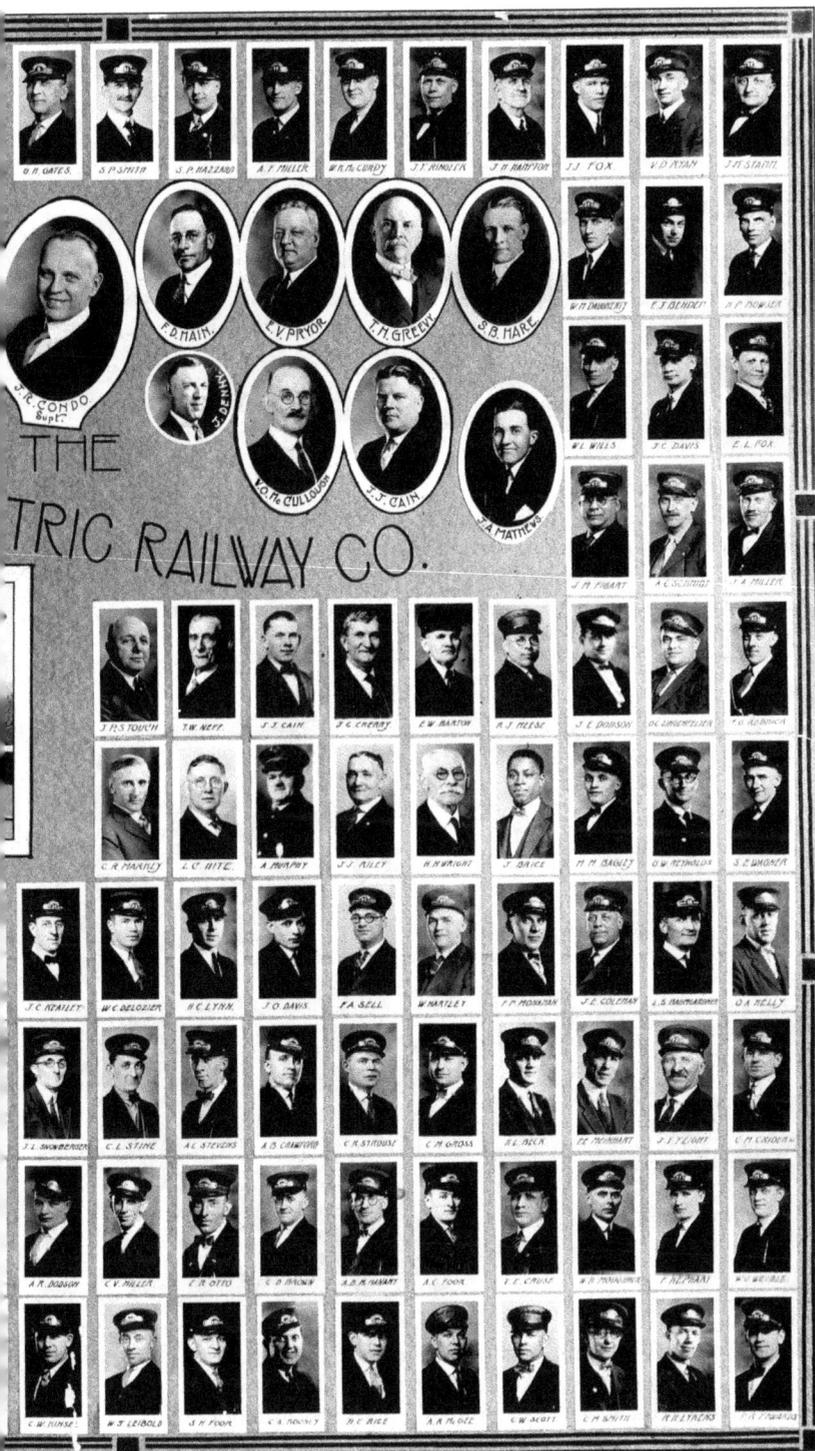

In 1924, Logan Valley again had all of their employees' photographs assembled in a frame at the main office. Unique to this photograph are the men in the fifth and sixth row from the top left. They do not have Logan Valley badges on their hats. This is because they were bus drivers for the new Logan Valley Bus Company started in 1923, and the union forbid them to wear motorman or conductor badges.

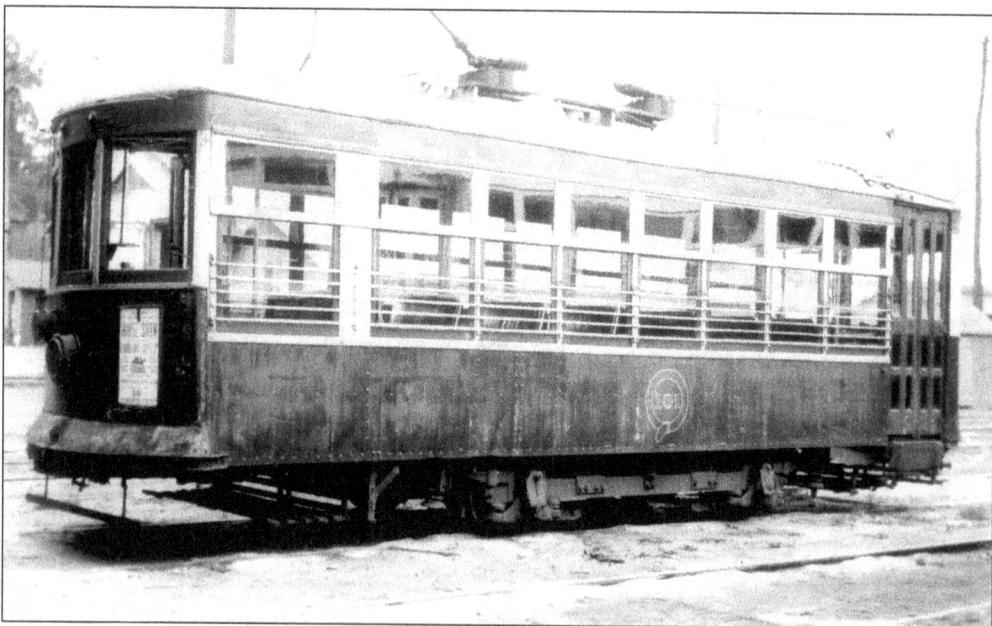

In 1925, Logan Valley disposed of most of its old single-truck cars. It still needed this type of car for the steep Fairview line, so in 1927, three Brill Birney cars were acquired from Oil City Pennsylvania Citizens Traction Company. Here is car No. 101 sitting at the carbarn in the early, almost all orange, paint scheme.

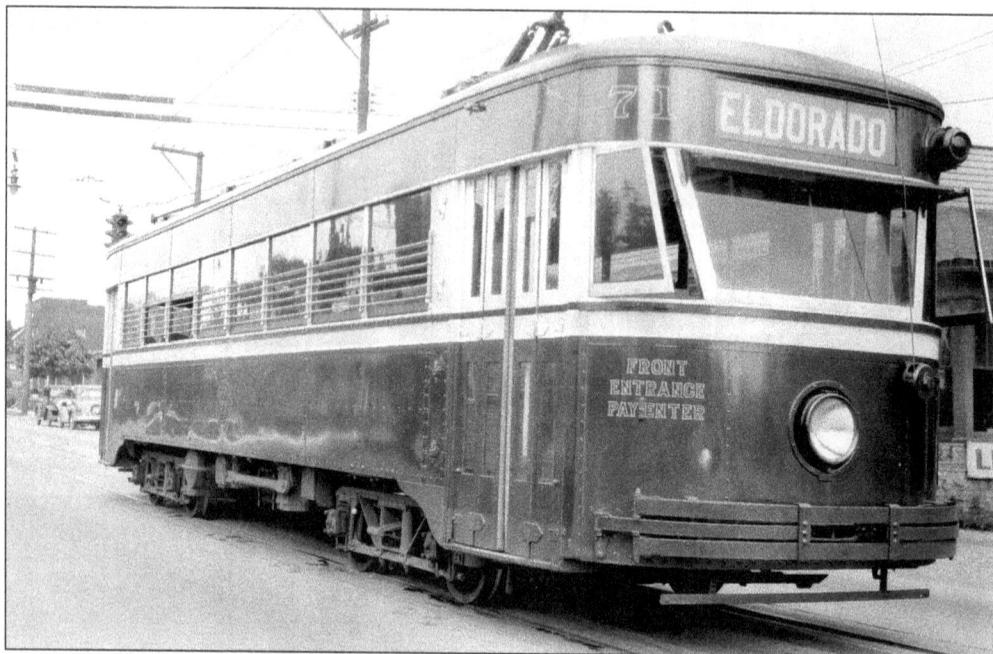

In 1929, the rebuild was done, and the last five new cars were delivered from Osgood-Bradley. They were sold as Master Unit streetcars and had a more modern appearance. They became known locally as Eldorado cars because that was the route to which they were assigned. Here is car No. 71 in the as-delivered paint scheme, ready to change ends in Eldorado to return to Juniata on the opposite side of the city.

Four

THE LAKEMONT PARK COMPANY

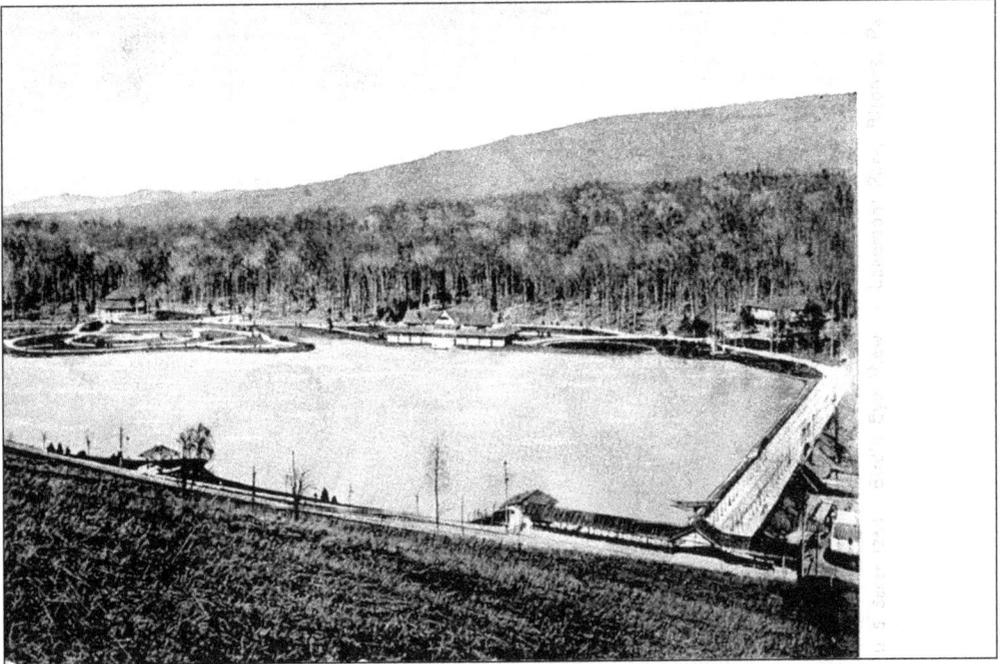

Every streetcar company worth a grain of salt had its very own park. These were usually located outside of town on the trolley route. This meant increased revenue for the company on off-peak hours, and riders also spent money at the park. Lakemont Park was built between 1891 and 1894 by Sylvester C. Baker, who originally mined iron ore in that location. He founded the City and Park Railway, and Logan Valley eventually owned Lakemont Park because it acquired that railway. This early postcard view shows the man-made lake and the trolley station. In the background are the Casino, the Theater-in-the-Woods and some of the scenic paths.

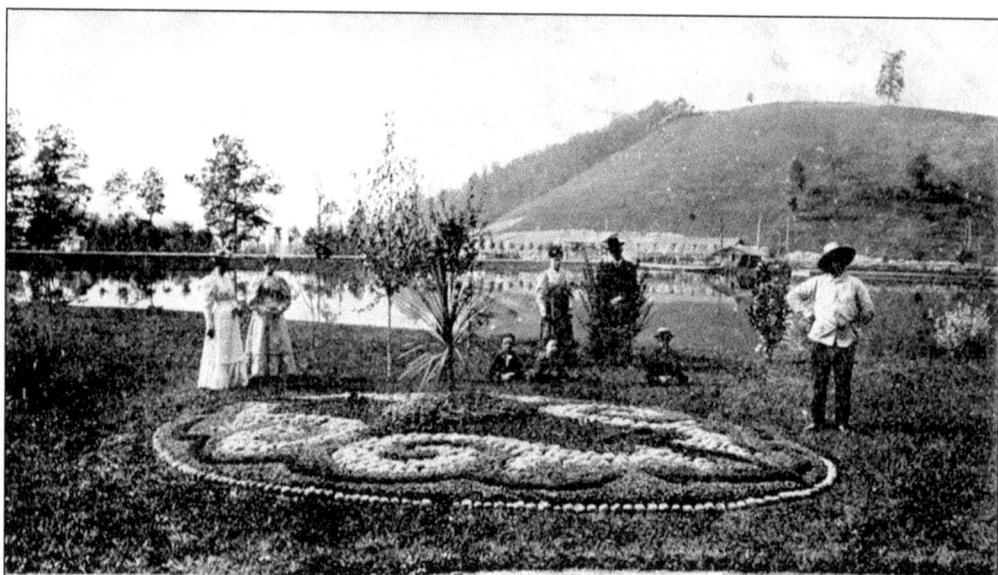

236. Floral Design, Lakemont Park, Altoona, Pa.

The park had many beautiful flower and shrub gardens designed by Wesley Motter, seen at the right in this postcard view. He especially liked to create gardens using cactus, which were wintered in the greenhouse located near the trolley station.

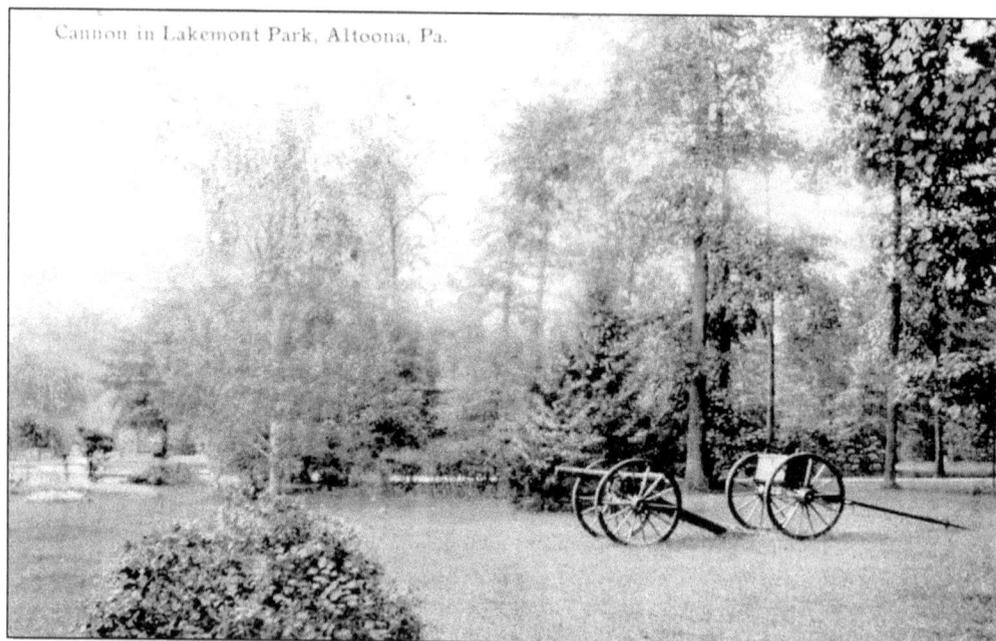

Cannon in Lakemont Park, Altoona, Pa.

The park had many Civil War cannons located throughout the grounds. In later years, some of them were moved to the track-side hill above the lake. During World War II, they were all melted down for scrap metal as a contribution toward the war effort.

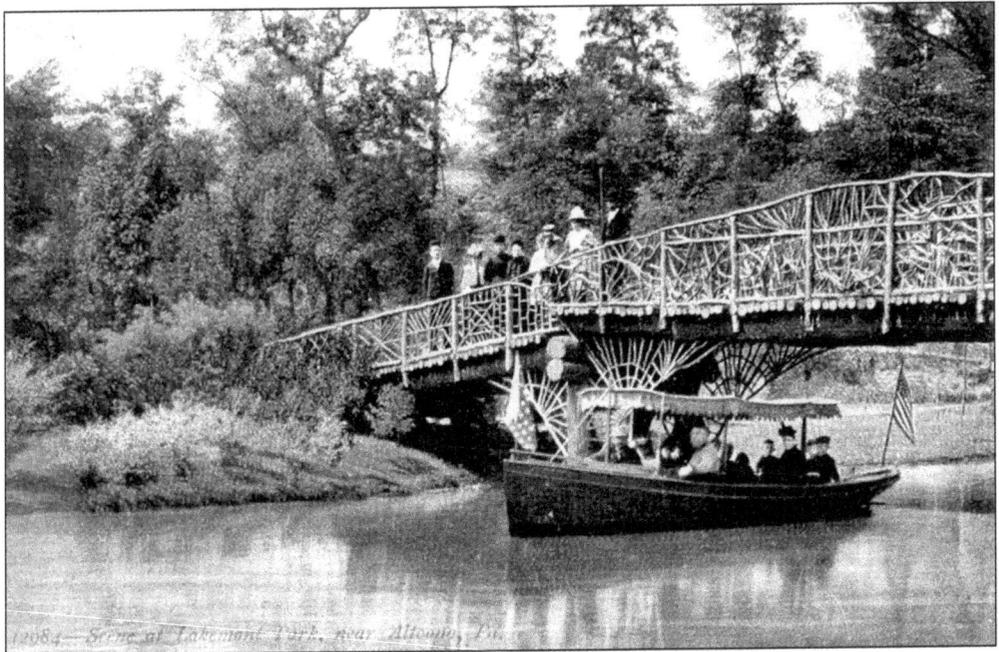

The park had many wood bridges constructed from native tree limbs, resulting in a rustic appearance. These bridges connected the park with the island in the center of the lake. In this postcard view, the electric launch passes under the bridge in the early 1900s.

No park would be complete without a merry-go-round for kids and those who are kids at heart. E. Joy Morris built the carousel for Lakemont, and it contained hand-carved animals (26 horses, 3 camels, 3 goats, 3 giraffes, 3 donkeys, 3 deer, 3 zebras, 1 tiger, 1 hippocampus [or sea serpent], and 1 lion), along with four chariots. In 1982, this carousel was sold for $225,000 to a collector because it was deemed worn out after providing rides to kids for 80 years.

The Whip, located between the carousel and the roller coaster, provided many thrills to riders over the years. This ride simply took riders around a circle but with very fast turns. It, too, disappeared in the 1970s.

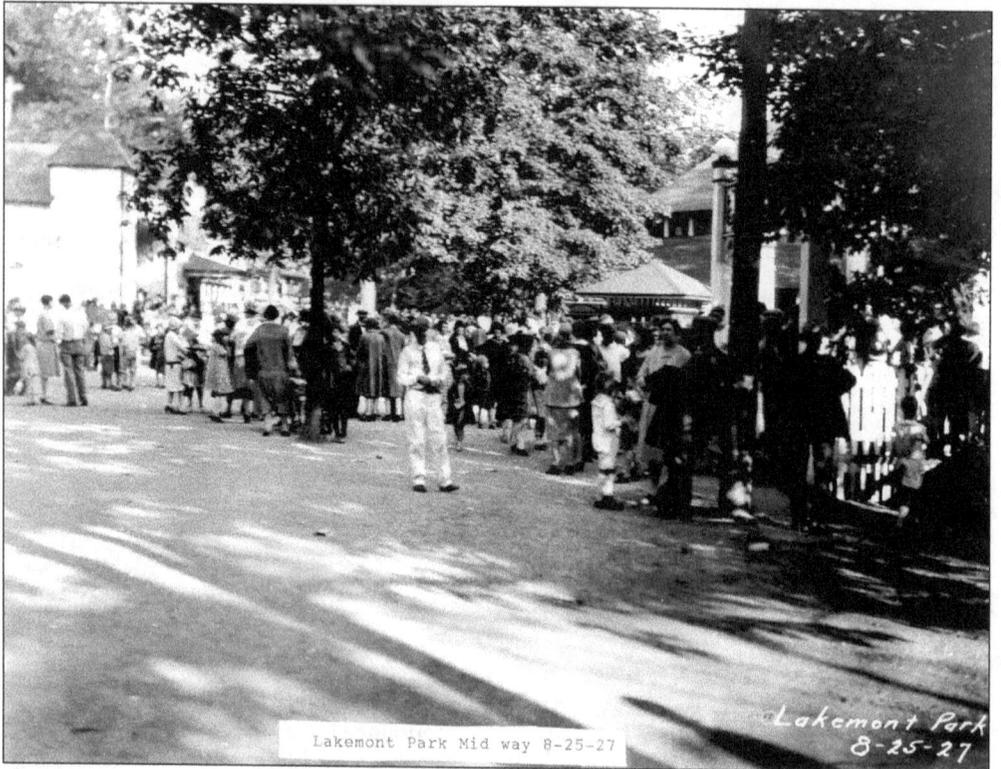

Lakemont Park Mid way 8-25-27

Lakemont Park
8-25-27

The Lakemont Park midway offered a place to try your luck at games or pick up something to eat. This August 25, 1927, view shows the way folks dressed up to go out to the park.

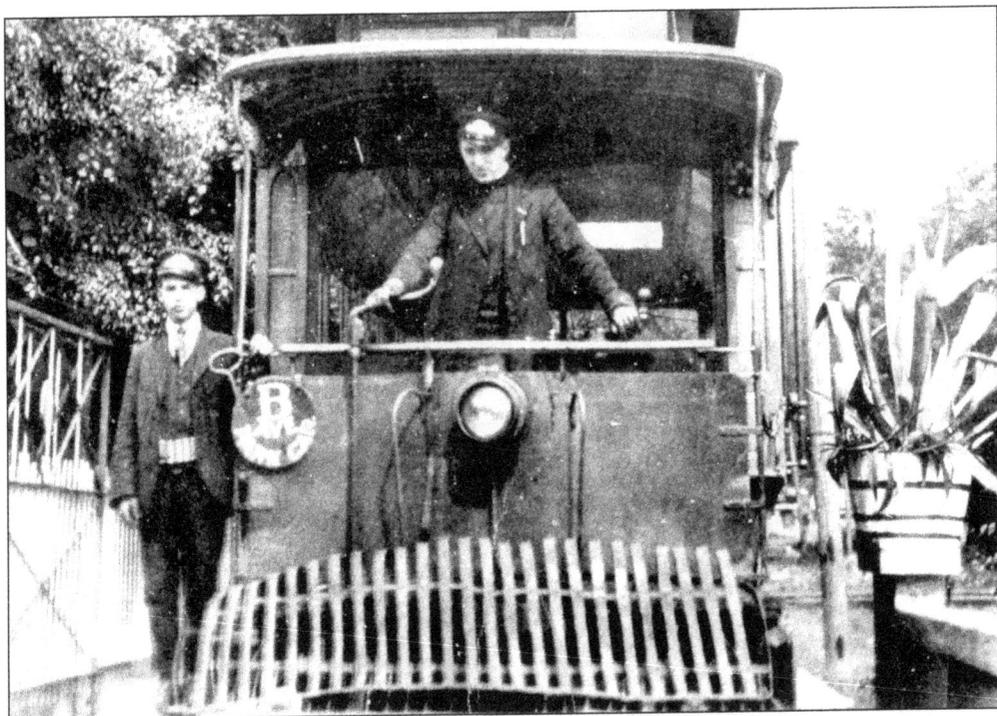

One of the open-air park cars is shown on the trolley loop at Lakemont Park. Also shown are motorman Hommer Ayle and conductor George Feltenberger. There were approximately 30 such open-air park cars for the summer seasons.

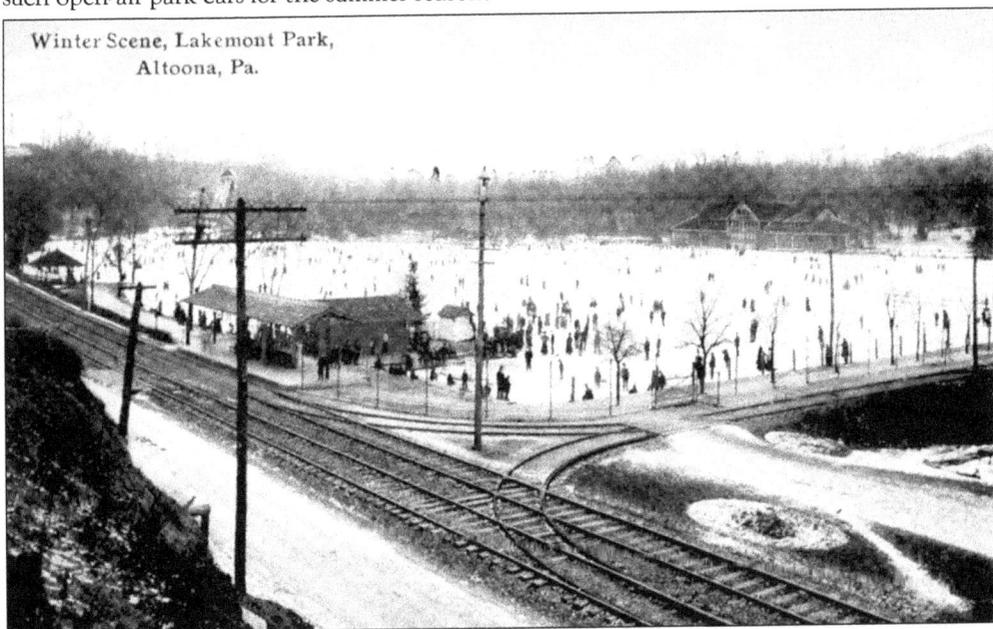

Ice-skating was a popular sport at the park during the winter months. When the lake was sufficiently frozen, a large red ball was hung on the trolley cars to alert citizens that the lake was ready for skating. In this postcard view, the ice skaters frolic near the reduced-in-size trolley station after the trolley loops were installed.

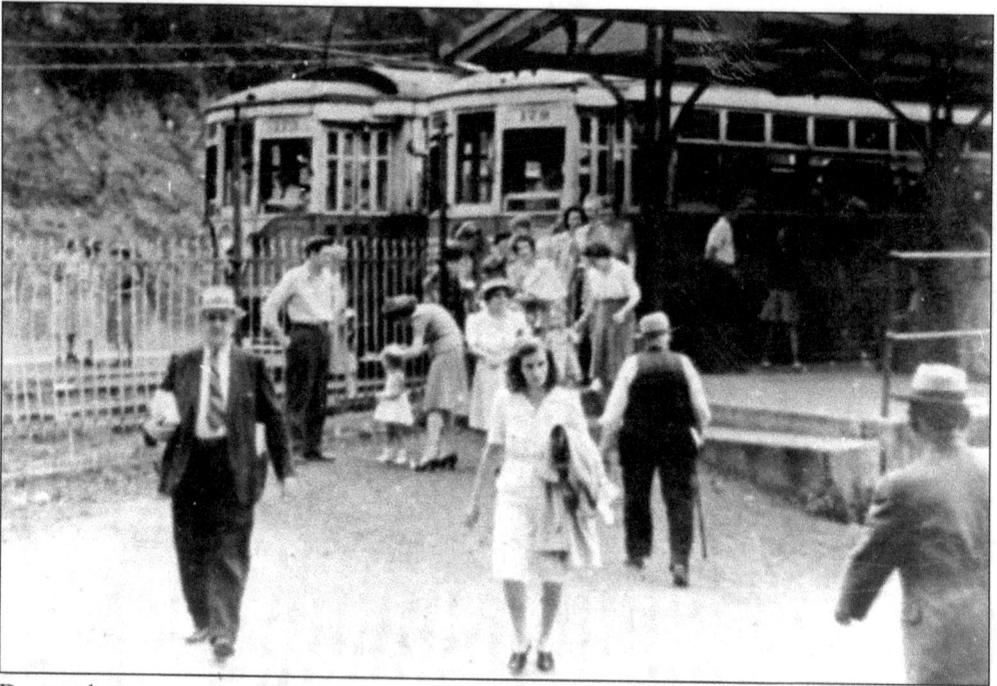

During the summer, usually around the end of July and into August, the Central Pennsylvania Bible Conference was held at Lakemont Park, either in the casino or the theater. The trolley company operated many special cars to this event during its 10-day run. Shown here, some of the attendees arrive at the station and begin their walk across the breast of the dam to the casino, an open-air pavilion.

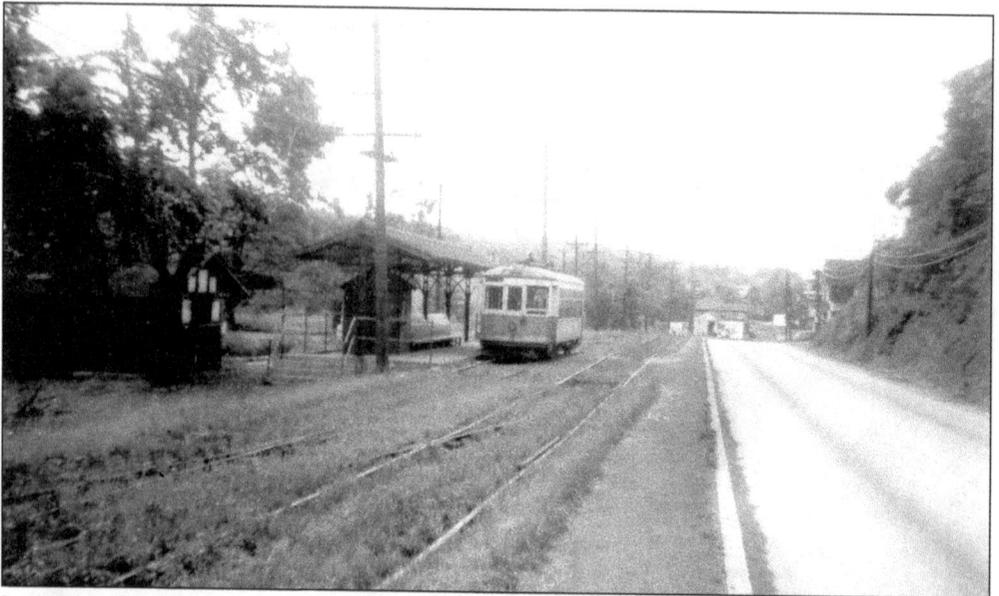

In 1936, a flood destroyed much of the park, including the greenhouses and some of the loop tracks. Logan Valley did not have funds to rebuild the park, so the company sold it to Blair County. The trolleys still stopped at the station, but in this 1950s view, weeds have grown over the busy Hollidaysburg line, and Lakemont station has no passengers waiting for a car.

Five

WORK EQUIPMENT

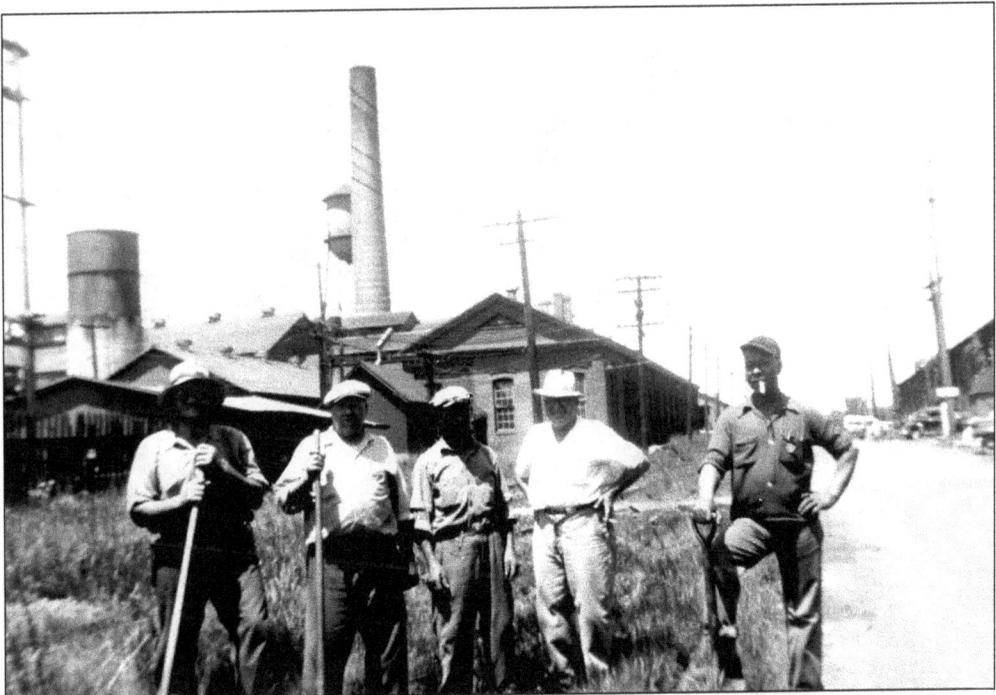

Track maintenance was always a daily requirement for safety and efficiency. A track gang is shown here, working in the carbarn and yard areas along Fifth Avenue. The track workers are not identified in this 1950s scene. Most tracks are not visible in the grassy areas shown.

This vintage Logan Valley coin counting machine was utilized during the streetcar era. In this view, the machine is on display at the Railroader's Memorial Museum in Altoona.

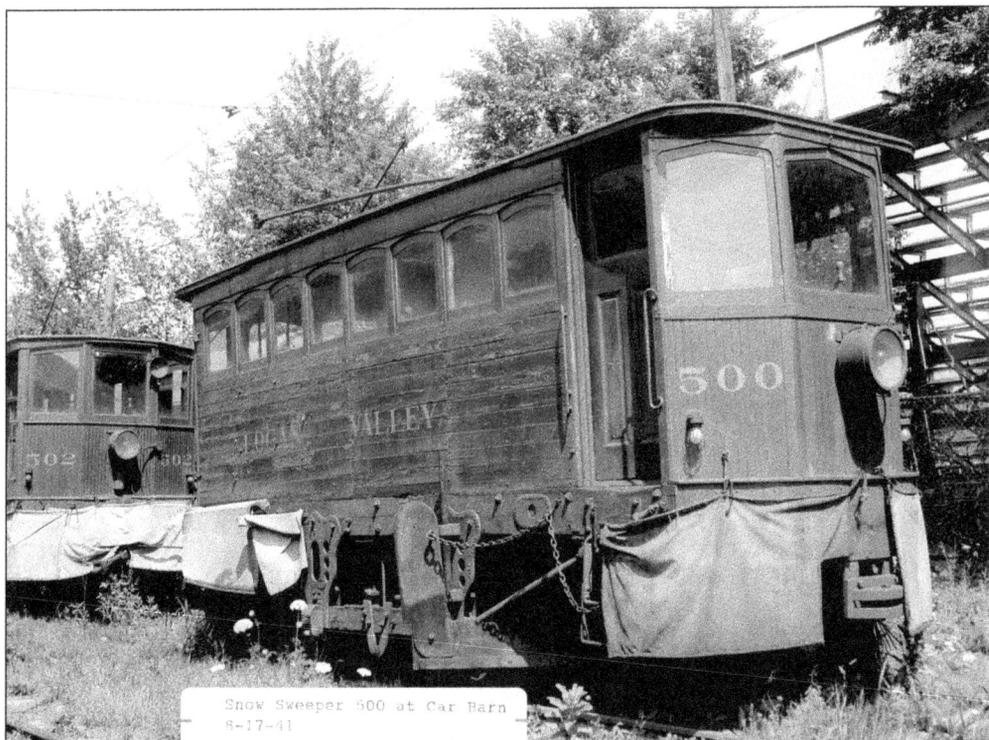

Snow Sweeper 500 at Car Barn
8-17-41

To keep the trolleys running in the winter required snow removal equipment. Logan Valley assembled a large fleet of such units. The first was No. 500, built in 1894 by the Brooklyn Rail Supply Company. Using the tarps was an attempt to keep the snow churned up by the brushes from blowing too far from the street and breaking windows.

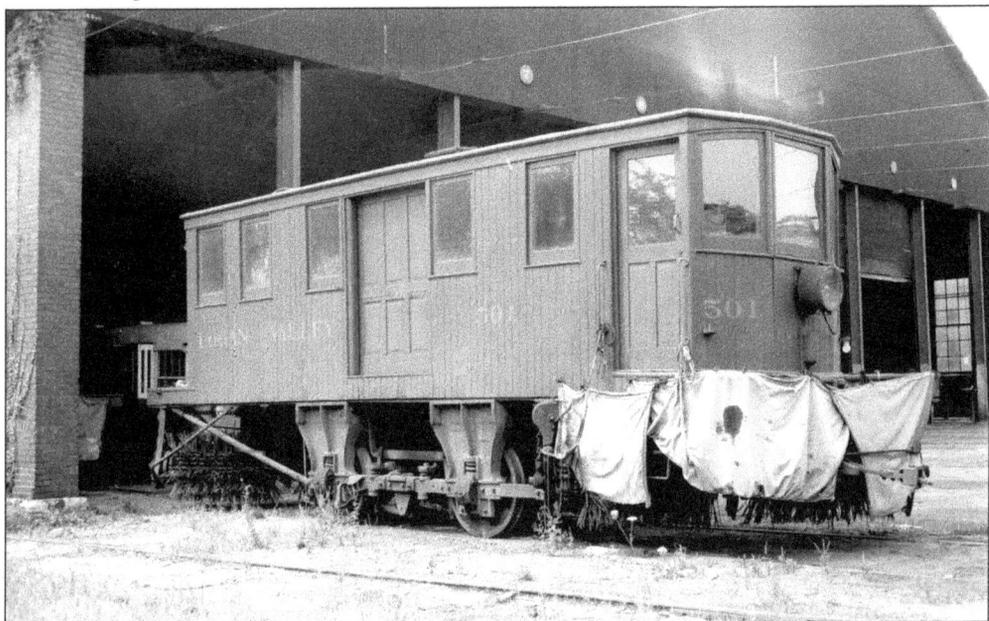

No. 501 was a 1902 McGuire-Cummings snow sweeper and was a little larger than No. 500. It is seen here in front of the carbarn on a warm August day in 1953.

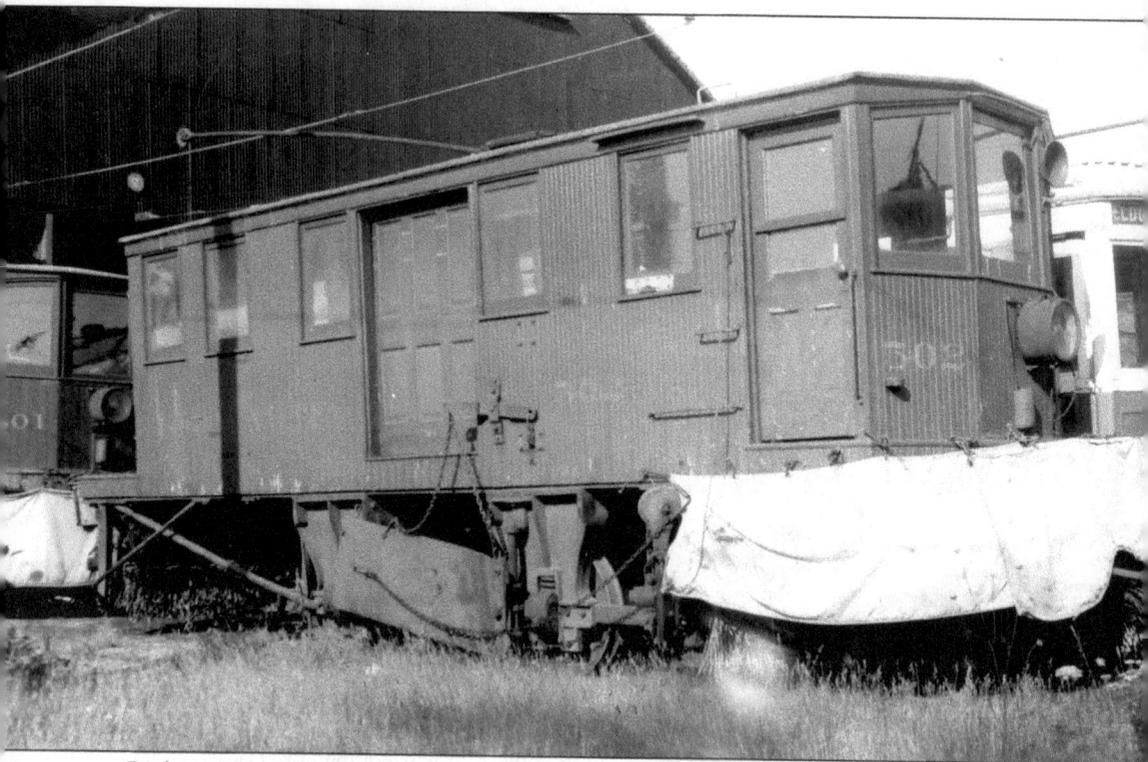

Built in 1904, No. 502 was also a McGuire-Cummings snow sweeper. It is almost the same, except the wood siding is smaller in size. It is seen outside the carbarn in August 1954 after trolley operations ceased.

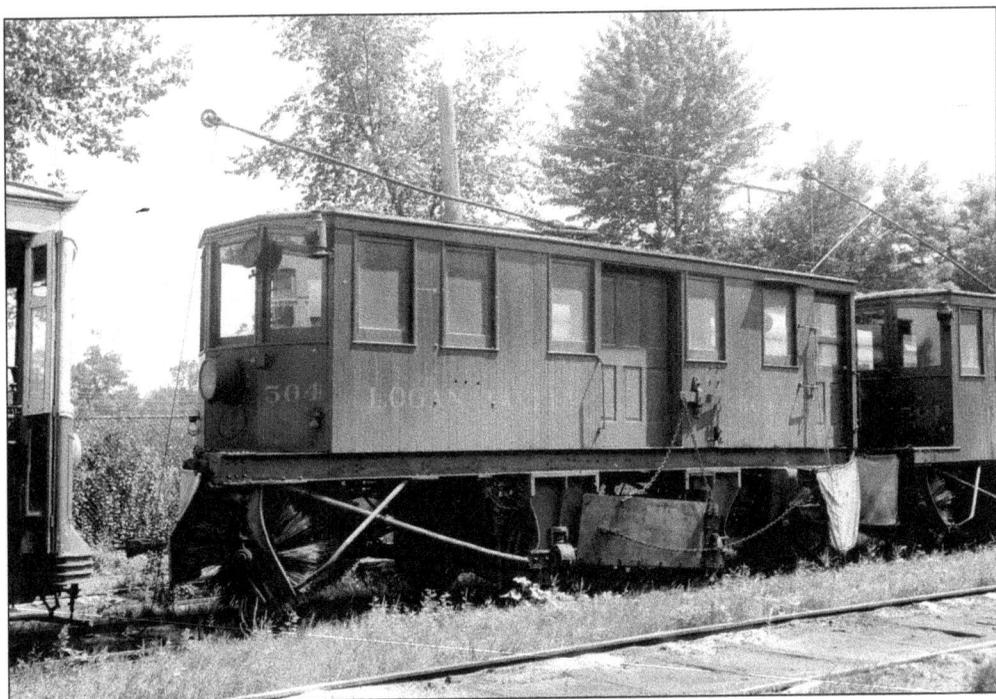

No. 504, built in 1913, was another McGuire-Cummings snow sweeper and very similar to No. 502. It is parked in the yard in August 1941, still in almost new condition. All Logan Valley work equipment was painted in a bright, red-orange color.

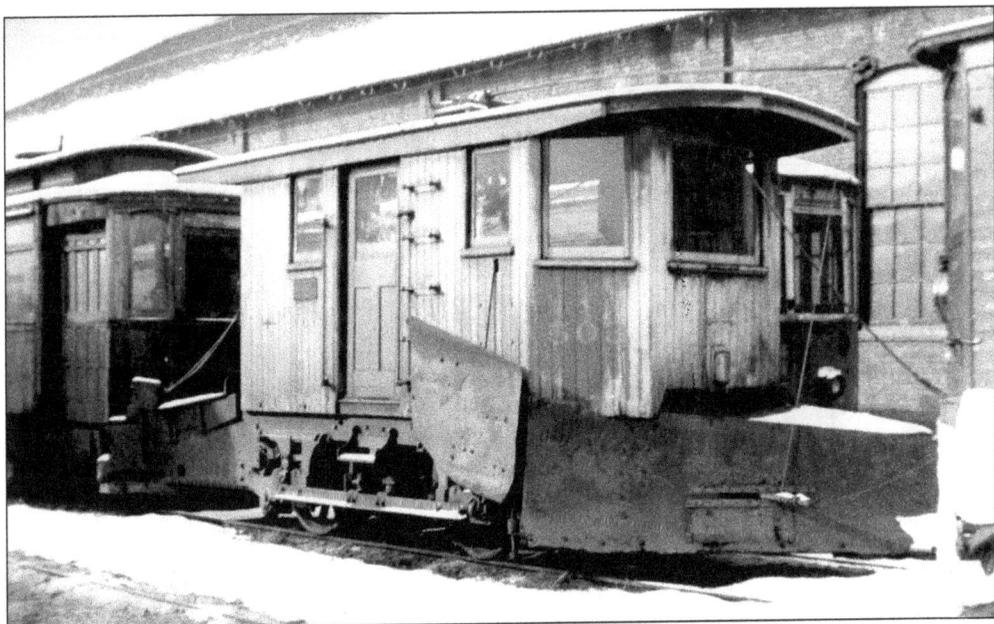

To remove snow from interurban routes, where drifts would be too much for the sweepers, Logan Valley purchased a 1902 Taunton snowplow, numbered 503. Still in good shape at 44 years old, it is shown parked at the carbarn in October 1946.

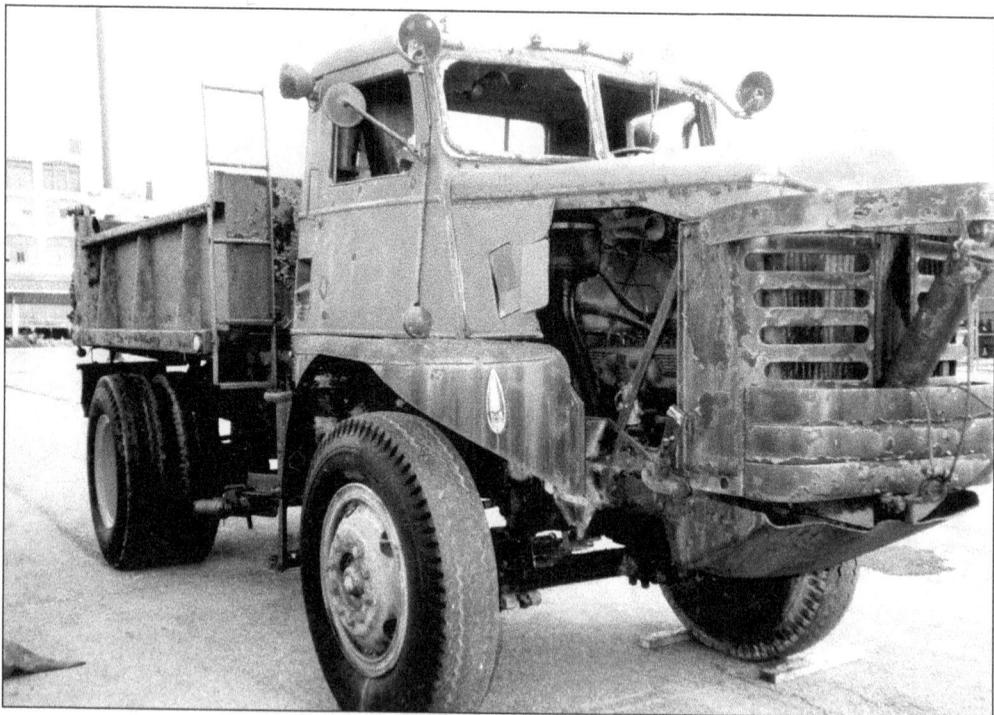

This 1946 Walter SnowFighter, used as service truck No. 18 by Logan Valley, is shown in a deteriorated state. The Horseshoe Curve Chapter of the National Railway Historical Society in Altoona later restored this truck.

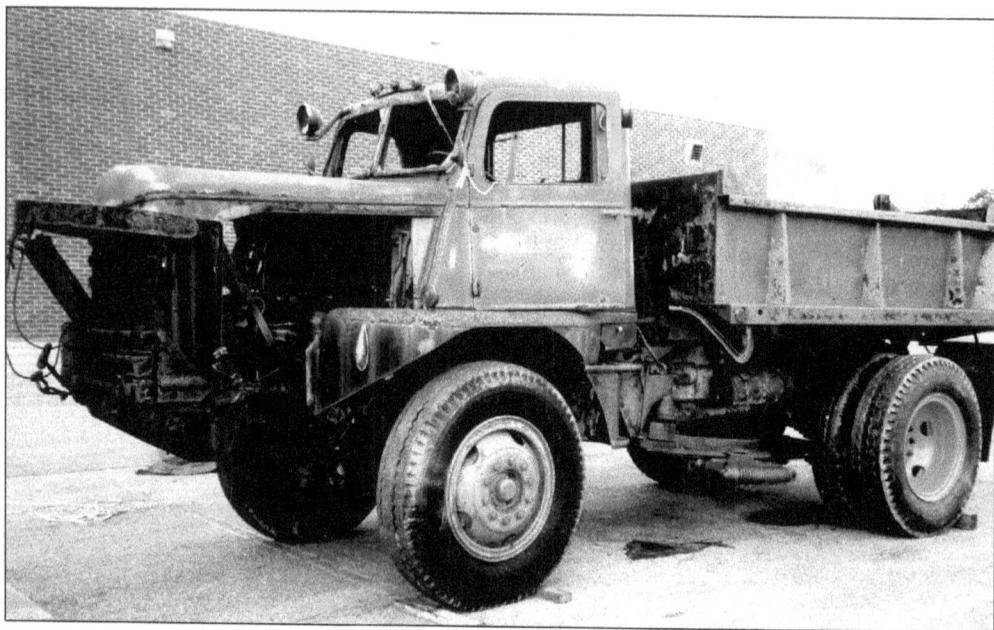

Prior to restoration, the 1946 Walter SnowFighter possessed broken windshields. With less than 16,000 actual miles, this truck is fully operational today and is featured in local car and truck shows. The truck also has its original nose-plow as well as a mid-chassis scraper blade as some of its optional equipment.

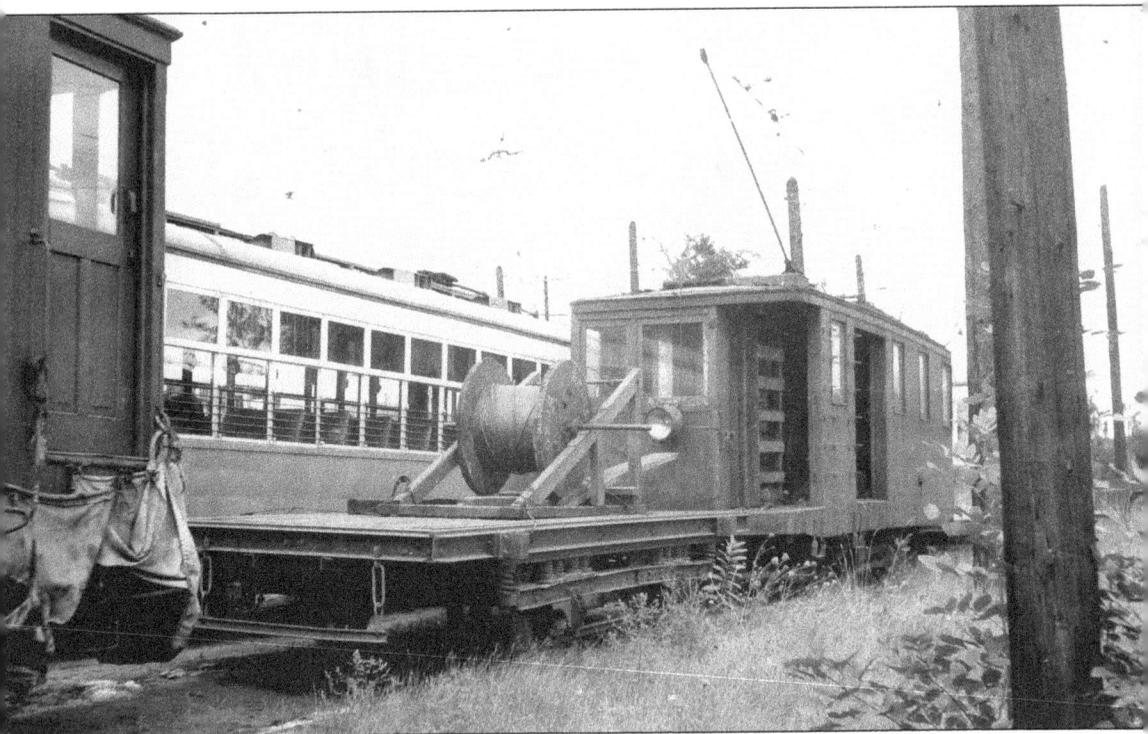

Flat trailer No. 608 is shown with a spool of wire to repair the overhead. It is coupled to No. 505, the line tower unit. These two cars usually were a pair in line service work.

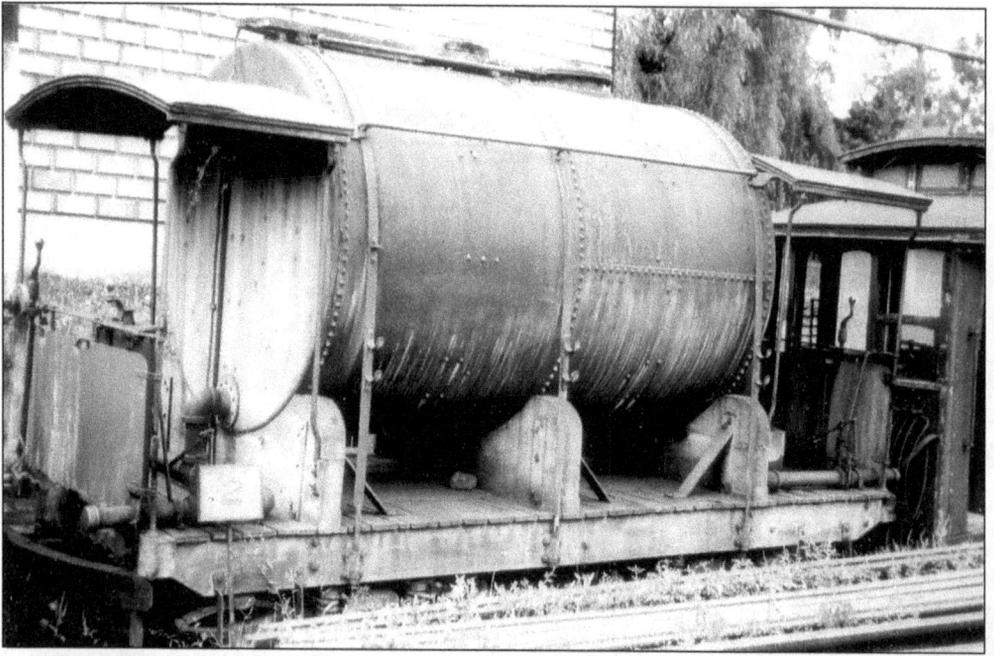

Sprinkler car No. 506, built *c.* 1906, is shown in this view on a siding adjacent to the Logan Valley bus garage. This vehicle, manufactured by Brill, served the needs of the Logan Valley system for many years.

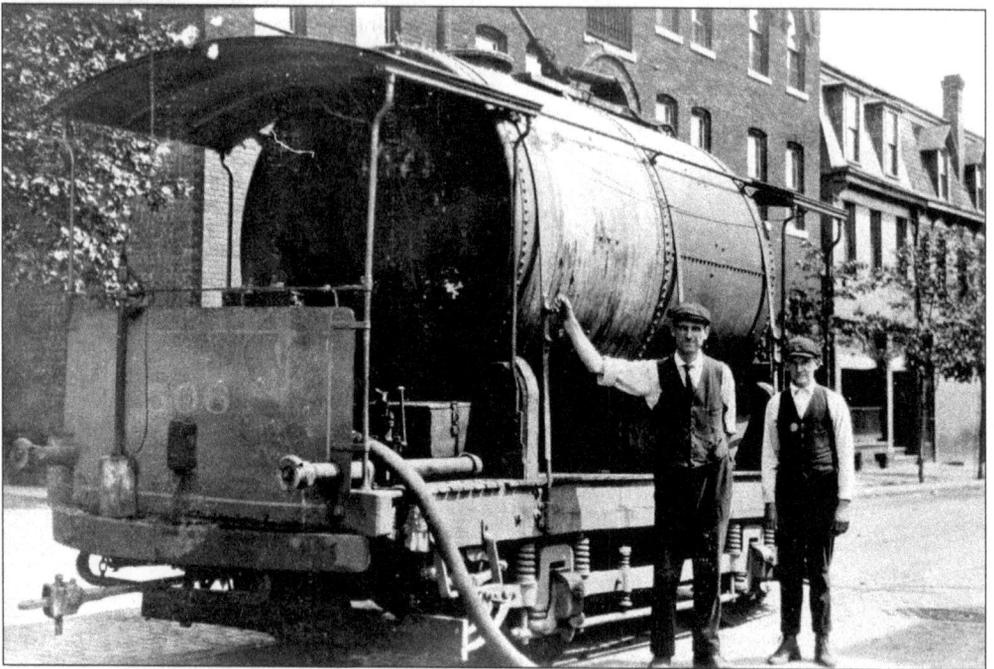

Trolley companies were usually required to water down the city streets to minimize dust or to clean paved areas. Logan Valley also did this in Altoona, utilizing No. 506, a 1906 Brill sprinkler car, to handle the task. It is shown here having the tank refilled at a city route location, possibly Eighth Avenue.

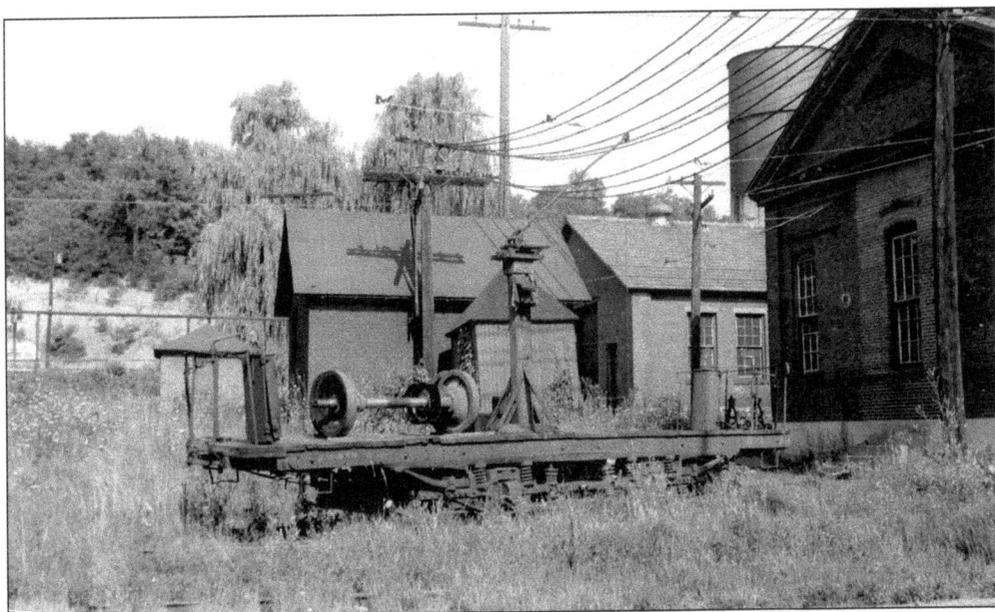

In 1912, Logan Valley purchased several flat cars from the Russell Car Company. These were used to carry items around the shop complex and to take supplies to line-repair locations. No. 514, a small single-truck car, was used primarily around the shops to move heavy items from shop to shop. In this view, an axle and wheel set is being moved from the machine shop.

Car No. 515 was also a Russell car that had closed ends and an open gondola-type middle. It was used to carry tools and supplies to line-repair locations. It is shown here on the ash siding around 1935, after many years of use.

The twin to car No. 515, car No.516, sits on the ash siding around August 1935 following years of hard work. These were small single-truck cars. Note the switch turnouts stored nearby.

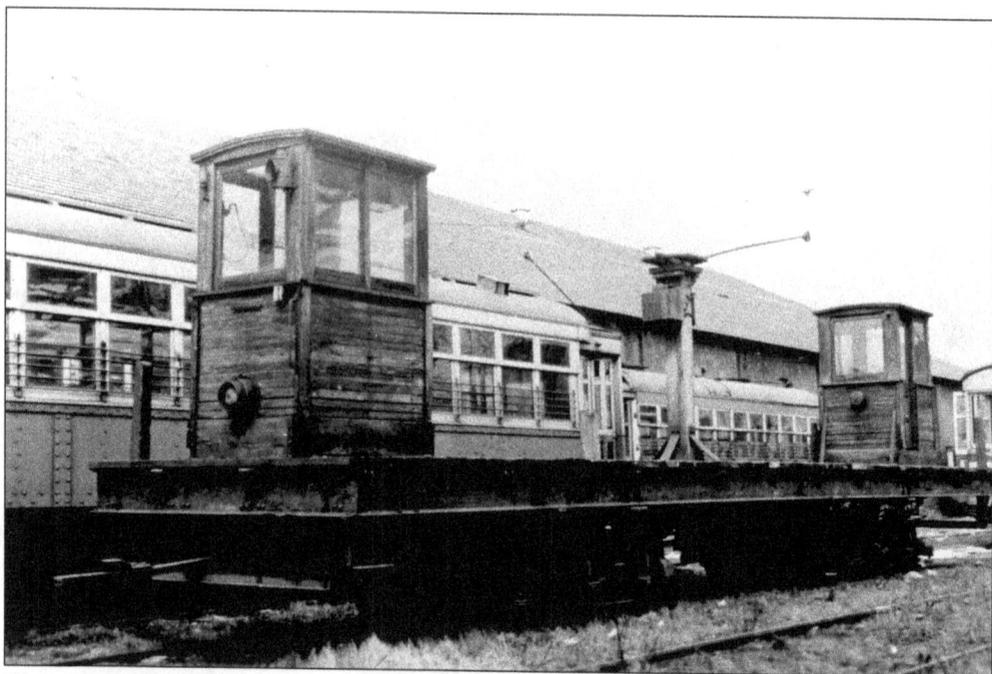

The other two Russell cars in the order were larger double-truck cars. No. 518 is parked in the yard near the carbarn. These cars were used to haul heavy objects such as rails and poles to line-repair locations. They were basically utility flat cars with opposing-end cabs for the motormen.

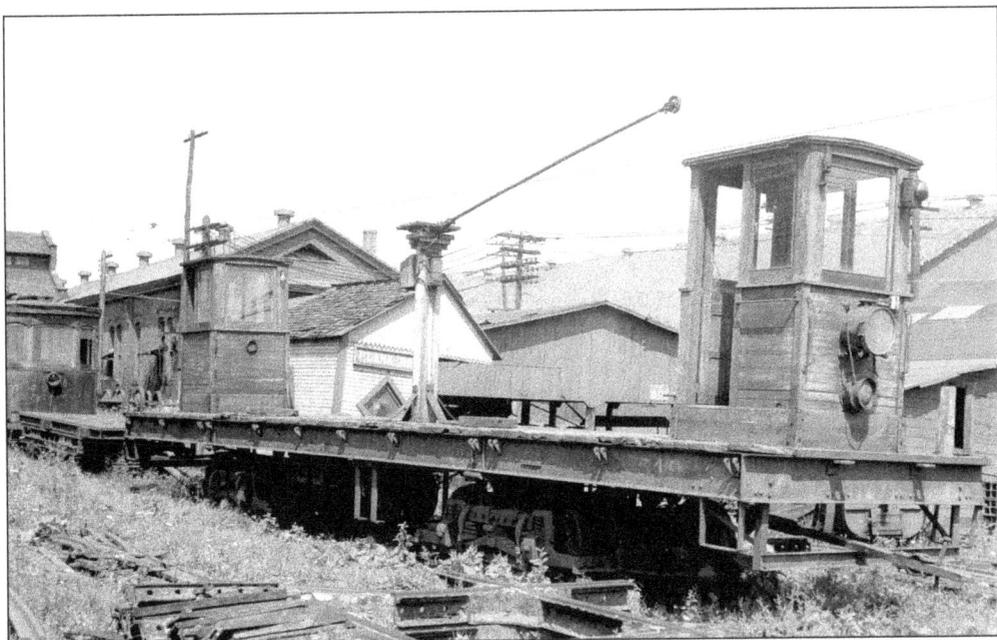

Car No. 519 sits in the storage yard at the rear of the lumber shed in June 1940. In the foreground are many rail sections used for repair locations. To the rear of this car is the old Plank Road station building, removed from its former location due to road widening. These cars were also used to tow disabled trolleys back to the car shop.

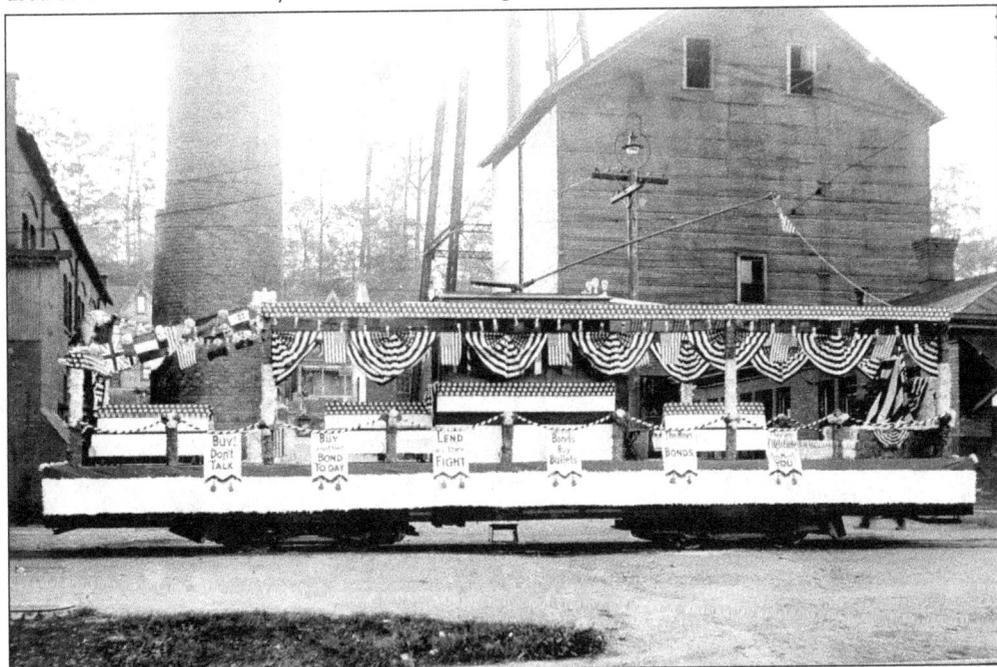

During World War I, car No. 518 was modified by having one cab removed and the other cab relocated to car center. It was then used as a float in parades in an effort to promote the purchase of war (Liberty) bonds. This is, most likely, the best-looking work car Logan Valley ever had. It is seen exiting the carpenter shop along Fifth Avenue.

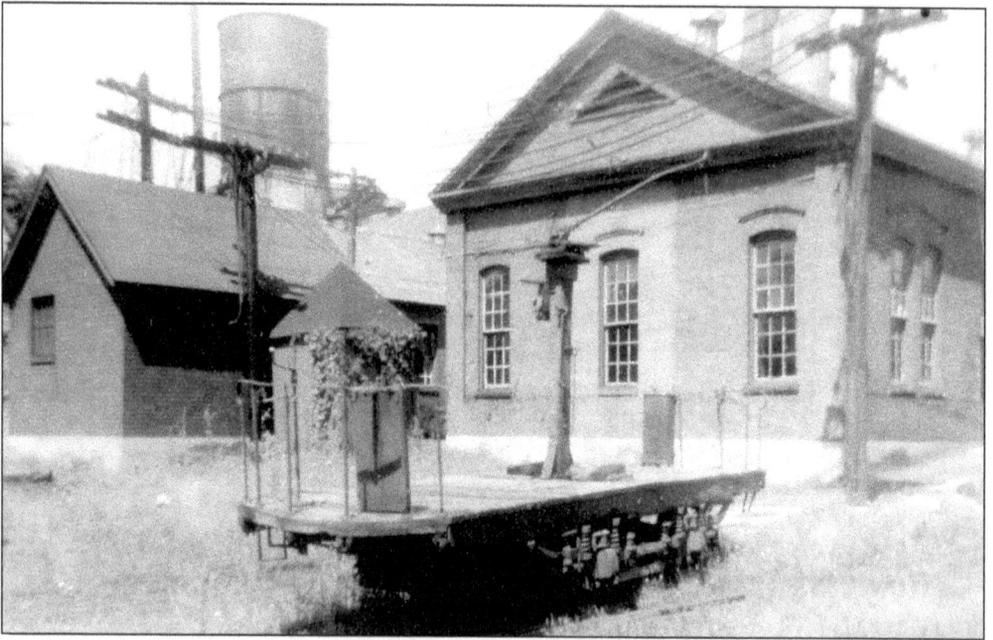

"Tony," a single-truck work car built by the Logan Valley shops, was used to transport wheels from the machine shop to the carbarn repair shops. Most likely built from an old passenger car frame early in the second decade of the twentieth century, it is shown here in September 1952 behind the carpenter shop building along Fifth Avenue. This car was never given a number, just a name.

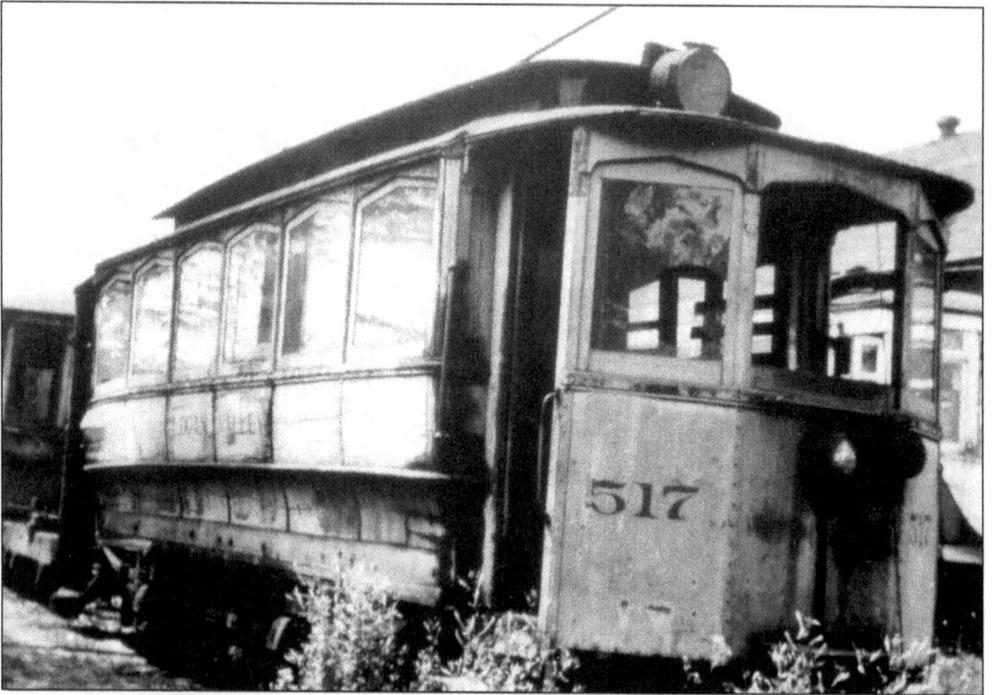

Shown here is car No. 517 (St. Louis 1906), which was later rebuilt into a line tower car by the Logan Valley shop forces.

Constructed in 1931 to lift heavy objects and derailed cars, crane car No. 520 is another example of a Logan Valley design. The back portion of the car could pivot 180 degrees and could lift 30-ton loads. It is seen here sitting in the yard in June 1951. This was the last rail vehicle to be added to the Logan Valley fleet.

Photographed on April 3, 1939, crane car No. 520 lifts new wheels from a PRR car on the siding used to bring coal into the power plant, and transfers the shipment to Tony for transportation to the shop buildings.

The Logan Valley shops also converted several single-truck passenger cars into work cars by removing the seats and installing a door on the side. No. 507 was converted to a sand car used for transporting sand to fleet cars for traction. An 1894 Brill car, it is shown here on the ash track around 1935.

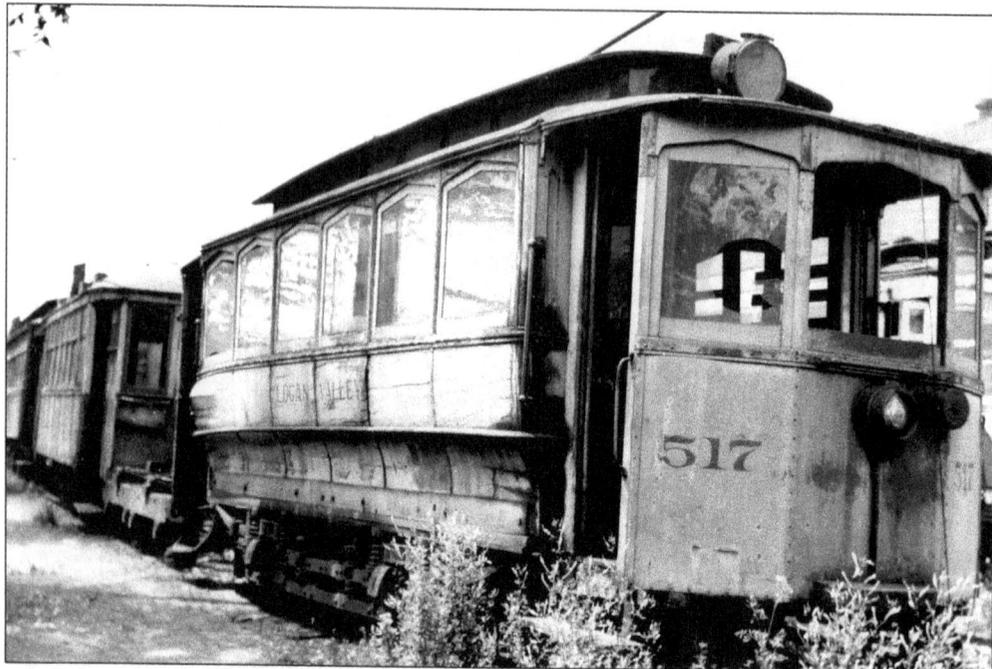

Another passenger car converted to work status was No. 517, a 1906 St. Louis car used to transport workers and tools to the repair sites along the line. It is shown here, sitting in the yard around 1939.

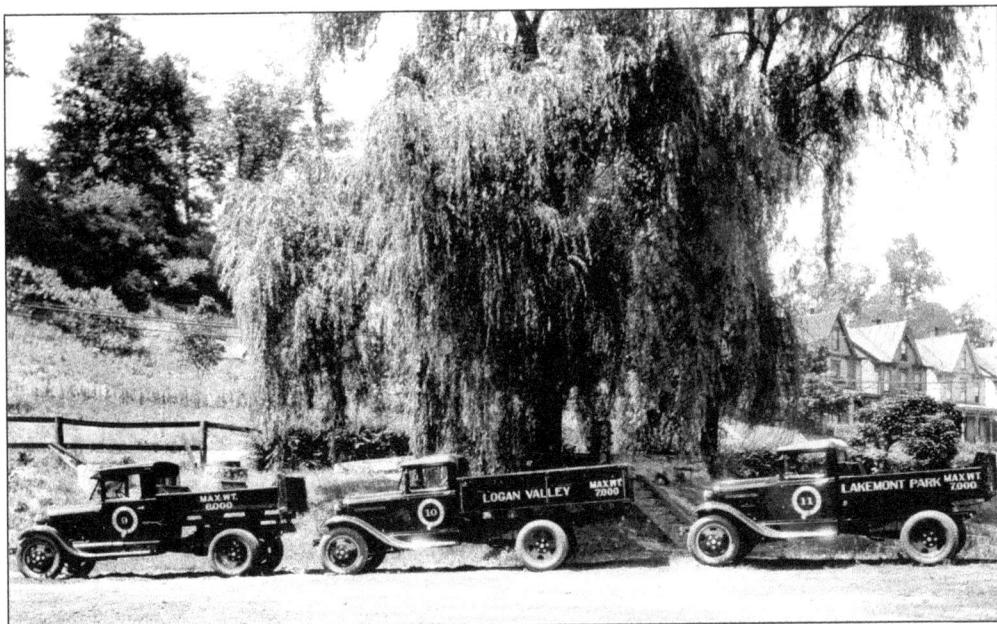

As trucks became more reliable, Logan Valley purchased some for work units. These c. 1930 new Ford trucks are parked near the bus garage along Sixth Avenue. No. 9 had a small dump bed used to haul ashes and ballast. In later years, an air compressor replaced the dump bed. No. 10 was equipped as a flatbed to haul supplies. No. 11 had a small dump bed to haul supplies around Lakemont Park, the amusement parked owned by the Logan Valley.

Another example of equipment built by the Logan Valley shops is truck No. 20, a 1941 Ford line tower unit. This is the same wood tower from the former horse-drawn wagon of 1892, and truck No. 20 is the fourth vehicle the apparatus was recycled to. When the trolleys were retired in 1954, this truck was transferred to the home electric division in Tyrone and used there until the late 1950s as truck No. 49. The employees are unidentified.

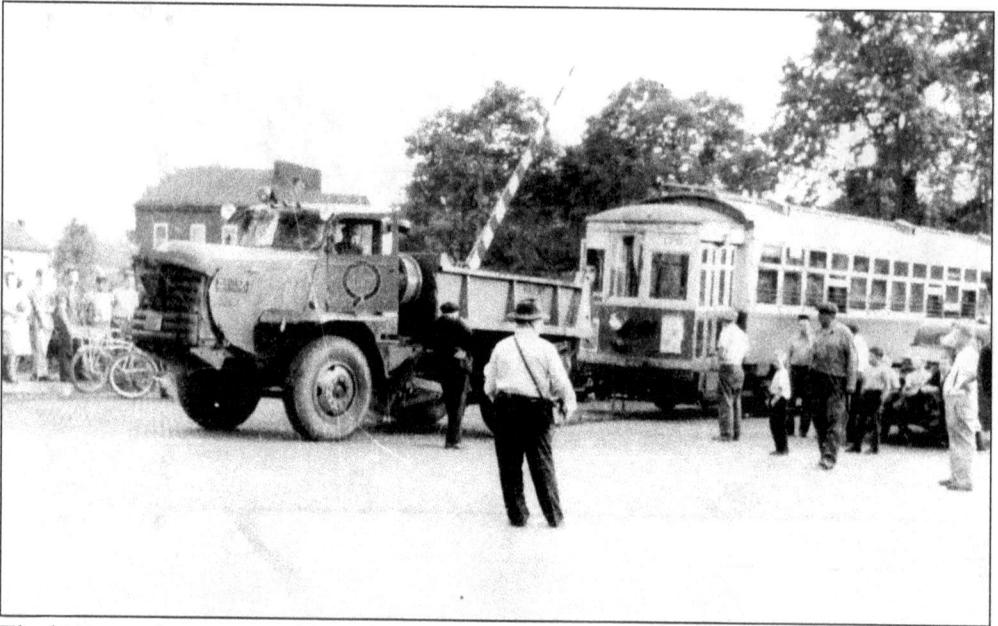

The largest and most powerful truck Logan Valley purchased was truck No. 18, a 1946 Walter SnowFighter equipped with a dump bed, snowplow, middle chassis grader-blade, and winch. It was utilized for plowing, cindering bus routes, and towing disabled trolleys and buses. This truck survives today, fully restored, with the original plow and grader-blade and is now owned by the Horseshoe Curve Chapter of the National Railway Historical Society with less than 16,000 original miles.

In this and the preceding view, service truck No. 18 is towing trolley No. 178, a 1913 St. Louis car, after having run past the end of the track on Allegheny Street in Hollidaysburg toward the PRR station area at the Gaysport crossing.

64

Six

YEARS OF DECLINE
1931–1954

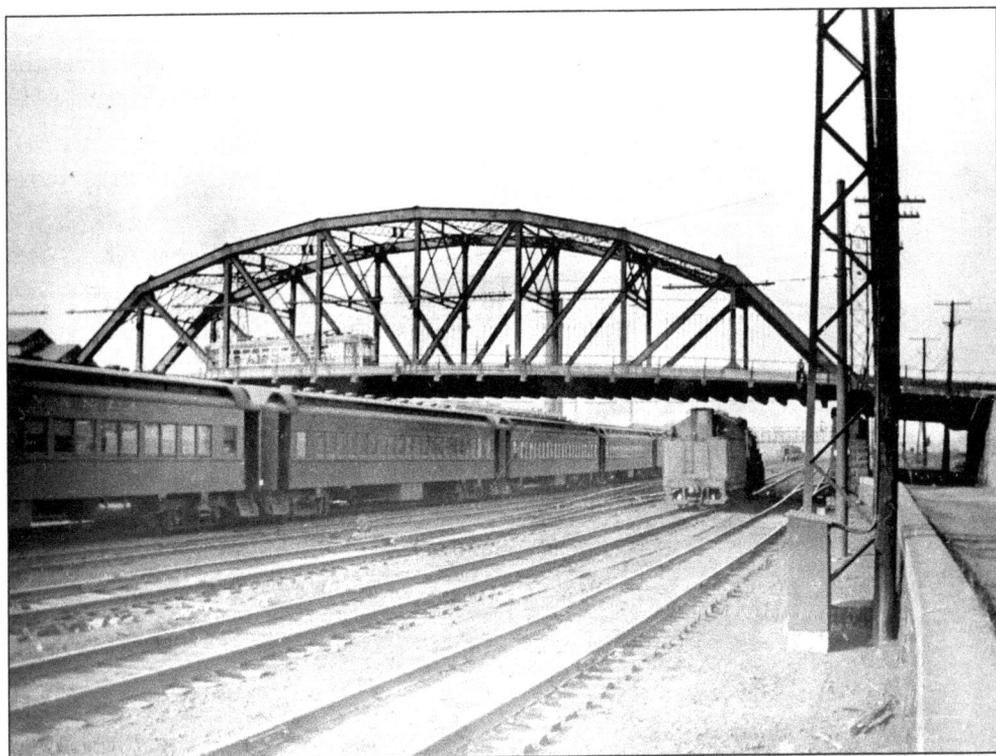

At a special picnic held at Lakemont Park in 1931 for the 300 employees, management announced that Logan Valley had just completed rebuilding all tracks and had purchased 25 new cars and 7 buses, and that more expansion was planned for the future. But, just a few months later, Logan Valley was in receivership. This photograph of the Seventh Street Bridge in 1931 shows a 50-series car on the Second Avenue route crossing the PRR main line. In 25 years, the trolleys and steam engines would be gone. In 50 years, the PRR was gone, and by 2004, the girder-style bridge was replaced.

A late spring ice storm and early thaw resulted in severe flooding on March 17, 1936. The ice downed many wires and closed the system for some time. Flooding washed out some roadbeds and caused severe damage to Lakemont Park. In this view looking up Park Hill from the trolley station at Lakemont Park, the state road has been salted, but the trolley line is still iced in and unserviceable.

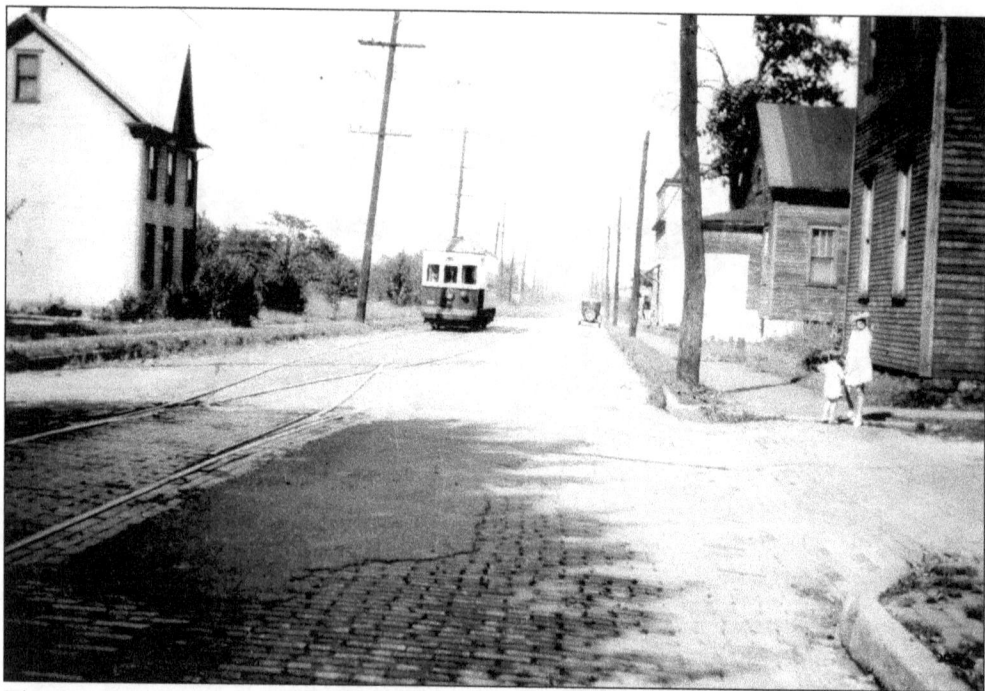

The first line that shut down and switched to buses was the Tyrone line. This happened on April 1, 1938, after spring rains washed out some of the line again. Here is car No. 169 (Brill 1914) in Bellwood at a passing track. This chapter examines some of the lines as they were prior to the end of service.

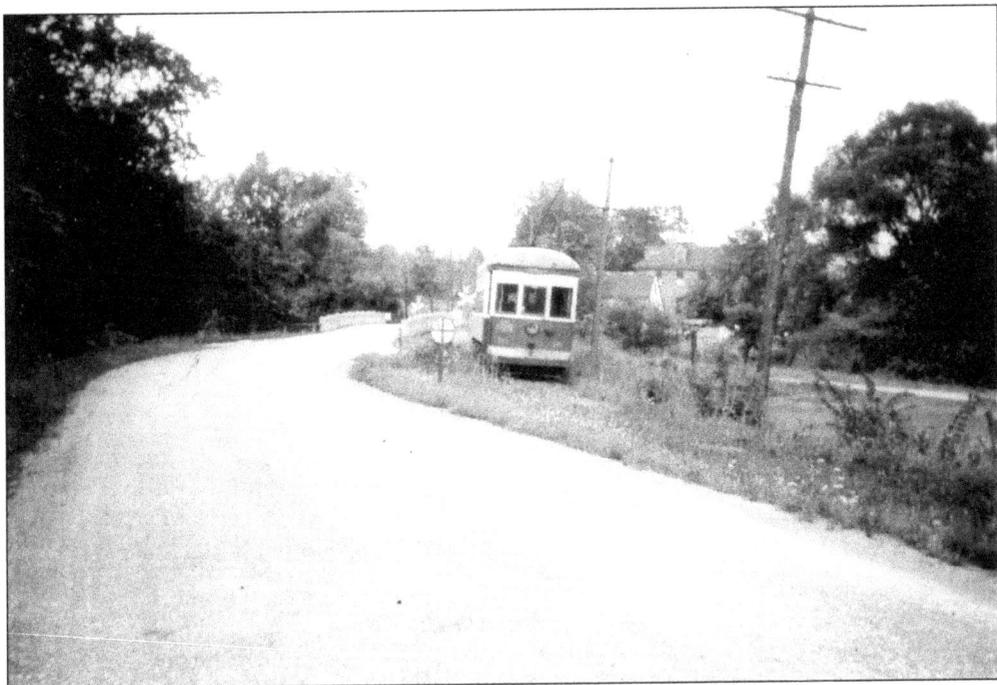

Here again is car No. 69 northbound, approaching Bellwood. These cars looked impressive and could easily pass for interurban cars. For most of the run from Bellwood to Tyrone, the line paralleled the PRR main line.

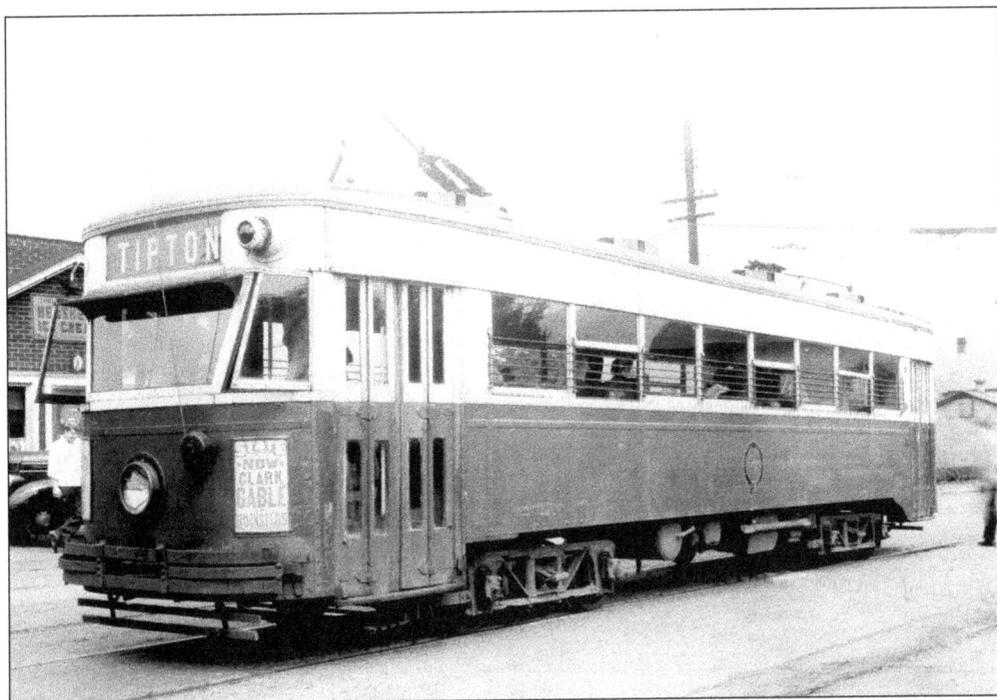

Car No. 70 is shown here in Tipton, a town between Bellwood and Tyrone. These Eldorado-type cars seldom ventured from the Juniata-Eldorado line, which makes this photograph rare.

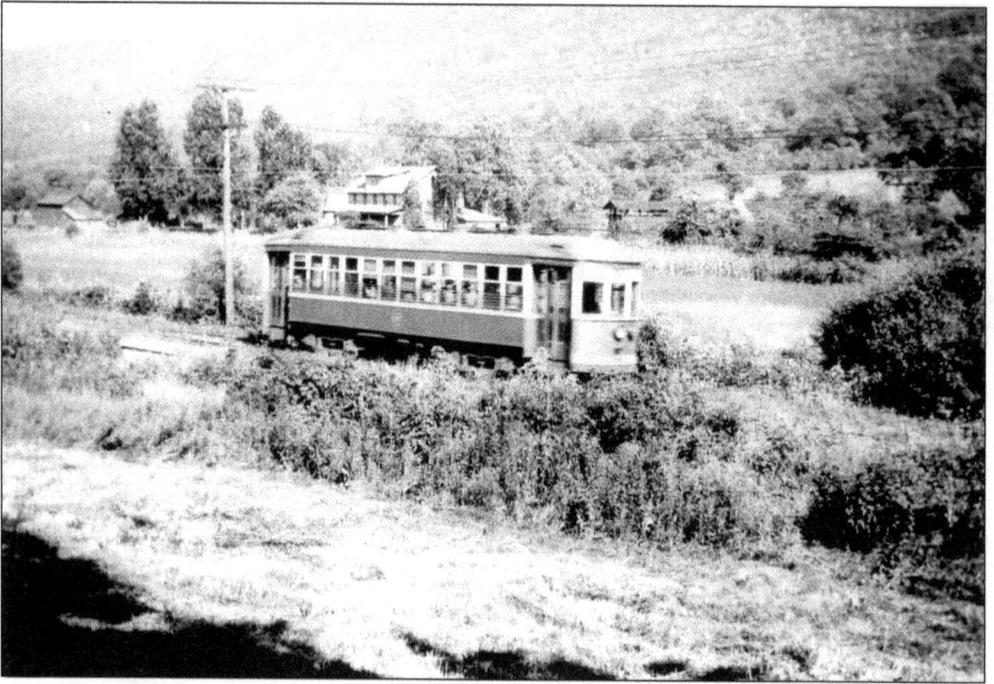

Car No. 169 is seen here near Grazierville returning toward Altoona, about another 10 miles south. Brush Mountain is to the rear, the path of Interstate 99 today, and the older U.S. Route 220 on the valley floor.

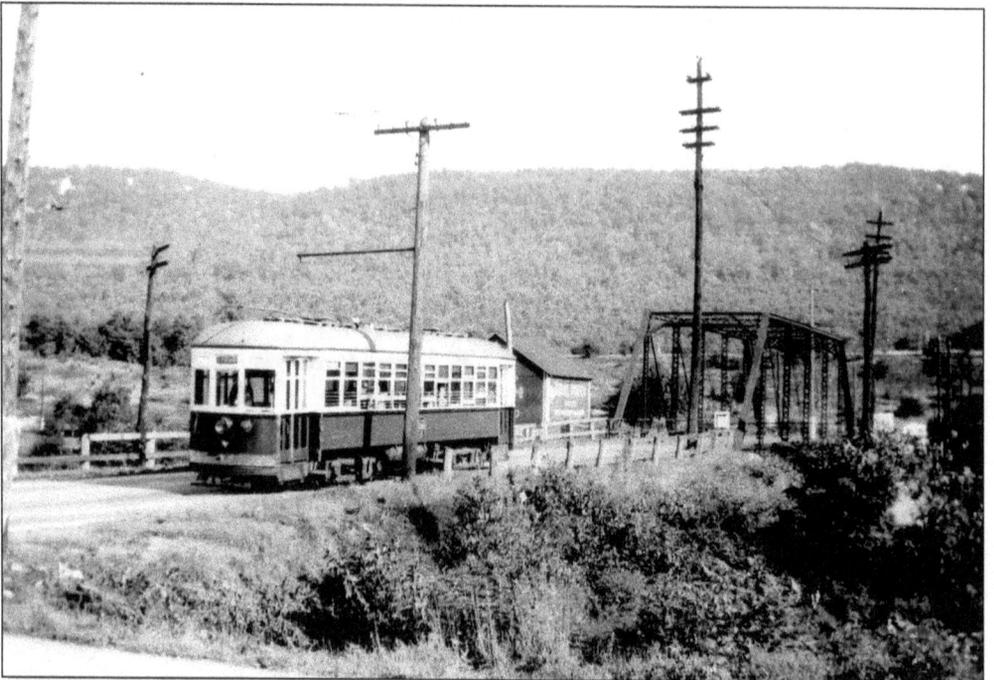

Nearer to Tyrone, car No. 169 crosses the bridge over the PRR main line en route to Altoona. Although most of the Tyrone line was private right of way, it became street trackage from Grazierville into the Tyrone borough.

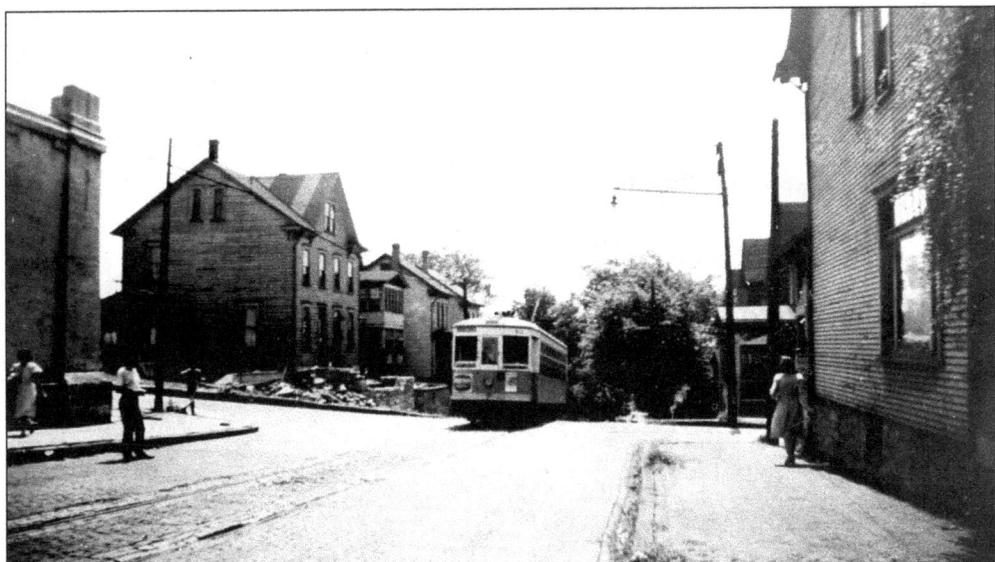

With the advent of World War II and rationing, the trolleys were heavily used once again. But, following the war, Logan Valley began replacing the less used routes with buses. The first to go was the Second Avenue route on July 31, 1948. Shown here is car No. 60 on the last day passing Prospect Reservoir at Second Avenue at Thirteenth Street.

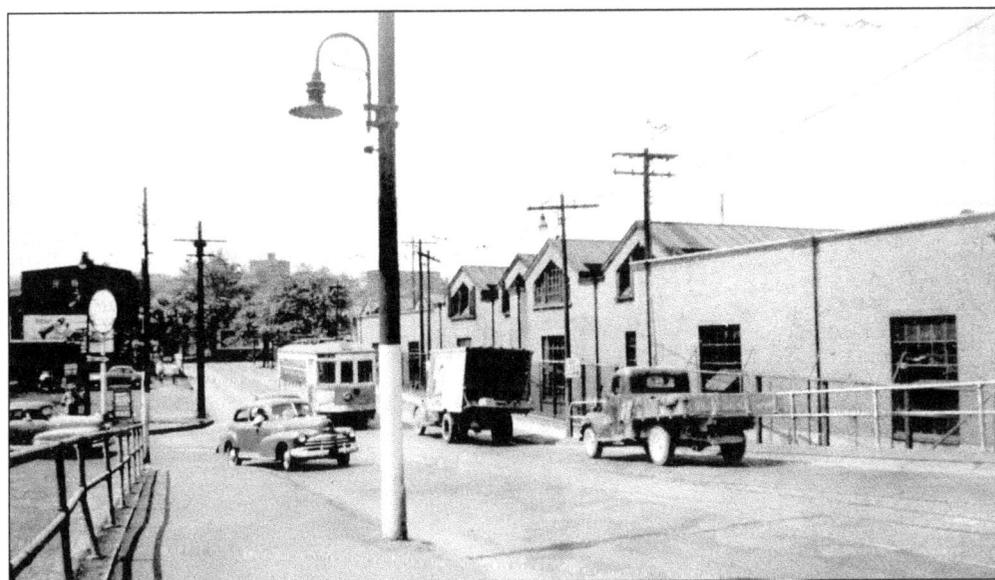

Seen here again on the last day of the Second Avenue route, car No. 60 (Osgood-Bradley 1925) is on Seventh Street, having just descended from the bridge to Green Avenue. It will go one block farther to Chestnut Avenue and turn left for downtown, make a loop of the business district, return on Green Avenue, and turn right to recross the Seventh Street Bridge. The gasoline station at the corner is a Tydol Flying A. Not visible at Chestnut Avenue and Seventh Street is the once-famous PRR athletic stadium known locally as Cricket Field.

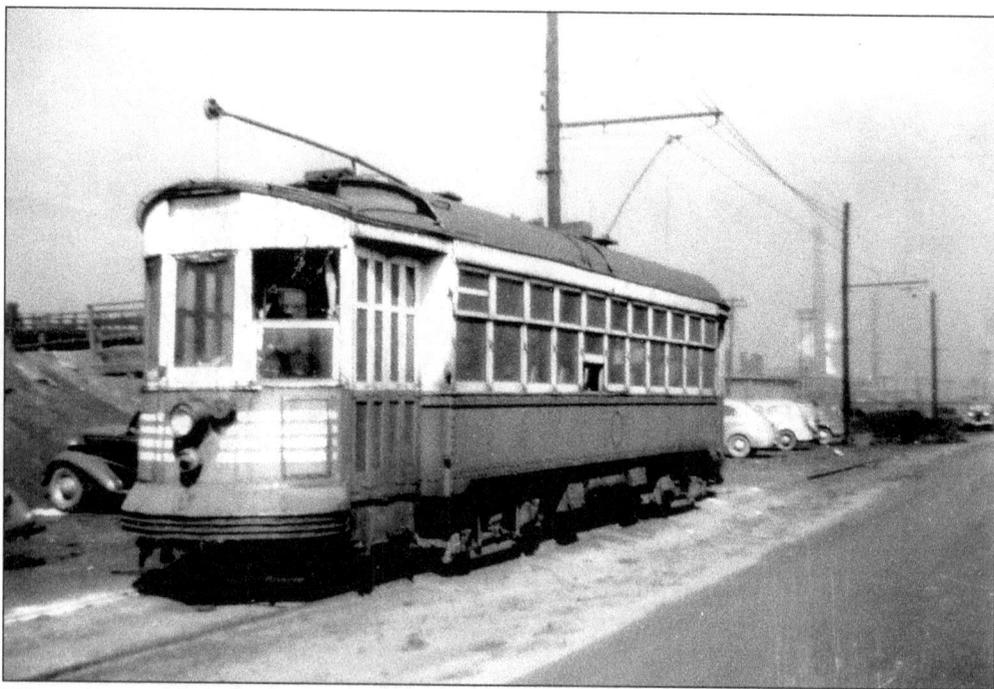

The next route abolished was the East Altoona run, which switched to buses on September 4, 1949. Here car No. 147 (Brill 1916) has just changed ends at the Seventeenth East Juniata Bridge and will head back toward Hutchinson Crossing at Red Bridge (Eighth Street, Juniata). This reverse point was the location of the world's largest roundhouse (PRR). Notice the smoky atmosphere near the railroad yards.

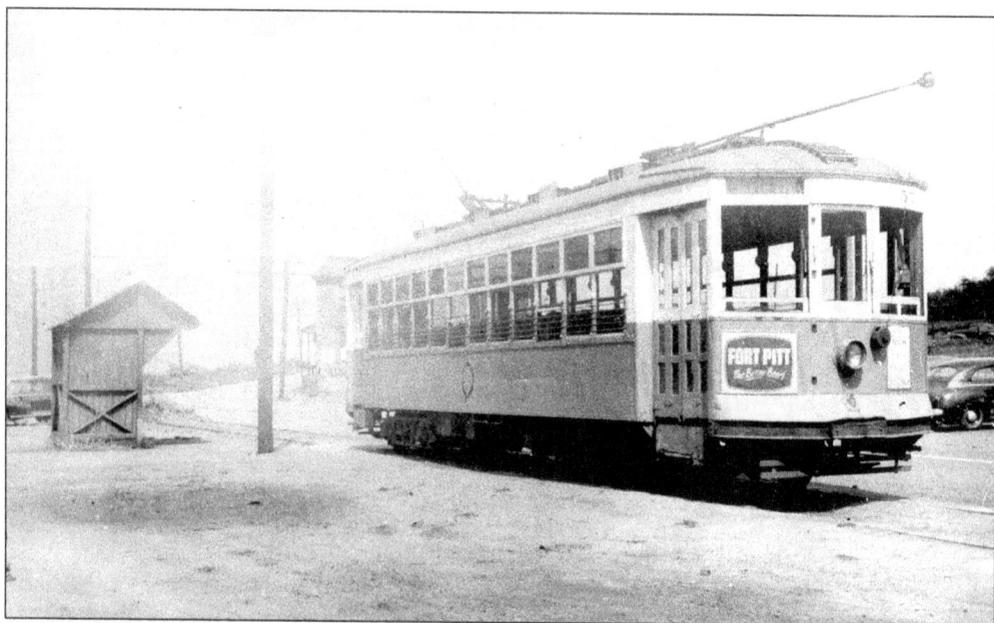

Car No. 55 (Osgood-Bradley 1925) stops at the Round House Inn station on the route's last day, September 4, 1949, which was Altoona's centennial year. This East Altoona line was mostly used by the PRR workers in the Altoona Railroad yards or roundhouse of the Pennsylvania Railroad.

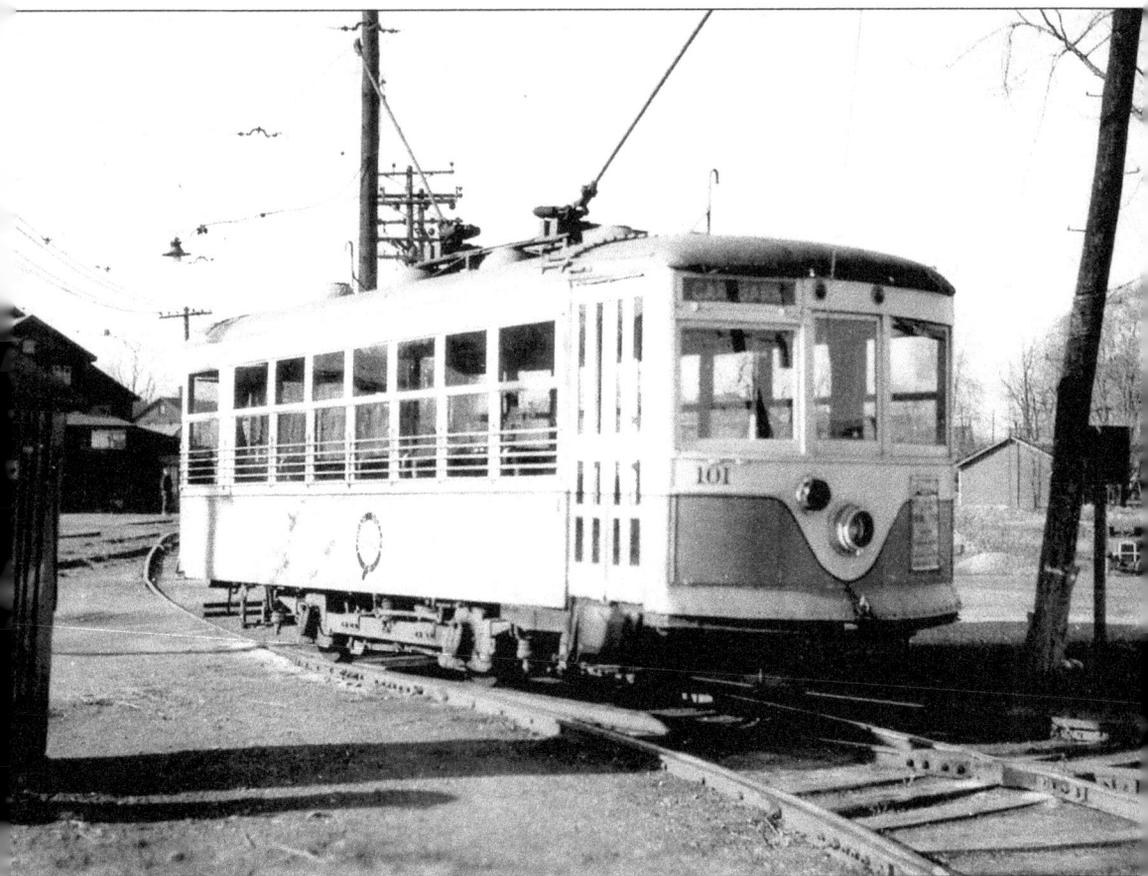

Birney car No. 101 is seen here again with yet a later paint style. The dip under the headlight in the ivory color attempted to convey a streamlined modern look. In this view, car No. 101 is at the yard switch on Fifth Avenue, apparently changing ends to transfer to another track because both poles are up.

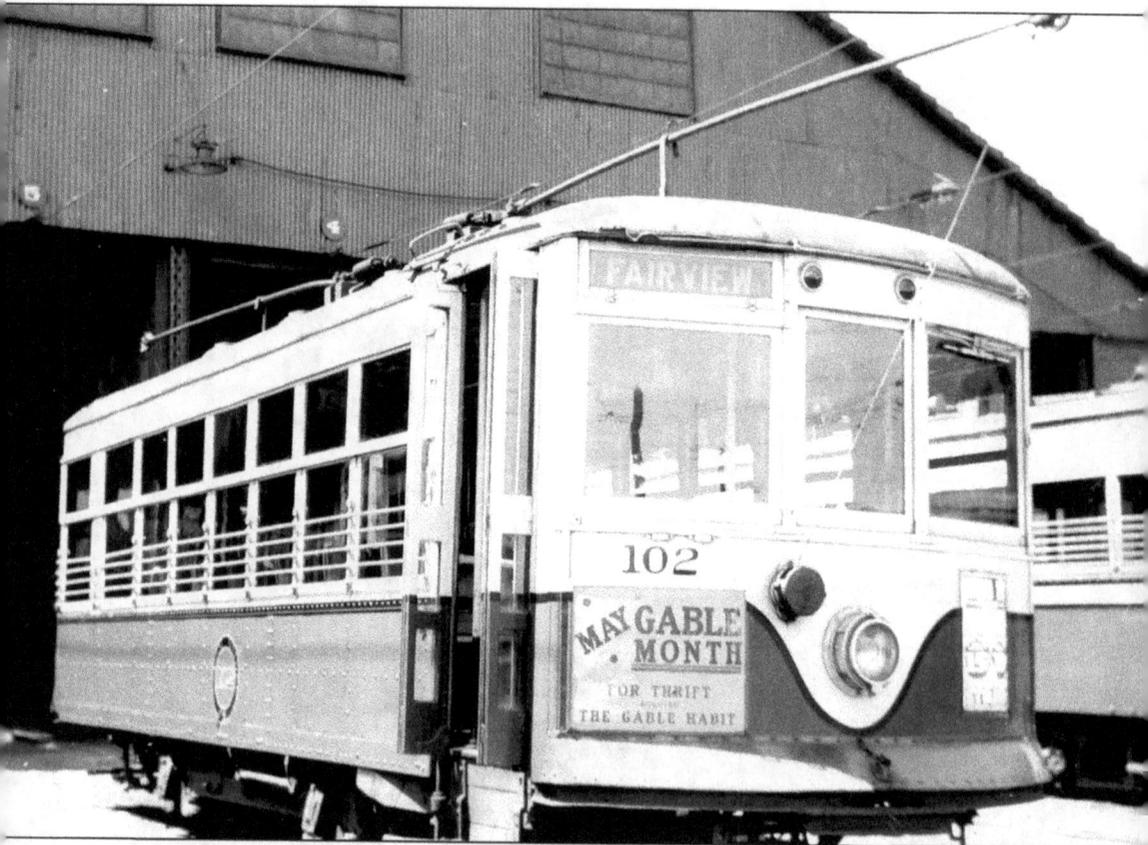

Birney car No. 102, the last of the triplets assigned to the Fairview line, waits at the carbarn. Gables was the largest downtown anchor department store, revered by Altoona shoppers. Gables closed in 1980 following the opening of Altoona's first retail mall outside the city limits.

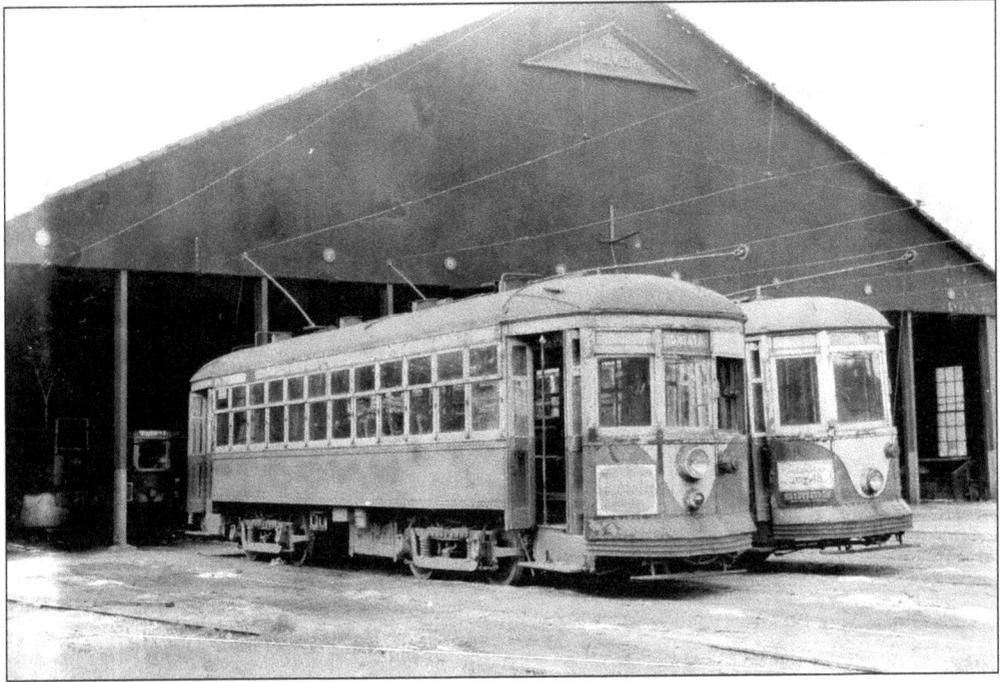

Cars No. 34 and No. 35 (Brill 1914) sit at the carbarn awaiting their next runs on the East Juniata line. These lines primarily transported railroad workers to the vast Pennsylvania Railroad shops and yards.

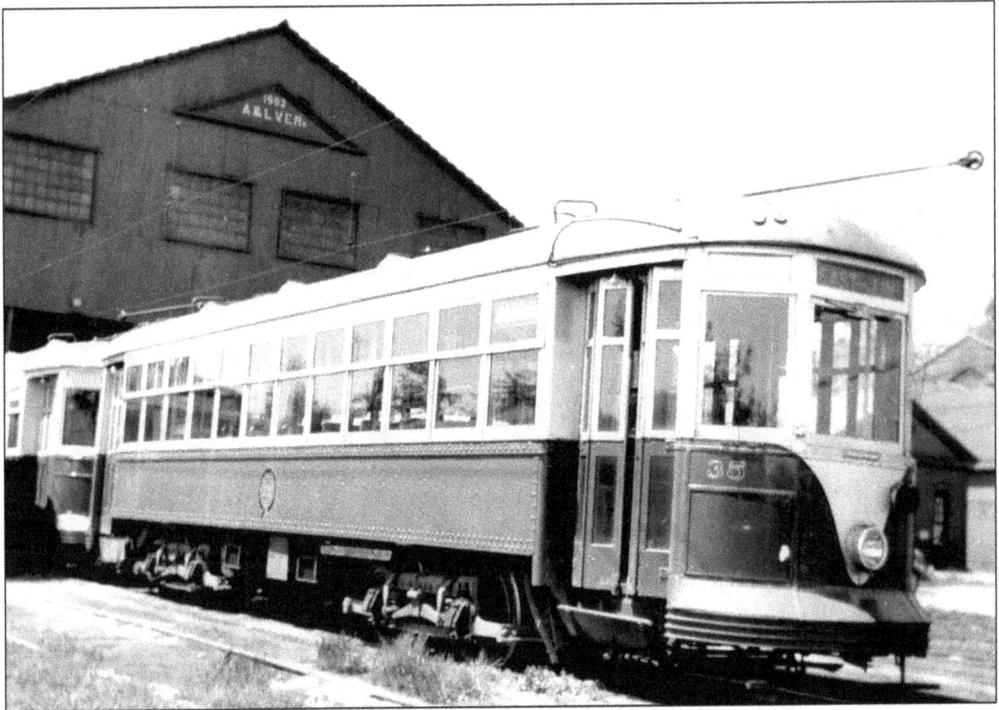

Car No. 35, signed for East Juniata, sits on the lead tracks ready for the next run. As nice as this car looks fresh from the paint shop, it is hard to tell that it is over 30 years old.

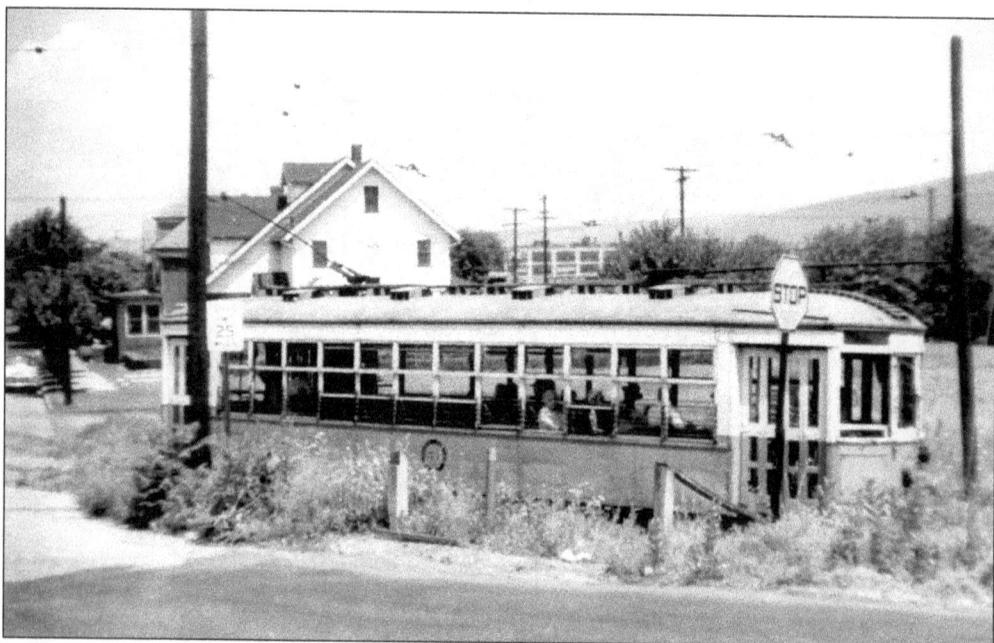

A 50-series car leaves street trackage at Broad Avenue near Race Street, entering the private right of way to Hollidaysburg while serving the Park and Broad Avenue line. Notice in this 1950s view how the weeds have grown over the right of way.

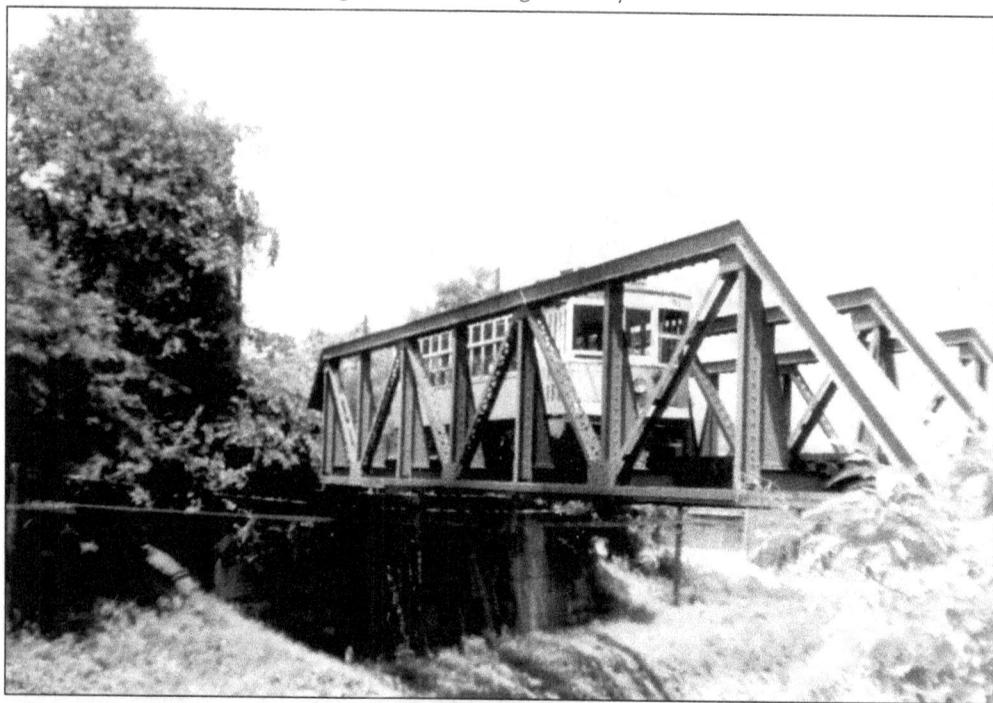

The same car from the preceding photograph crosses the bridge over the PRR branch line. At the time this photograph was taken, only one of the two tracks on this span was still in use. Track maintenance for routes being converted to buses was almost nonexistent. This right of way is now a four-lane roadway.

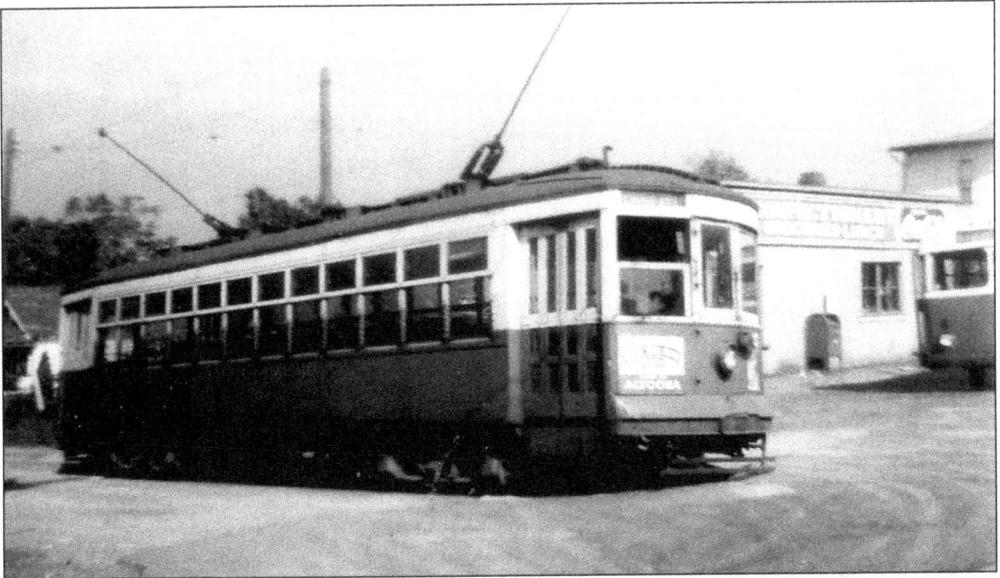

The next route abolished was the Third Avenue line. Here is a 50-series car at the line end meeting a Logan Valley Beaver bus, which was still in use to feed the trolley line this day. The trolley would soon disappear, and the bus would travel the complete route to downtown Altoona.

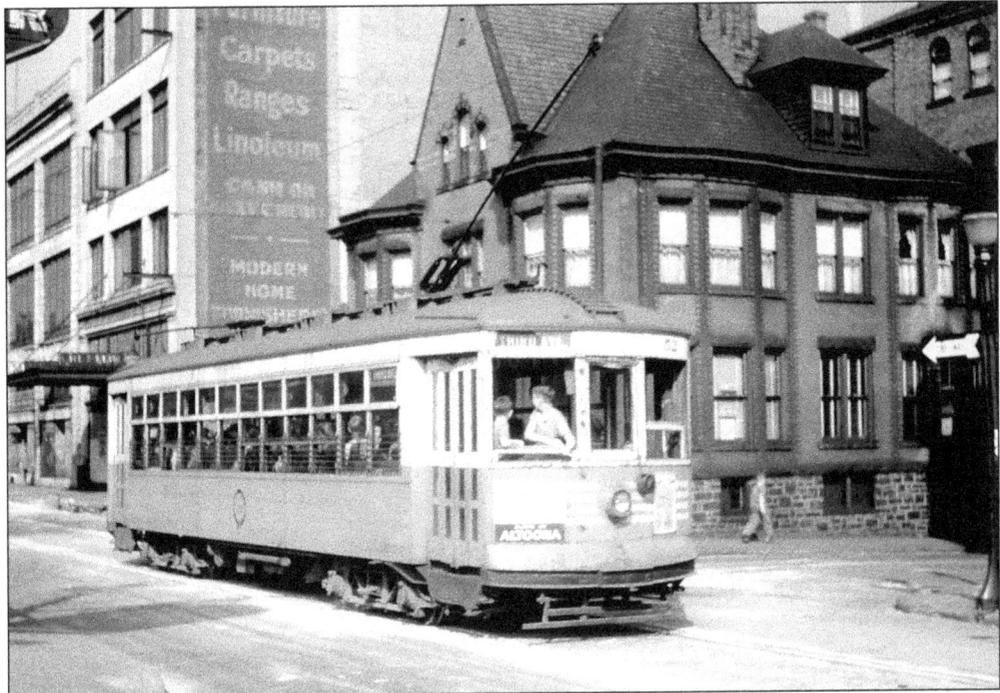

Car No. 52 travels in downtown Altoona on Twelfth Avenue passing Fifteenth Street with a full car, including two young boys who were enjoying the open window at the rear of the car. The advertisement is for Horseshoe Curve beer, a popular brand of the Altoona Brewing Company. The brewery later went out of business, but the brand was revived a half century later in 2004. The large Penn Furniture building is seen at the front of the streetcar.

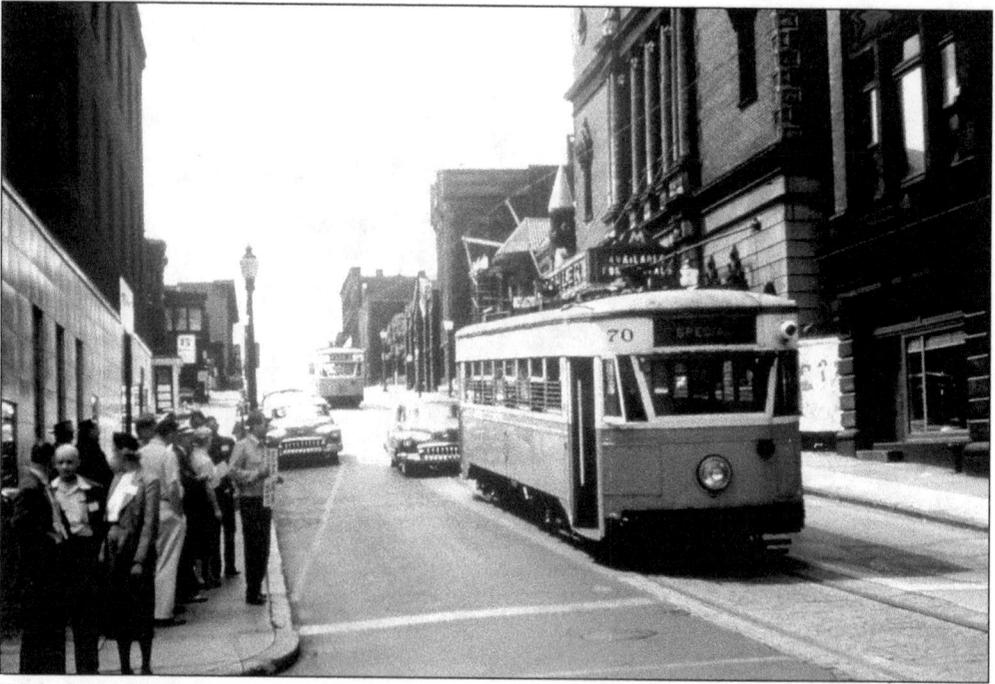

With the trolleys being replaced by buses, several groups sponsored rides on the remaining lines around the city. Here car No. 70 (Osgood-Bradley 1929) descends Twelfth Avenue, passing Altoona's revered Mishler Theater, and arrives to pick up the waiting group from the Lehigh Valley Chapter, National Railway Historical Society. Note the 1950-model Buick automobiles. The Rothert department store is seen at the extreme right.

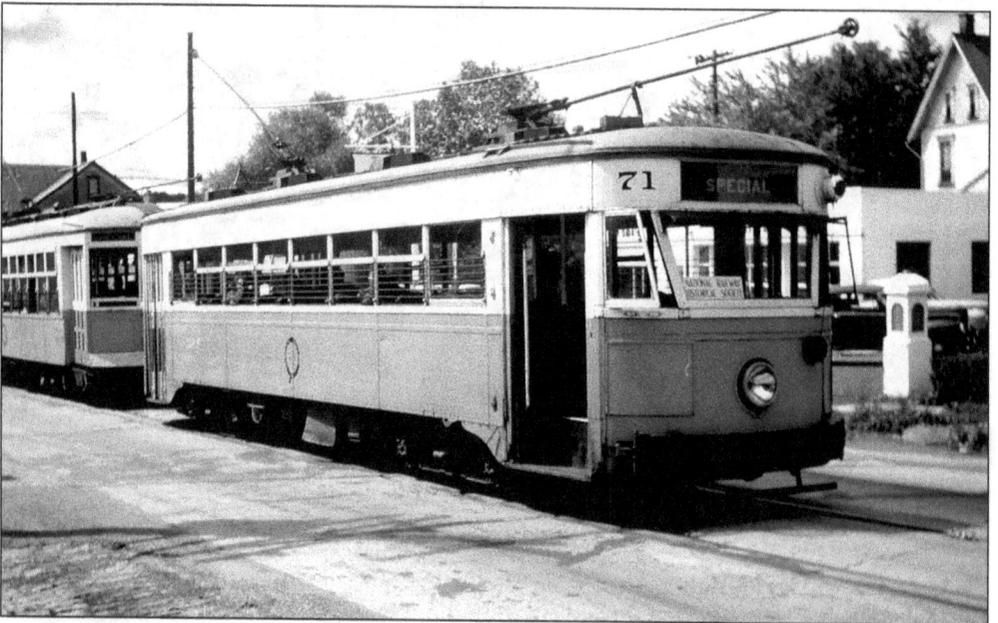

Car No. 71—with the Lehigh Valley Chapter, National Railway Historical Society—is ready to leave Eldorado in the early 1950s to return to downtown or the carbarn area for their chartered excursion.

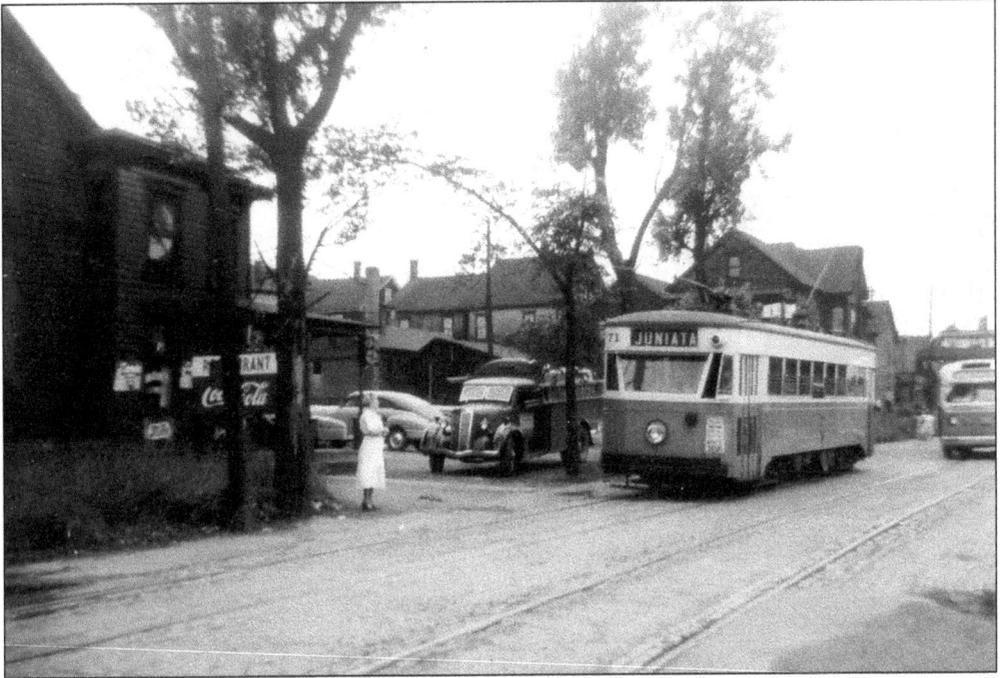

The last routes closed were the Juniata-Eldorado line and the Hollidaysburg line. The original end of line in Juniata was at Eighth Street and Third Avenue at the edge of Red Bridge. The East Juniata shuttle traveled over the bridge, but the Juniata trolley stopped here to reverse direction. In this photograph a GM bus has already replaced the East Juniata cars.

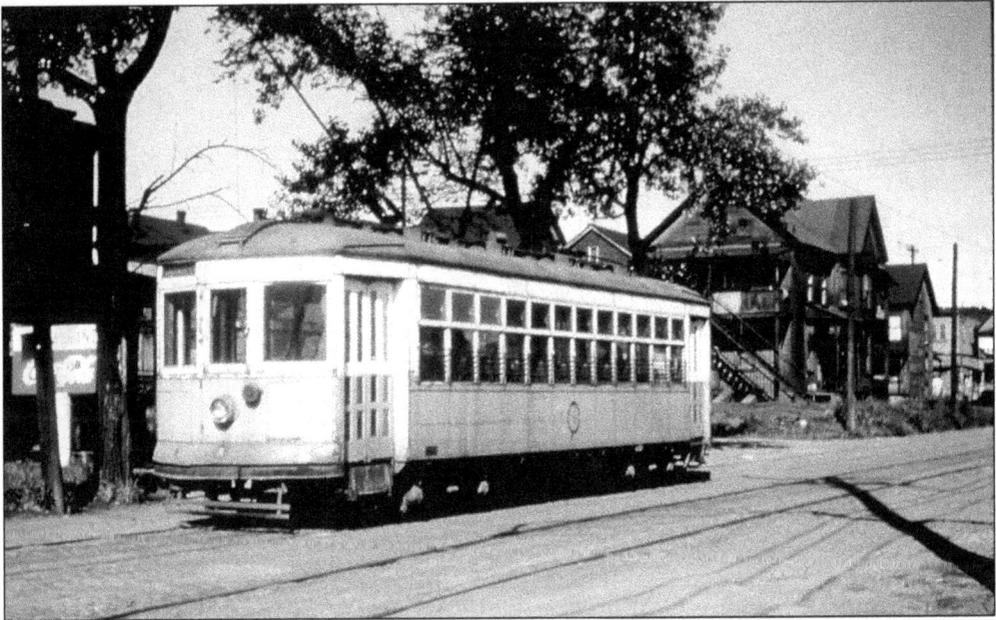

Car No. 54 has changed ends in Juniata and is about to reverse for the 10-mile journey to the Eldorado section of Altoona. During the last few years of traction in Altoona, only the Osgood-Bradley cars were used, which looked quite different from each other although they were only four years apart.

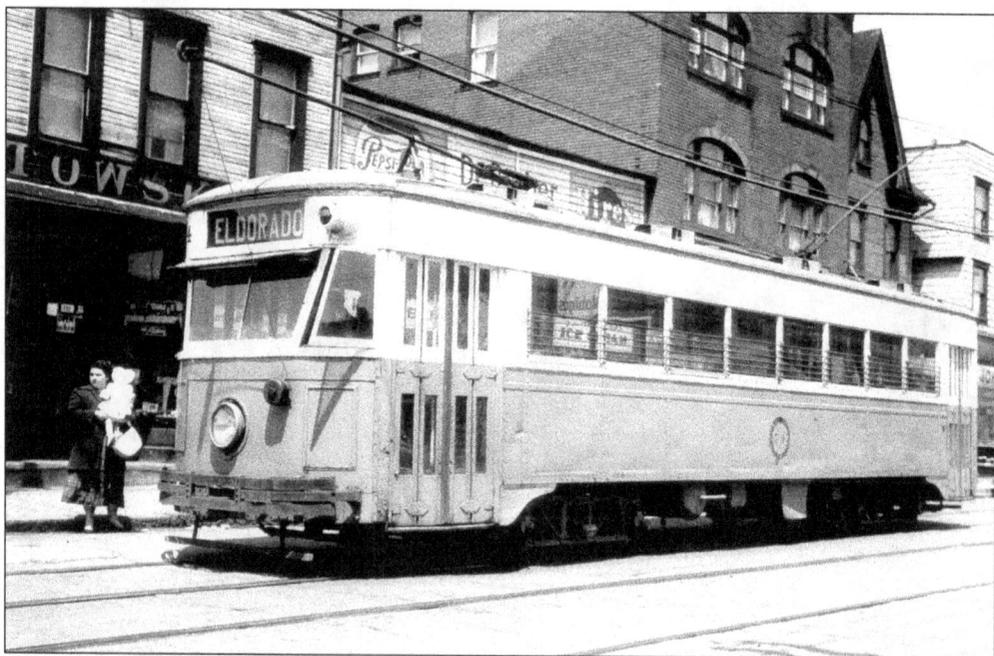

Car No. 74 has begun the crosstown journey and is seen on Fourth Avenue, Juniata, in front of the Ratowsky (Sam and Grace) Store, where a mother and child will board. The weather is still somewhat cold in this May 1953 photograph.

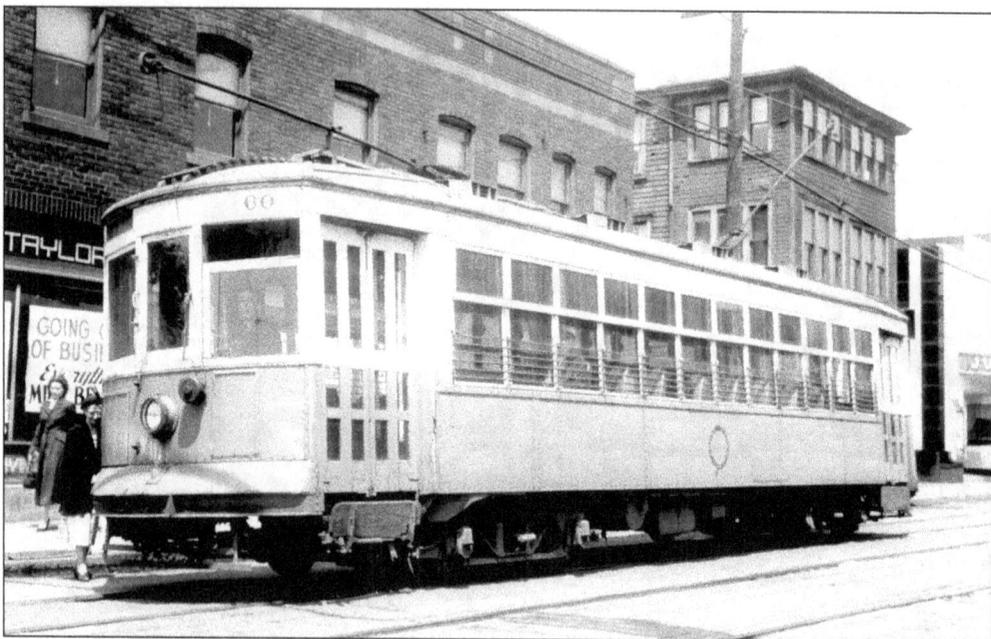

Car No. 60 (Osgood-Bradley 1925) stops at Fourth Avenue and Sixth Street, Juniata, in May 1953, almost one year prior to the end of trolley service in the Altoona area. This car looks in good condition at 28 years old. The Juniata Theater may be seen at the right edge of the photograph. Juniata, in close proximity to the PRR shops and yards, had a separate business district from downtown Altoona, two miles farther west.

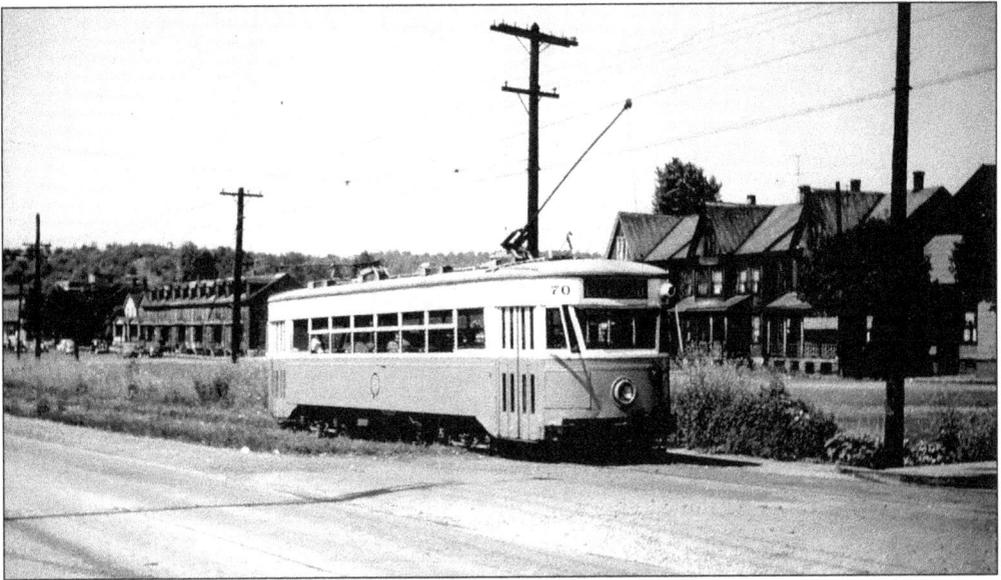

From Juniata (annexed to the city of Altoona in 1929), once it was out of the business district, the Logan Valley moved off the street and onto a private right of way en route to Altoona. In this view, car No. 70 enters the private right of way at Fifth Street opposite the PRR locomotive shops. This photograph evidently occurred during summer vacation shutdown, as the PRR parking lots are empty.

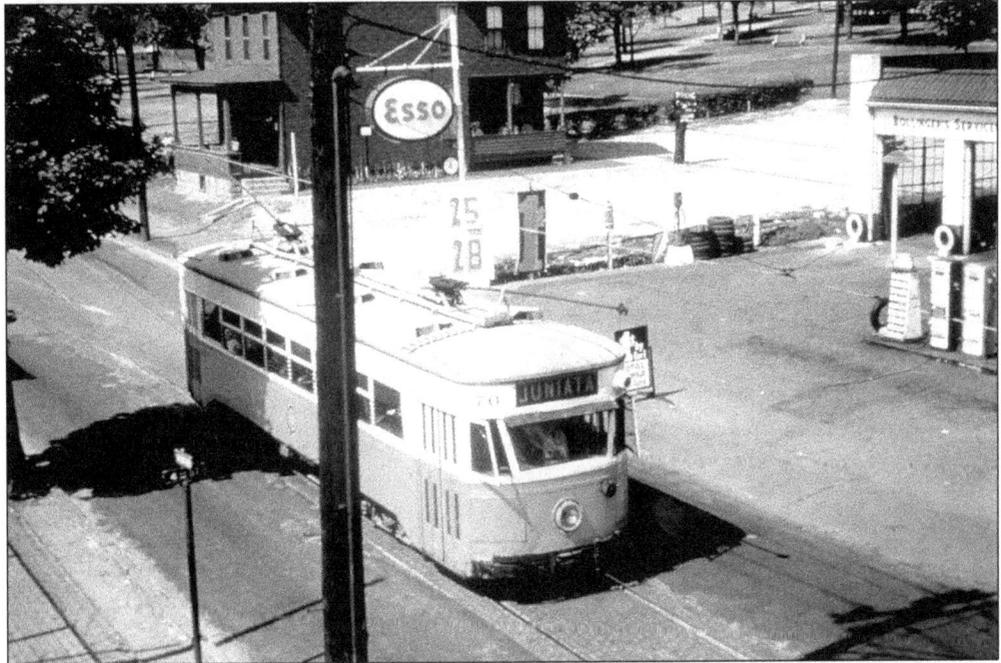

Car No. 70 is seen on Chestnut Avenue, Altoona, approaching Fourth Street and passing Bollinger's Esso Service. Three blocks farther, at Chestnut Avenue and First Street, would have been the location of the City Passenger Railway carbarn. Car No. 70 has just passed the PRR sports stadium, Cricket Field, at Seventh Street. Chestnut Avenue becomes Fourth Avenue, Juniata, about 1.5 miles farther east, as seen in the preceding photograph.

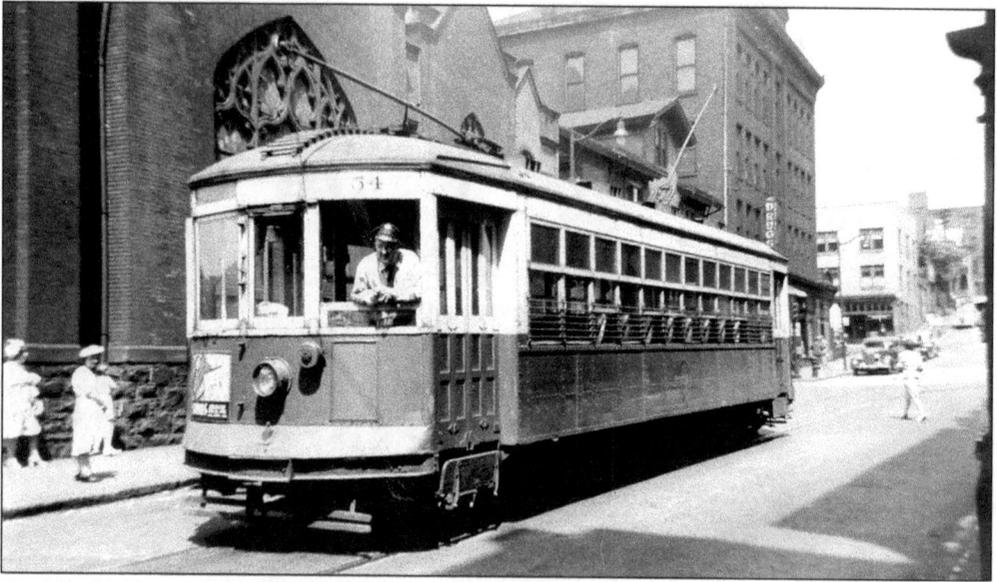

Car No. 54 (Osgood-Bradley 1925) sits on Eleventh Street at Twelfth Avenue around 1948. The trolley ticket office would be behind the photographer. Grace Lutheran Church stands to the rear, and the four-story building at rear is the Casanave Building. The identity of the motorman, regrettably, is unknown.

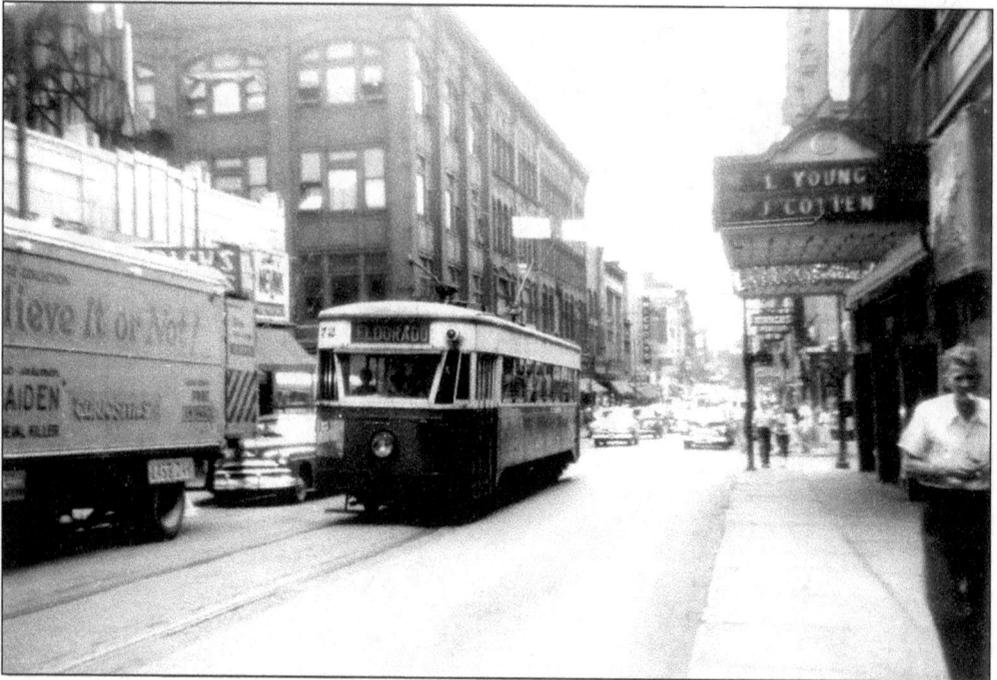

Car No. 72 traverses Eleventh Avenue in the heart of Altoona's business district on June 25, 1951. On the right is the Capitol Theater, and Gables Department Store is at rear left. At one time, Eleventh Avenue had five major movie theaters and others were located elsewhere downtown. Loretta Young and Joseph Cotten are listed on the theater marquee. Shirleys Shoes and Nevins Fountain and Drugstore are on the left, behind the truck.

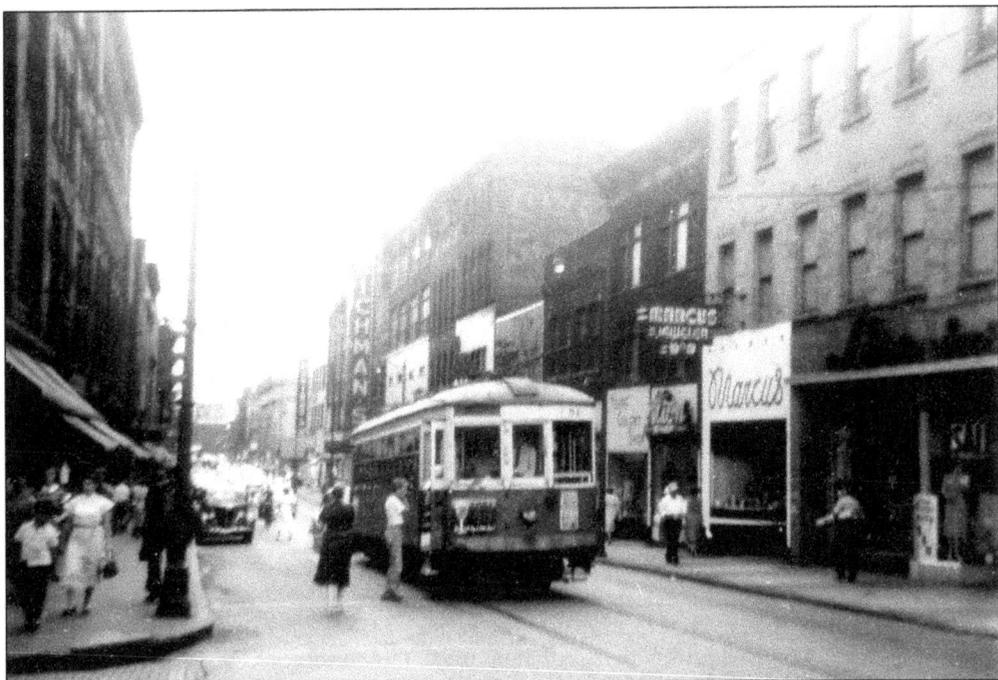

Car No. 51 stops on Eleventh Avenue at Fourteenth Street in front of Gables Department Store (left) on June 25, 1951. This car is destined for the county seat of Hollidaysburg. Once the primary business district, the area's decline began in the 1960s and continued, with much finality, until Gables closed in 1980 after a mall was constructed in Logan Township.

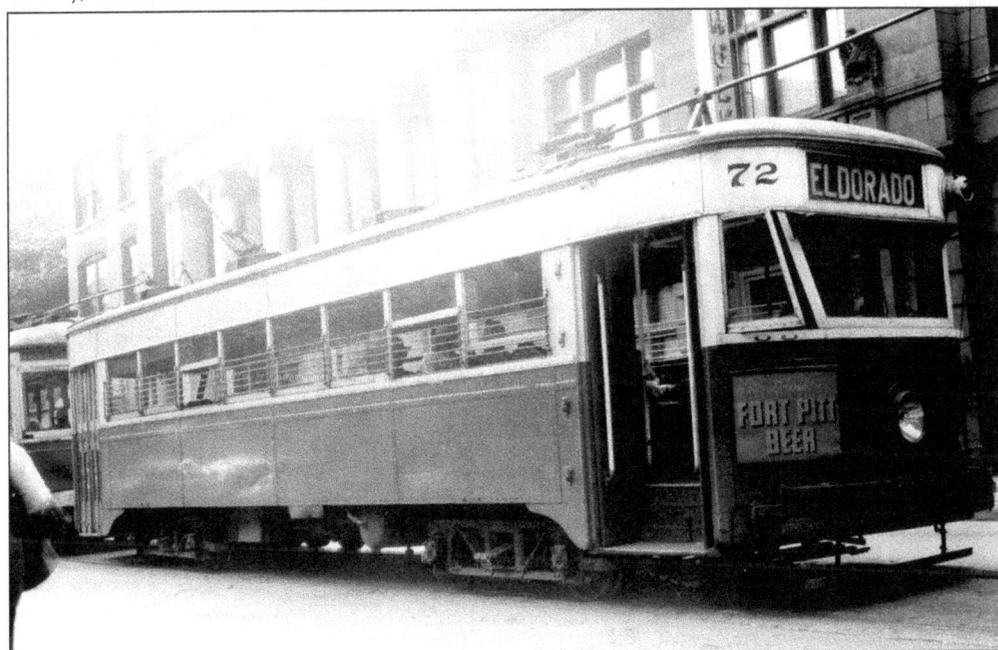

Car No. 72 sits on Twelfth Avenue near Eleventh Street on July 20, 1947. To the rear are the former Mountain City Trust Company and the Eagles Club. Fort Pitt beer was a popular brand due to Altoona's proximity to Pittsburgh, 100 miles to the west.

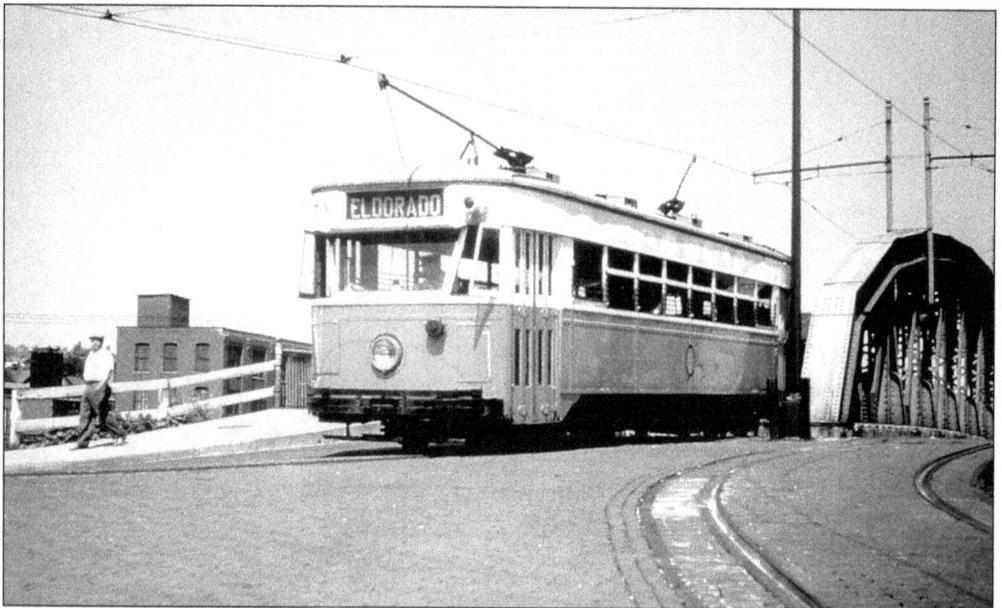

Car No. 70 has left downtown, crossing over Bridge Street (Seventeenth Street and Sixteenth Street converge onto the bridge in the foreground). This bridge crosses the main line of the Pennsylvania Railroad near ALTO Tower (left, out of view) and the PRR's famous test department (right, out of view).

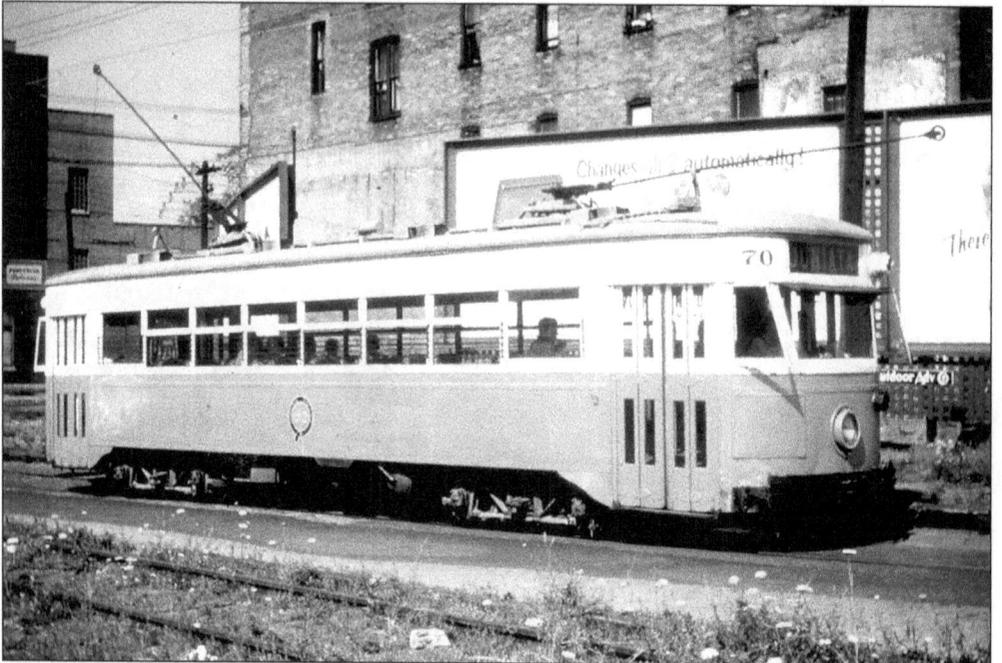

Car No. 70 traverses Ninth Avenue, one block between Seventeenth Street and Sixteenth Street inbound, towards downtown and will shortly pass the PRR test plant on Sixteenth Street. To the left, out of view, is the PRR public siding and large manual-crank crane, and Boyer Candy Company is to the rear left. All structures in this vicinity have been razed with the exception of Boyer Candy Company, which expanded in later years to occupy an entire block.

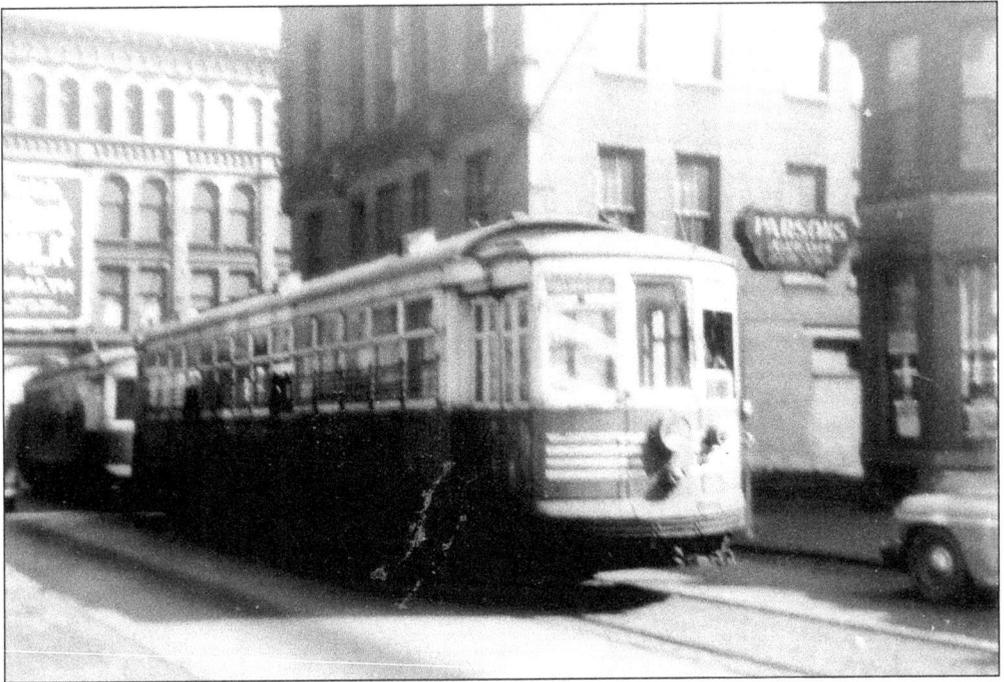

Car No. 180 (St. Louis 1913) is shown in downtown Altoona on Twelfth Avenue at Eleventh Street, the primary route-transfer point. In this photograph, taken on October 7, 1946, the car operates on the Hollidaysburg line. In the background, left, is the vacant Penn Theater. The Masonic building (rear center) is the Pennsylvania Department of Public Welfare office today.

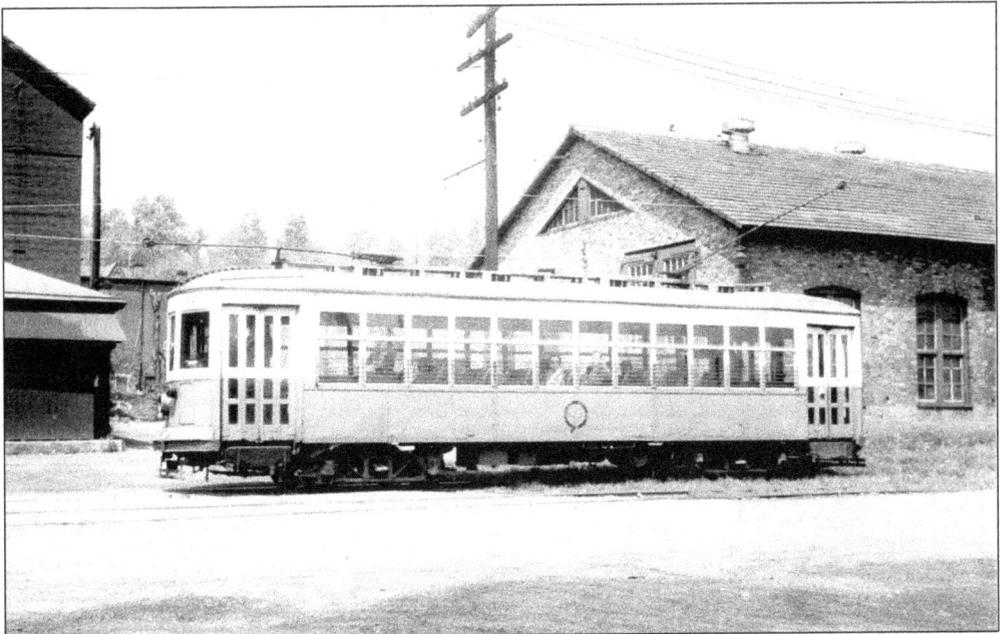

Car No. 62, heading to Eldorado on May 9, 1953, passes the carbarn area. The coal tipple (left), yard office, and paint shop also appear in this view.

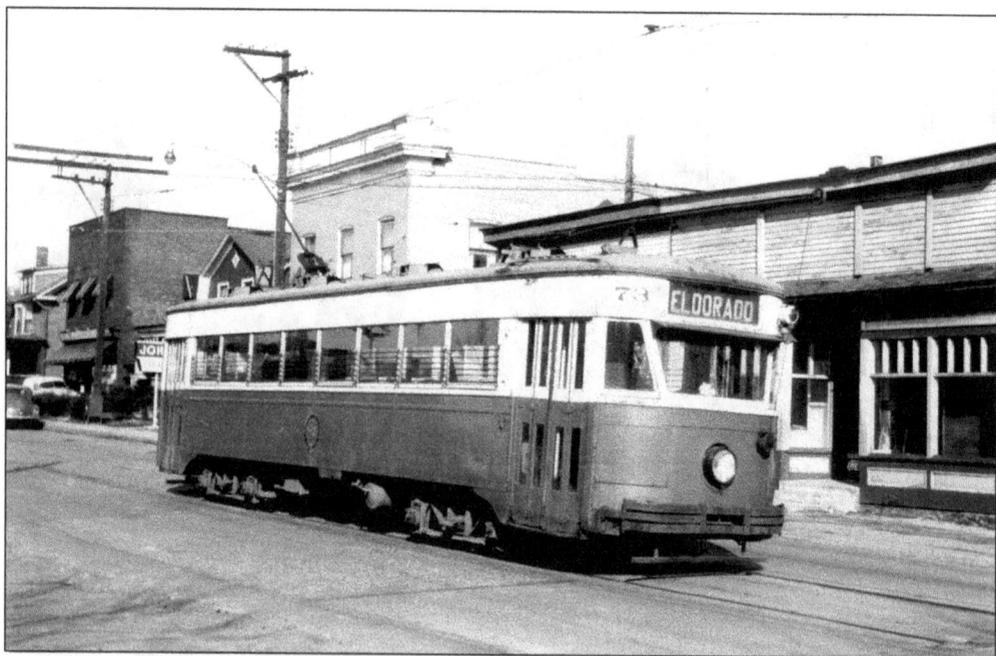

Car No. 73 has arrived near the end of the track in Eldorado on Sixth Avenue at Fifty-eighth Street (Pennsylvania State Route No. 764) around 1951. The motorman will reverse direction toward downtown and Juniata. Four to six cars were required to maintain a schedule on this route.

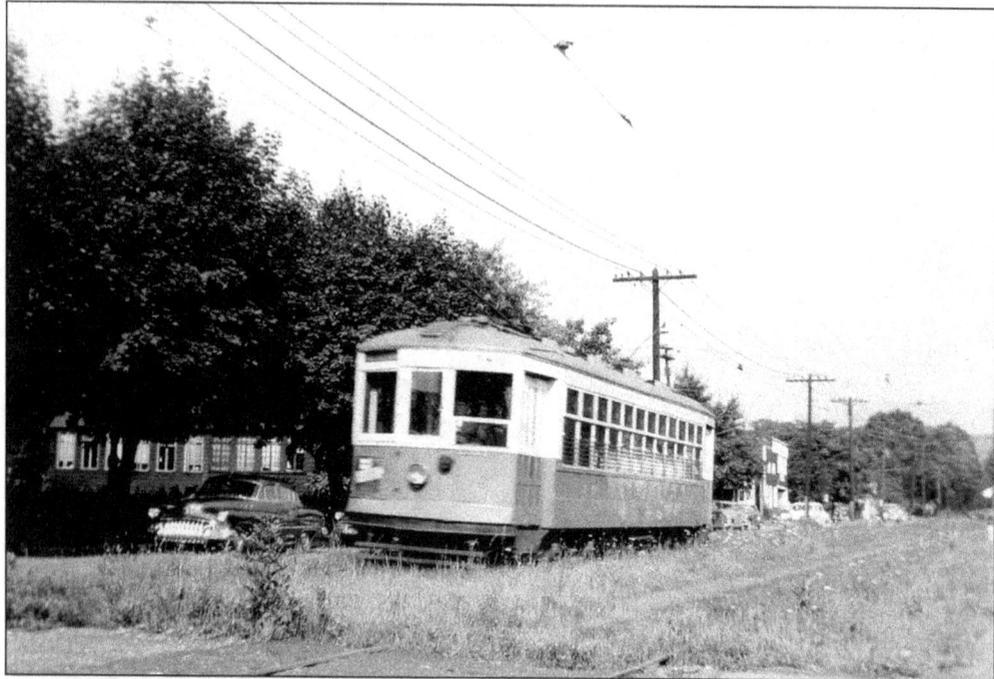

Car No. 52 approaches Eldorado-Hollidaysburg Junction southbound on Logan Boulevard at Fifth Avenue. Both routes were double-tracked at this 90-degree crossing point on private right of ways. The business to the rear of the trolley is the H. Fickes and Son Lumber and Millwork Company. A 1950 Buick is parked on the left.

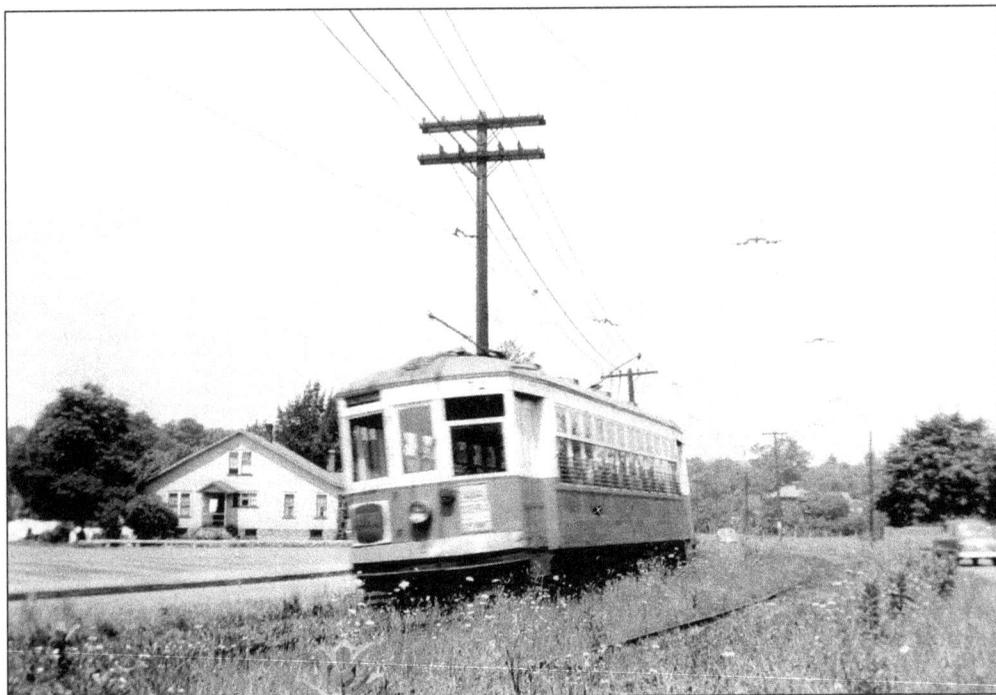

Car No. 52, southbound on Logan Boulevard, approaches Burgoon Road. The Rivoli Theater is on the left (out of view), and Mansion Park athletic fields are on the right (out of view).

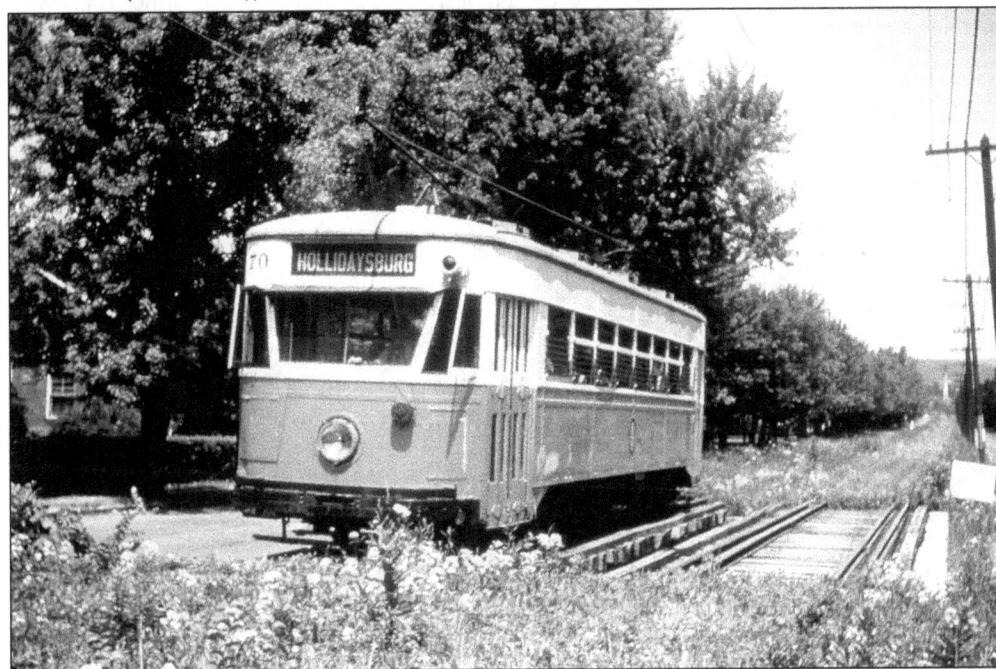

Car No. 70, formerly restricted to the Eldorado line, is seen on the Hollidaysburg route in the Llyswen section of Altoona on Logan Boulevard. This car travels inbound through Altoona, approaching Ward Avenue. The track area today is a small grass strip, and Logan Boulevard is a four-lane road rather than two (one lane on each side with a double track in the middle).

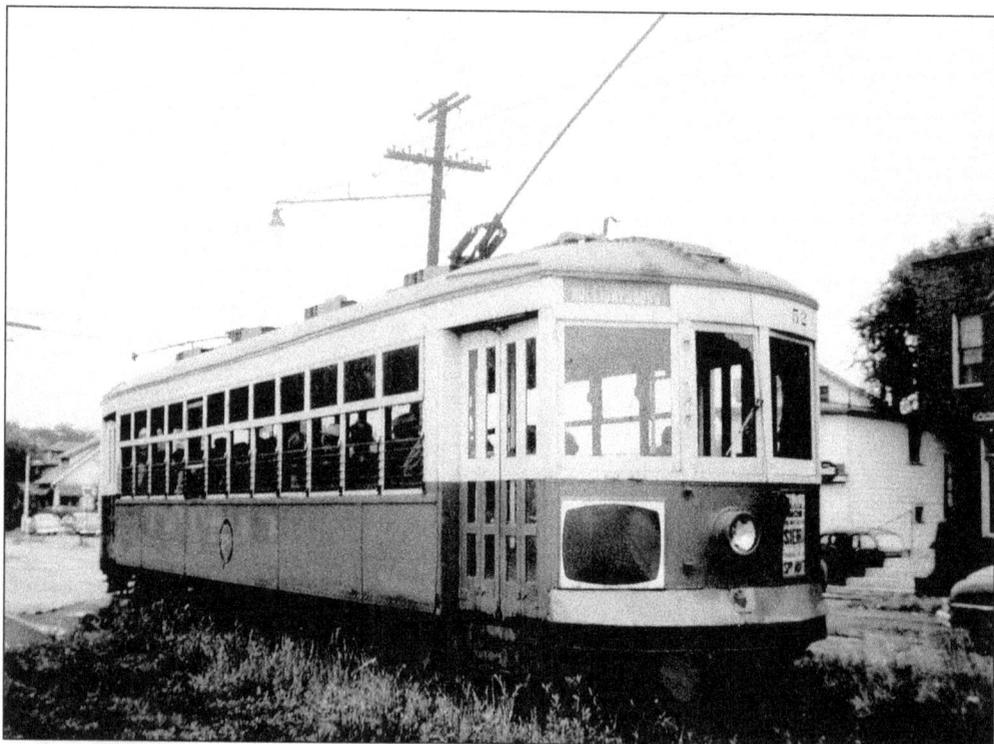

Car No. 52 arrives from Hollidaysburg to the Plank Road intersection. The former Boulevard Hotel is on the immediate right.

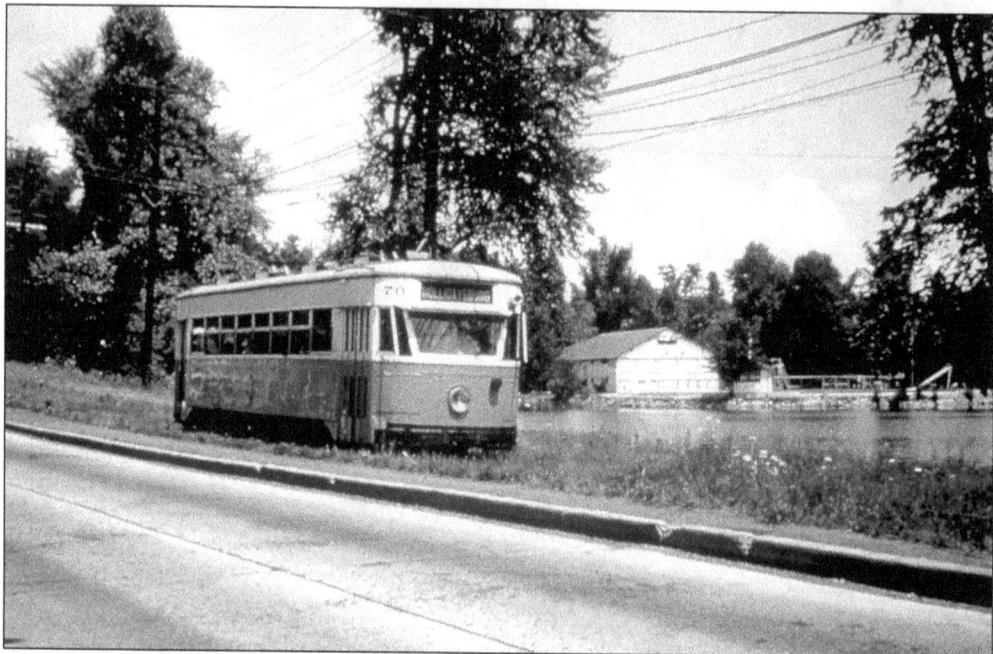

Car No. 70, en route to Hollidaysburg, has just descended Park Hill and is passing Lakemont Park. In the background are the park bathhouse and the Blue Island Pool in the center of the lake, which was always a popular destination on a hot summer afternoon.

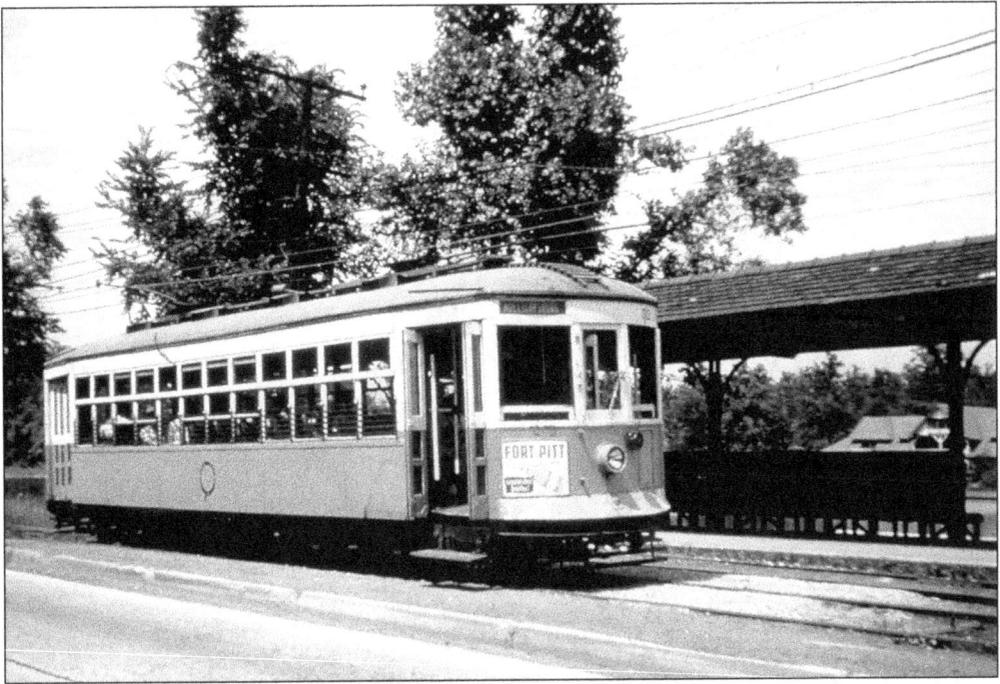

Car No. 52 sits at Lakemont Park station, en route to Hollidaysburg, in this 1953 scene. One year later, the trolley system would operate its last run, resulting in the end of an era by rail. The Lakemont Park trolley loops were busy during the summers, with school picnic specials to the park during the month of May.

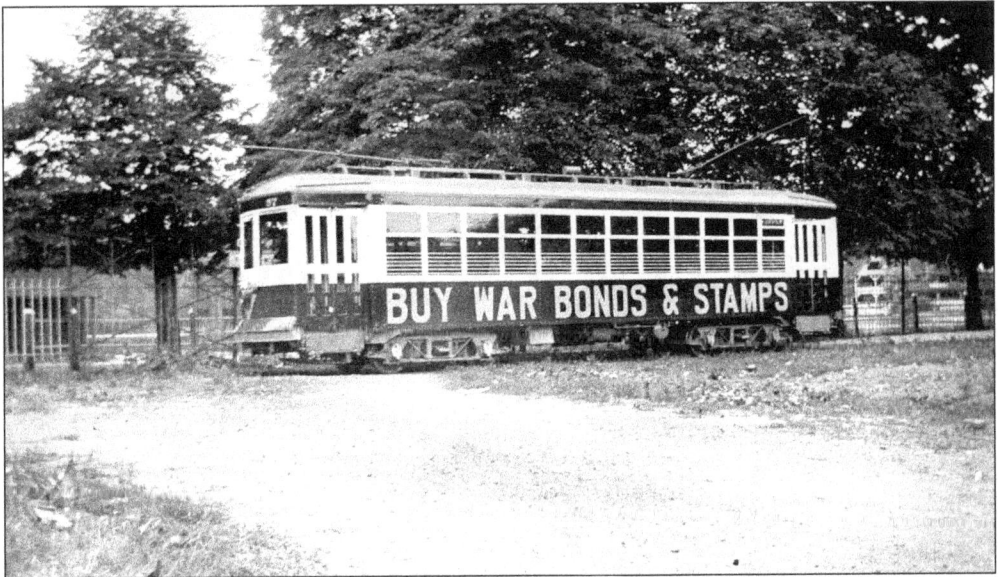

Car No. 57 was painted red, white, and blue during World War II to support the purchase of war bonds. A large V for victory was placed around the headlight. Here car No. 57 travels on the Lakemont Park loops during the 1940s. Prior to 1936, this area also was noted for the park greenhouses, which were destroyed in the spring floods of March 17, 1936.

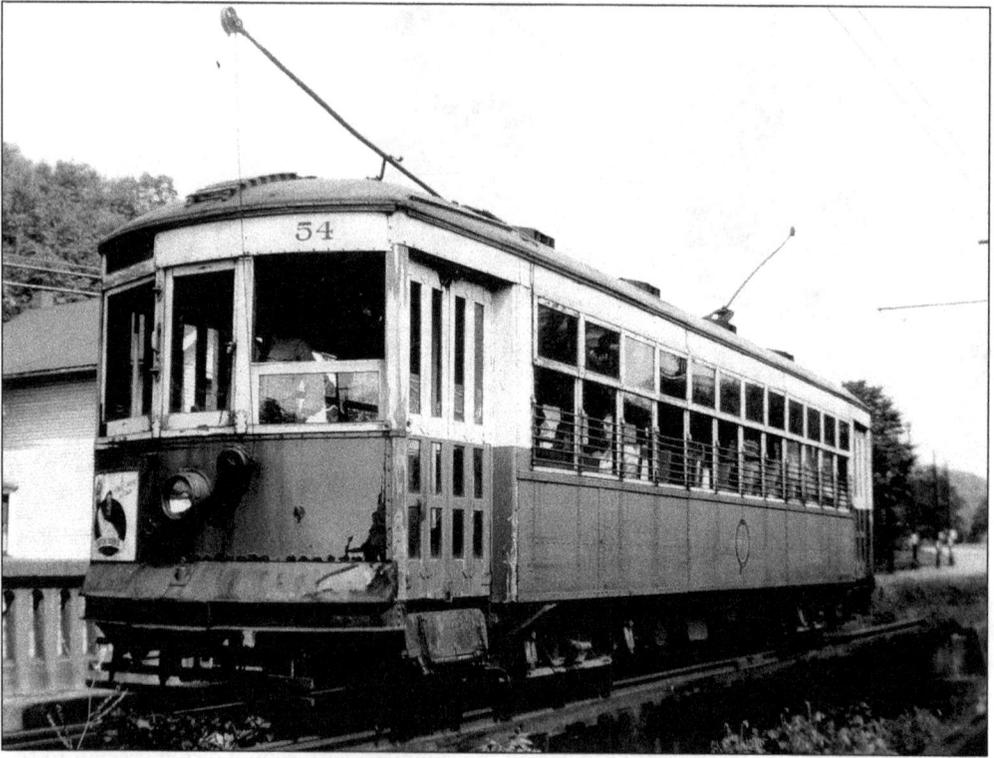

Car No. 54, inbound from Hollidaysburg, crosses Brush Run Bridge in Lakemont village. This image, taken near the end of service in 1954, shows that the maintenance on the equipment has been deferred. An advertisement for Duquesne Pilsner beer is seen on the pilot.

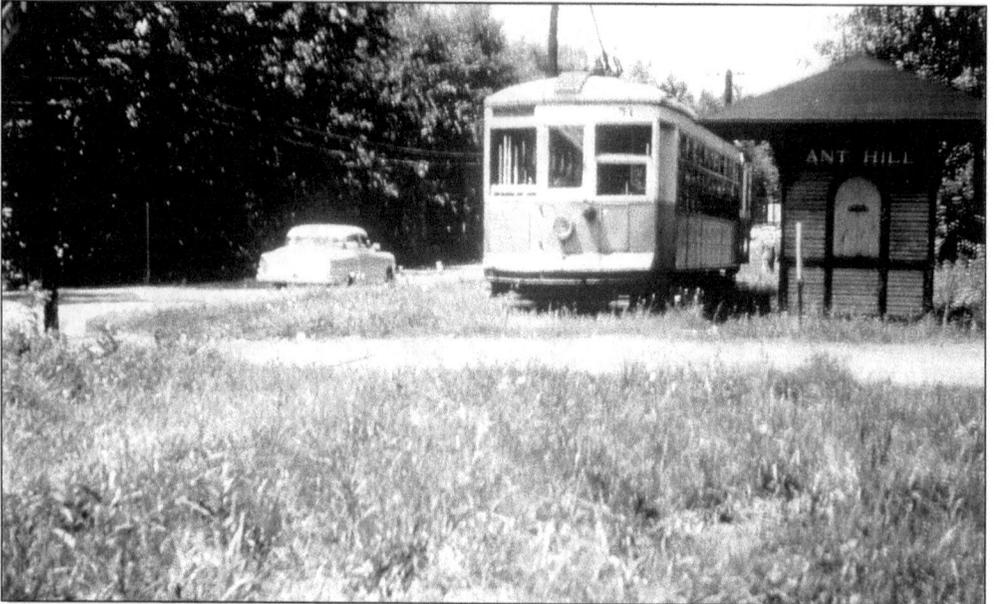

There were many station stops between Lakemont Park and Hollidaysburg, each of distinctive design in this fashionable area noted for large, impressive homes. This view depicts the Ant Hill shelter, named for large anthills that were once a novelty nearby.

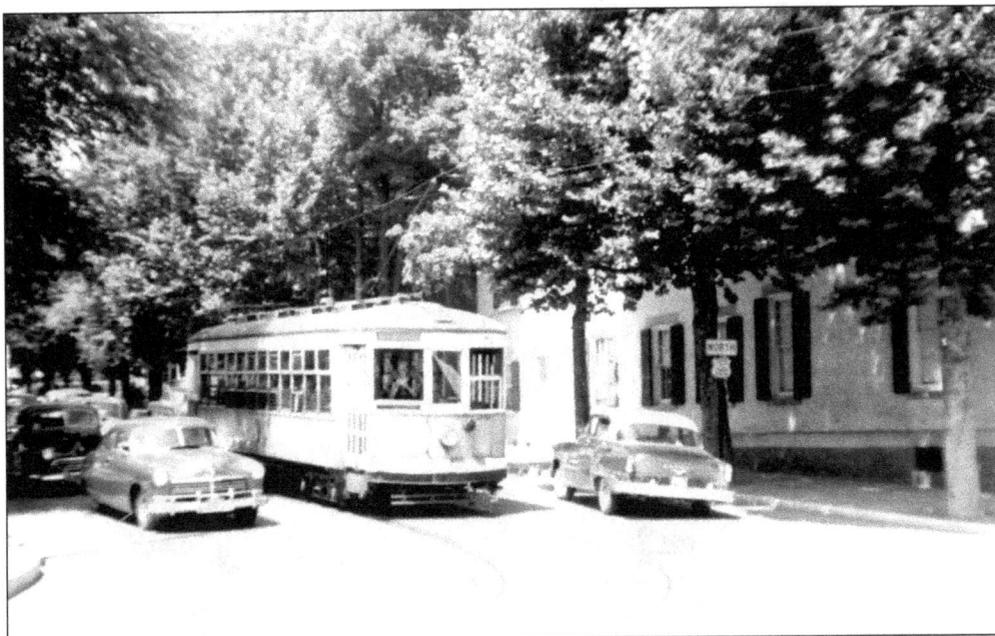

Car No. 51 is seen on Penn Street in Hollidaysburg. The post office is on the immediate left, out of view, and the tracks turn onto Allegheny Street to the main business district and the county courthouse. The vintage automobiles are an Oldsmobile and a Hudson, left, and a DeSoto, right.

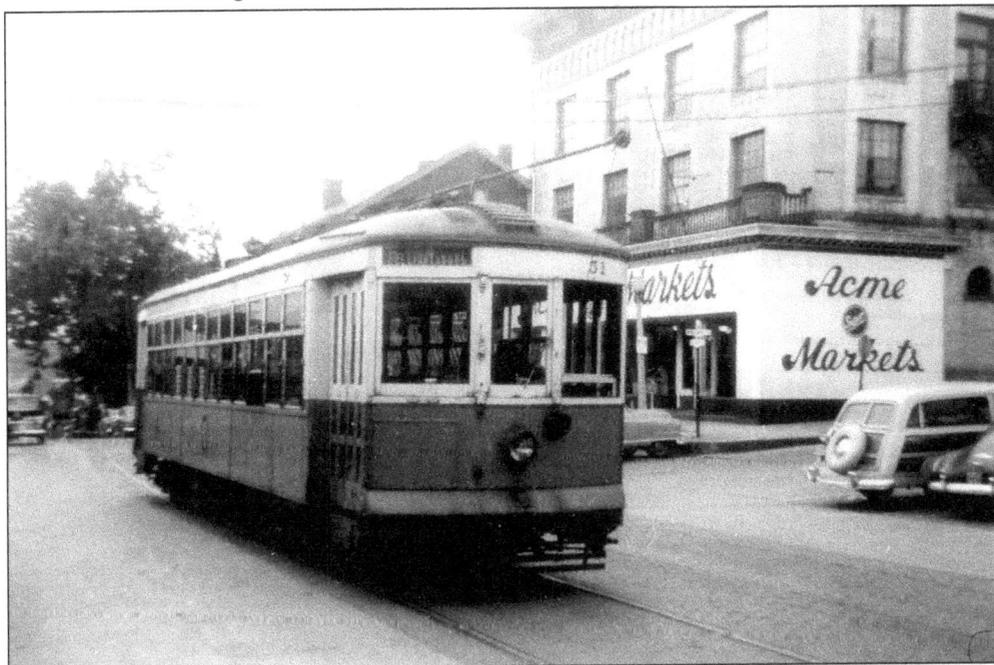

Car No. 51 is seen on the Diamond in Hollidaysburg on June 25, 1951. It has just reversed direction to return to Altoona. The Acme Market is long gone, and Weirman's Furniture stands in this location today. The H. L. Green and G. C. Murphy five-and-dime stores were formerly on the immediate right in front of the woody Ford station wagon. The Capitol Hotel, still operating today, is left, out of view.

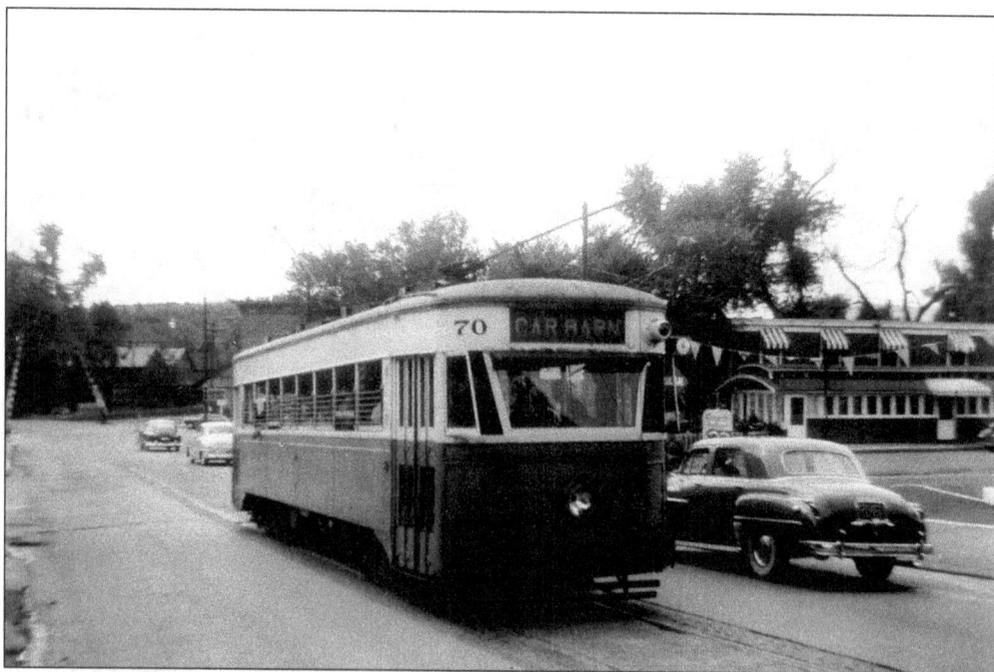

Car No. 70 reaches the end of the track in Hollidaysburg on Allegheny Street at Juniata Street on September 1, 1952. Hoover's Sunoco station and the O'Neil Hotel are on the left, out of view.

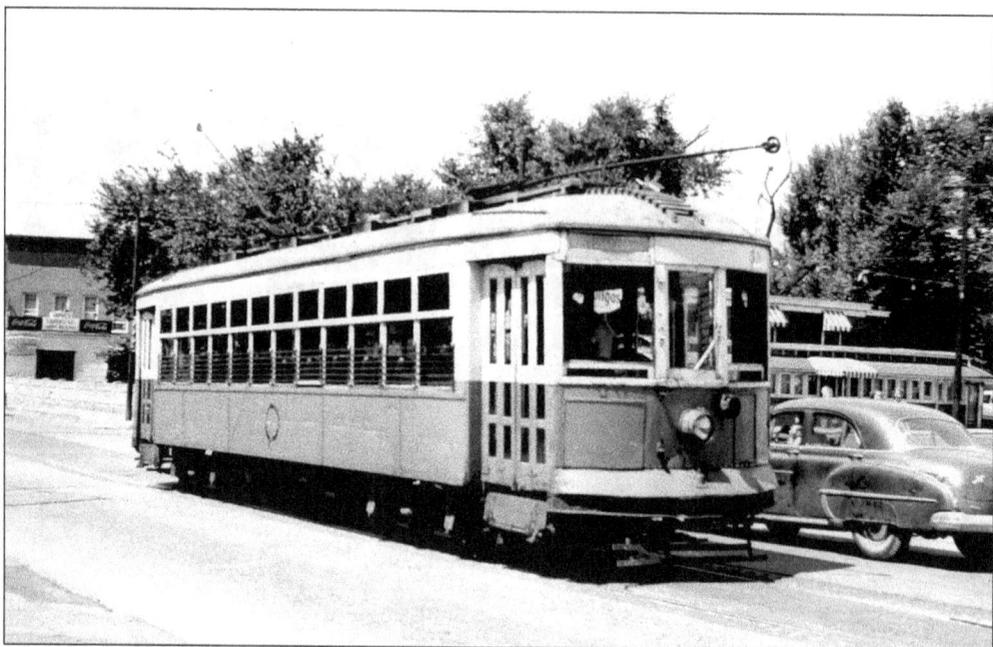

Car No. 59 arrives at the end of the track on Allegheny Street in Hollidaysburg in 1951. This location is at the bottom of a hill where some streetcars failed to stop and slid down toward the PRR station and the Little Juniata River.

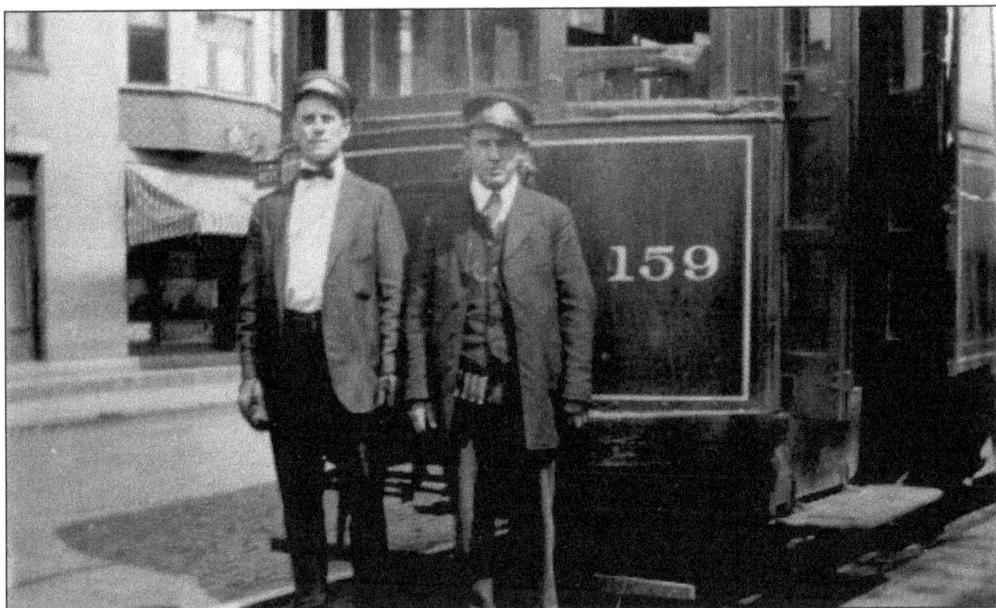

The next two photos shows a father and son as Logan Valley motormen. Clyde W. Kinsel Sr. (right) is seen with car No. 159 (Stephenson 1903) on Broad Street in Hollidaysburg. His conductor (left) is unidentified.

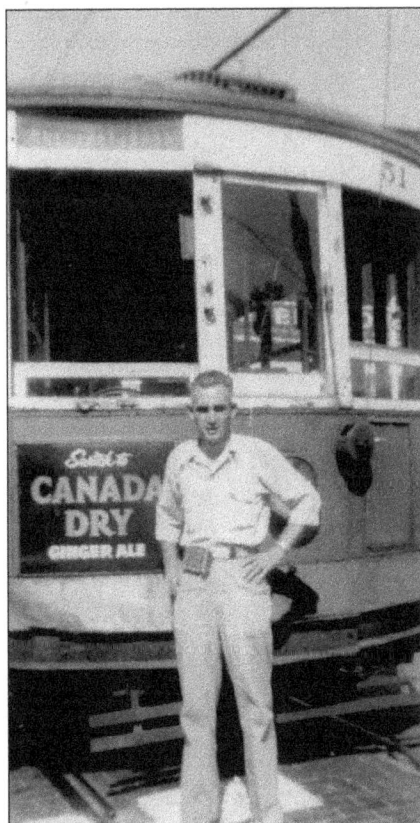

Clyde W. Kinsel Jr. is seen here with car No. 51 at the end of the track in Hollidaysburg on Allegheny Street. He is opposite Hoover's Sunoco on the last day of revenue service, June 2, 1954. Car No. 51 was also the last trolley on the final farewell ride on August 7, 1954.

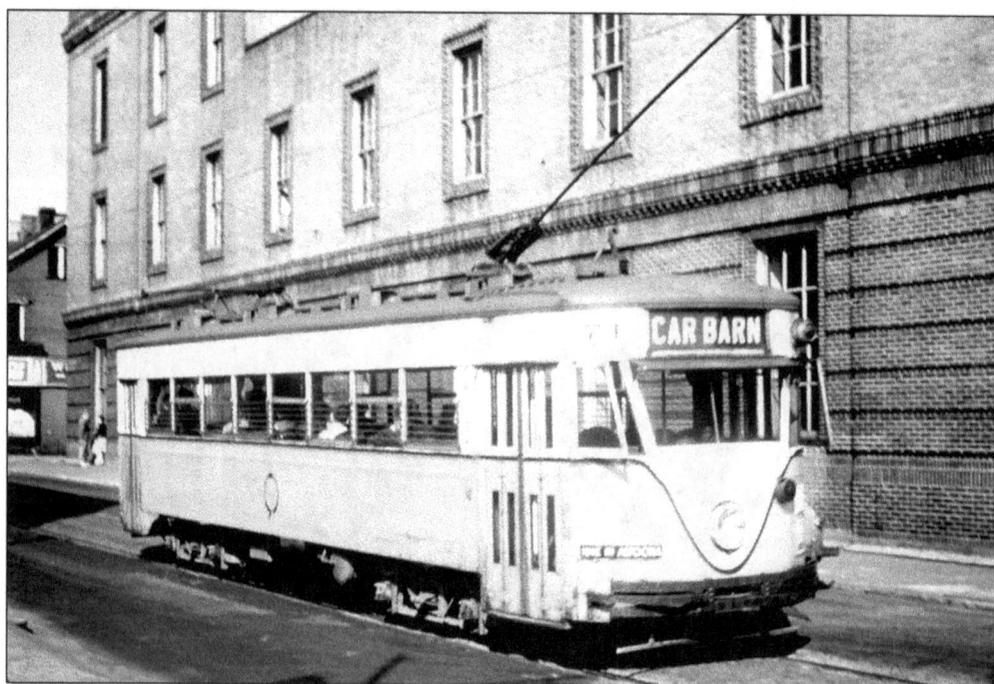

Car No. 74, the last trolley car purchased by Logan Valley, is signed for the carbarn as it traverses Twelfth Avenue, passing the Bell Telephone building at Sixteenth Street. At this time, buses have replaced streetcars during the evening after the rush hour. The sun is literally setting on No. 74 as it makes the final downtown loop.

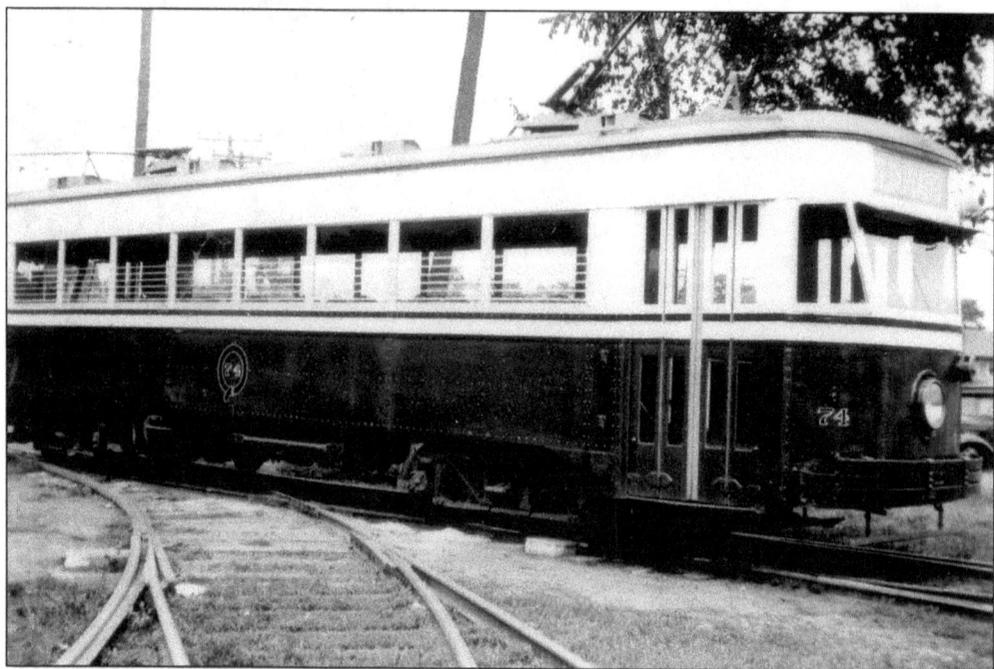

This photograph shows another view of car No. 74 on a carbarn movement. The paint scheme is the same as it was 25 years earlier.

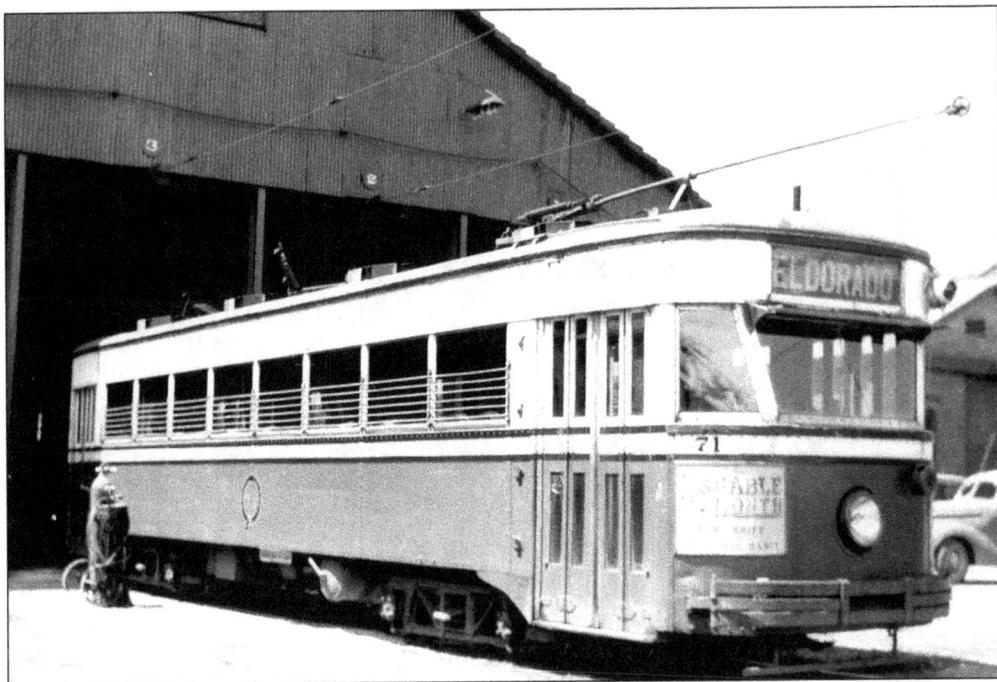

Car No. 71 sits in front of the carbarn in an earlier paint scheme. The advertisement for Gables Department Store establishes May as Gable month, an annual shopping event noted for sales promotions.

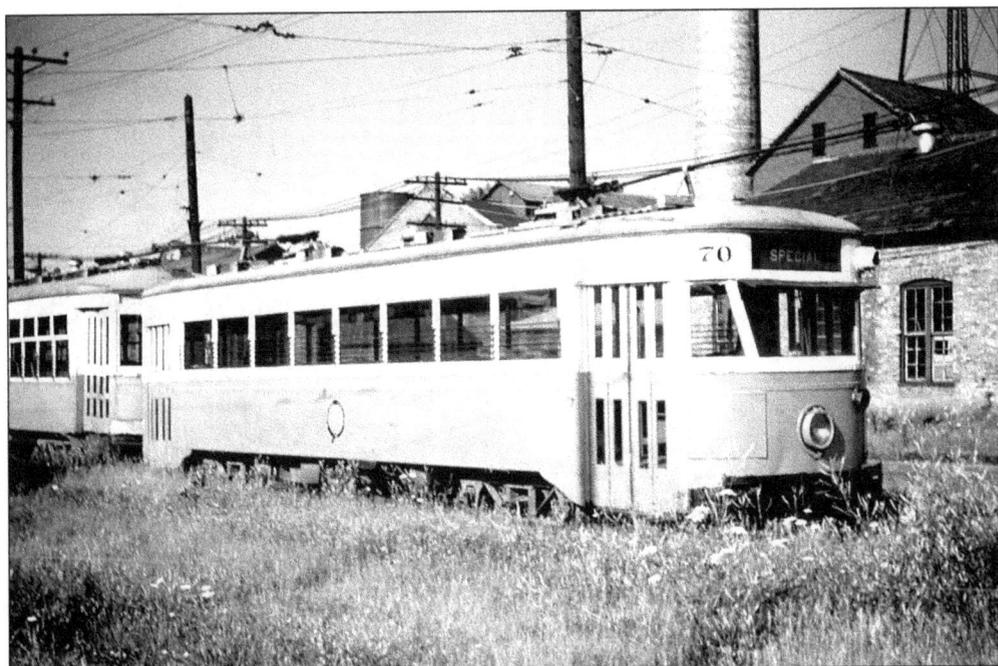

With a plain and simple paint scheme, car No. 70 sits at the carbarn area in the 1950s. High grass has taken over the track beds due to deferred maintenance, and the end of service looms on the horizon as 1954 approaches.

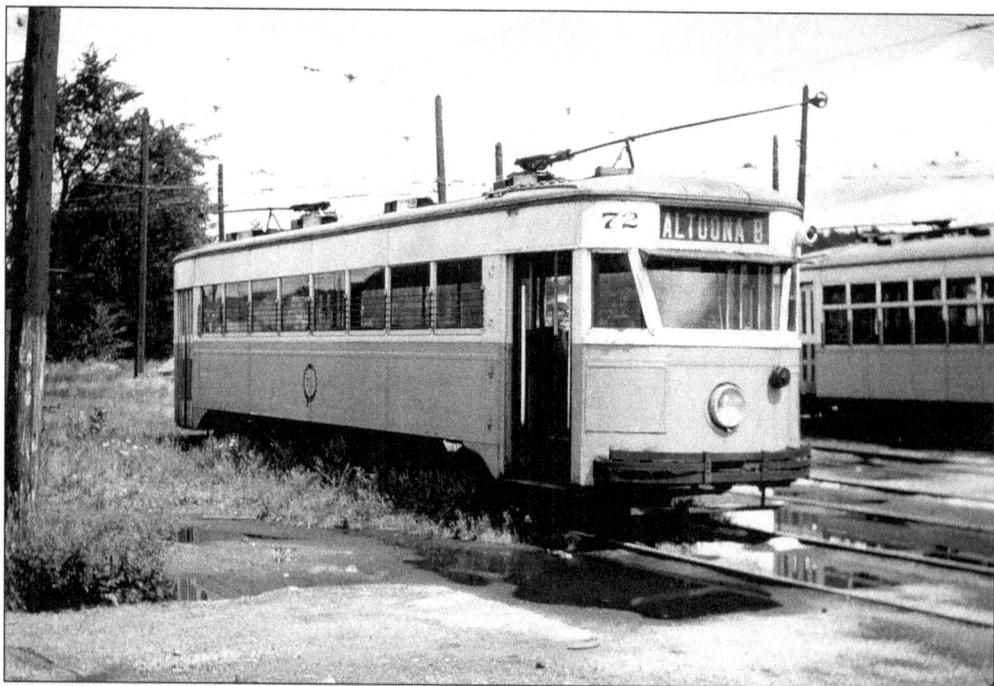

Car No. 72 awaits its final fate at the carbarn in late 1954. All such cars were scrapped on the property. This car appears to be in good condition after the years and miles of service it provided.

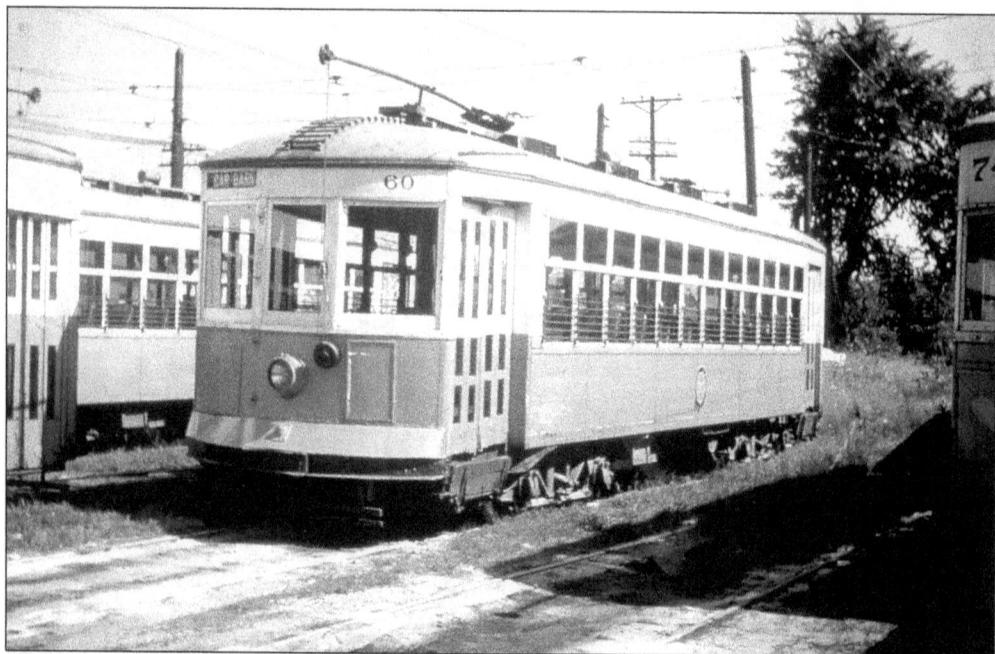

Car No. 60 sits at the carbarn lead tracks in late 1954, awaiting a call to action that will never come. This car, some 30 years old with bright, gleaming paintwork, displays an excellent appearance as the morning sun shines on the ivory and orange car body, a tribute to the skill of Logan Valley shop crews.

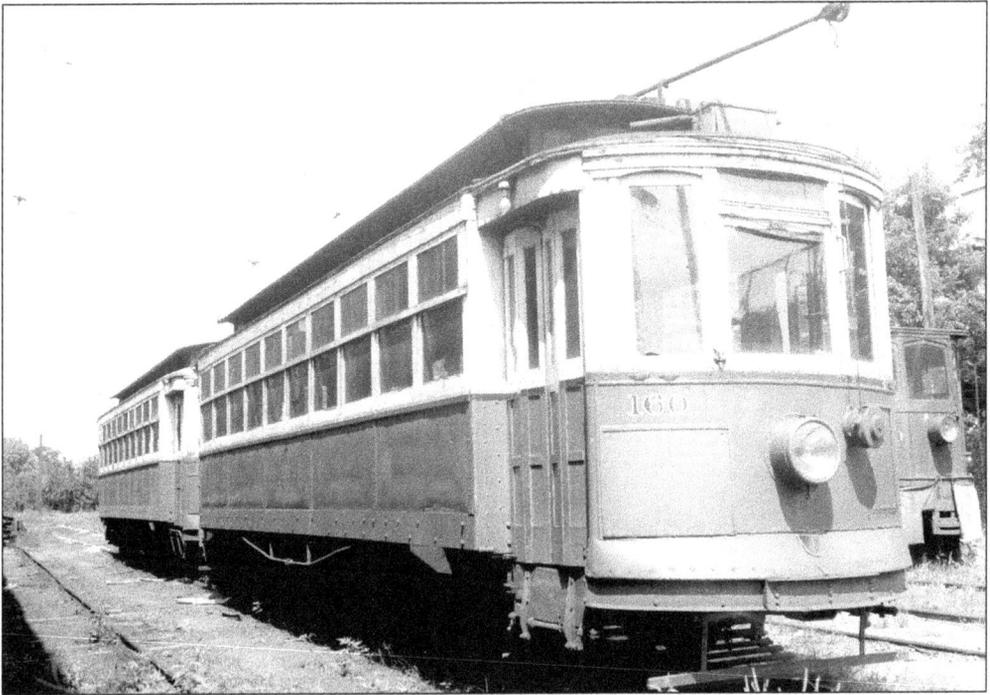

Car No. 160 (Stephenson 1903) rests on the yard tracks after retirement in 1948. Cars numbered 159 through 161 were from the same series and were originally wood-sided. Logan Valley shops rebuilt these cars in 1938 with steel sides and continued to use them until retirement. In this photograph, No. 160 is nearly 50 years old.

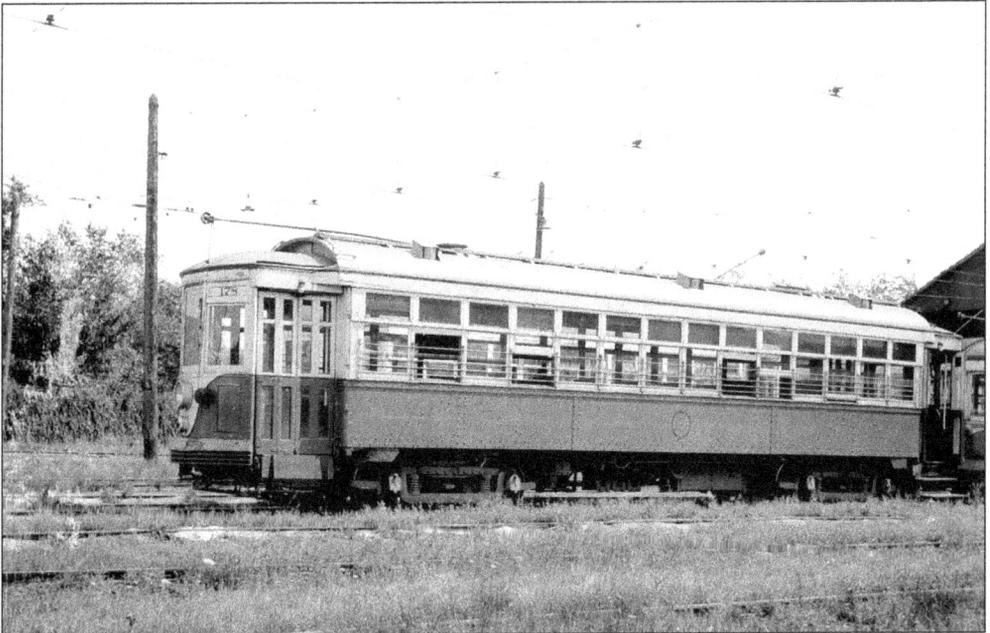

Car No. 178, a 1913 St. Louis car, sits on the lead tracks in May 1950. Although still in excellent condition, it was retired in 1951. These cars (numbered 173 through 180) were some of the largest cars used on the system.

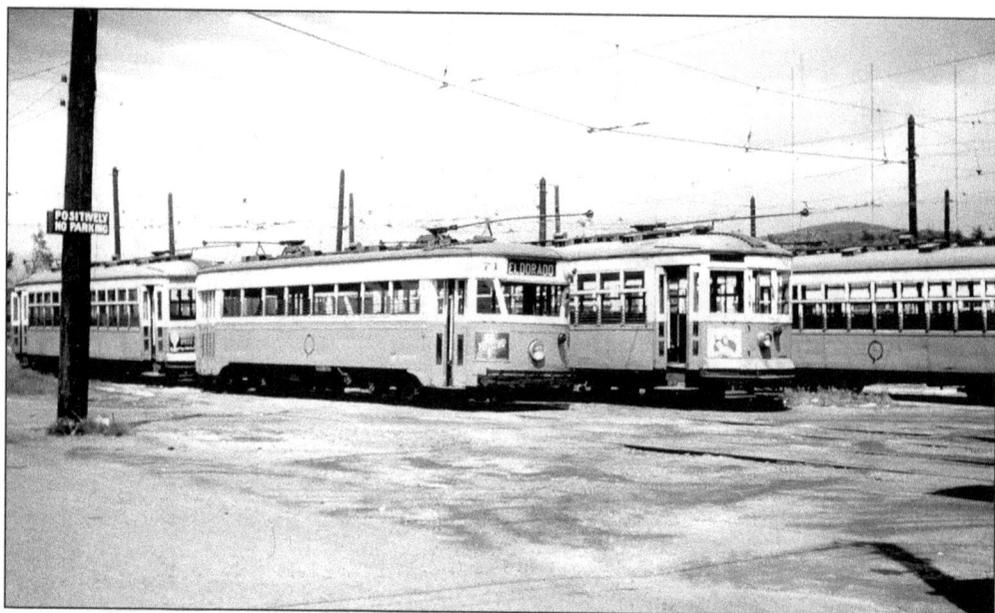

In June 1954, the trolleys stopped operating during the PRR summer vacation period. The buses could handle the ridership levels when the railroad shops were closed. Upon reopening in July, the trolleys still sat idle with the buses carrying the load. The final two years of traction operation in Altoona were handled with two types of Osgood-Bradley cars (shown here): the 1929 model (No. 71) and the 1925 model.

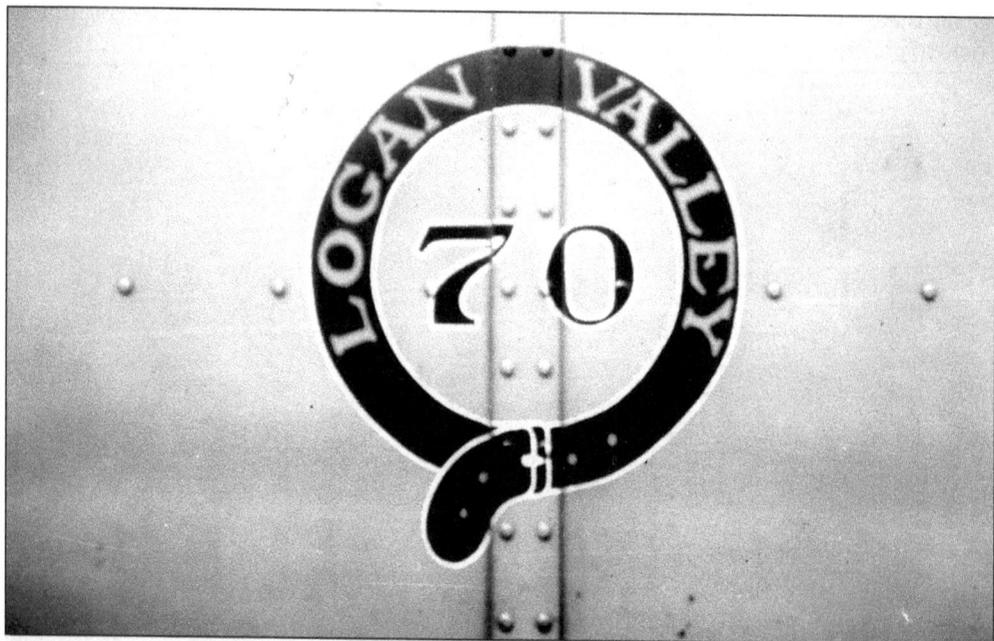

With the trolleys parked, only the buses would carry the Logan Valley logo to the streets. The symbol was a black belt with the unit number inside. Some say this is because the Logan Valley Beltline Company sold stock to raise capital for the system. Others say it meant the Logan Valley was the belt that held the area together. Either way, it would no longer be used on rail equipment.

Seven

THE LAST RIDE
AUGUST 7, 1954

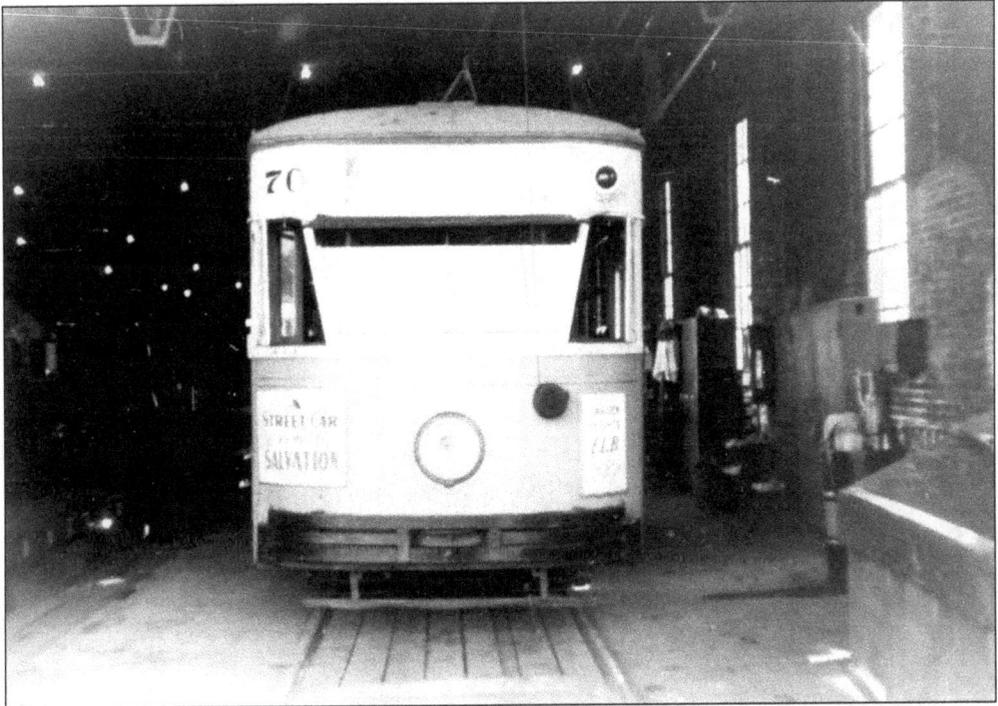

The trolleys no longer operated in regular service after June 1954. However, many rail fan groups visited Altoona to charter special excursions to photograph trolley operations, a source for many of the photographs in this book. Another group was the Garden Heights Evangelical United Brethren Church, which used car No. 70, christened "A Streetcar Named Salvation," for a ride around the system. The car had a portable organ for singing hymns. Martha McLaughlin played the organ and she was accompanied by Dean Esper on the accordion. About 70 people rode this special car in July 1954.

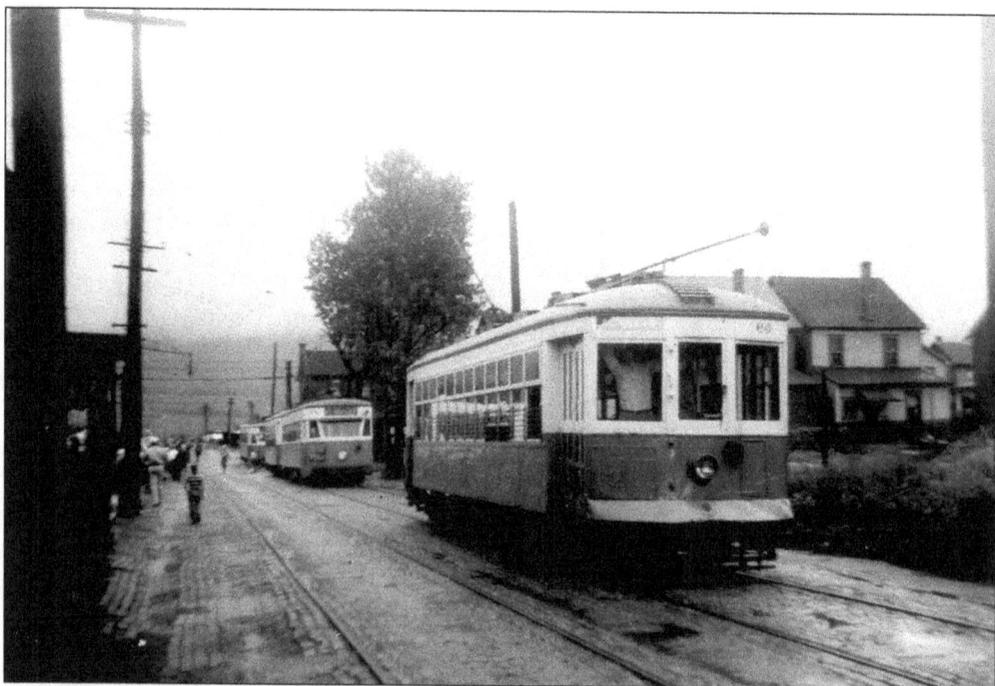

Another charter group in 1954 was the North Jersey Chapter of the National Railway Historical Society, which had four cars on the Juniata-Eldorado and Hollidaysburg routes. Here the four cars sit at Red Bridge, changing ends for the trip to Eldorado.

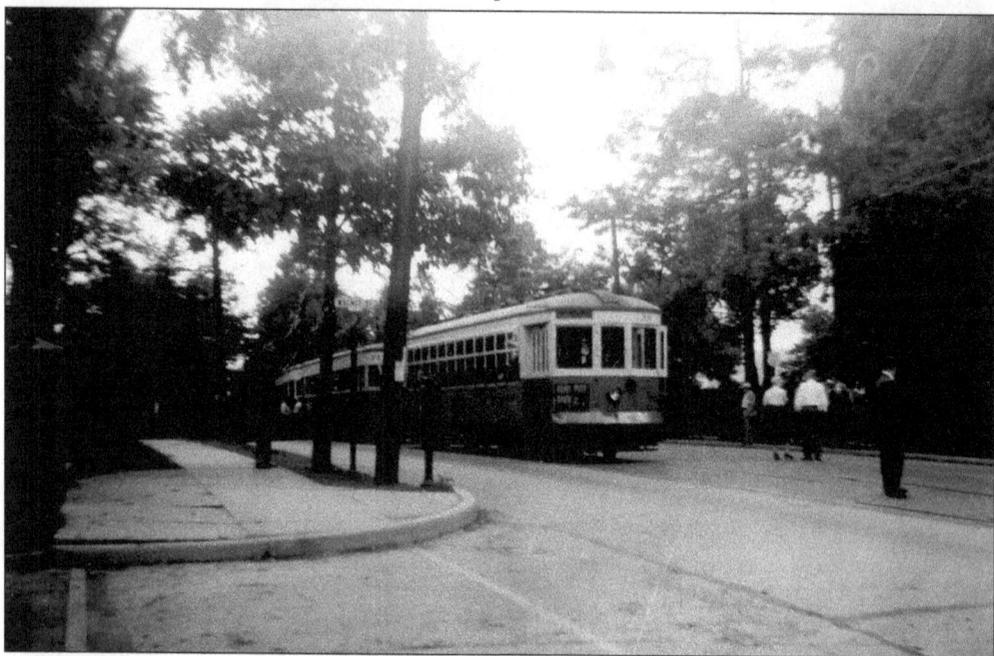

Continuing from the preceding photograph, the North Jersey Chapter group arrives in Hollidaysburg. They are stopped at Penn and Walnut Streets, near the landmark building Highland Hall and First Presbyterian Church. Hollidaysburg was the county seat and the courthouse was one block away.

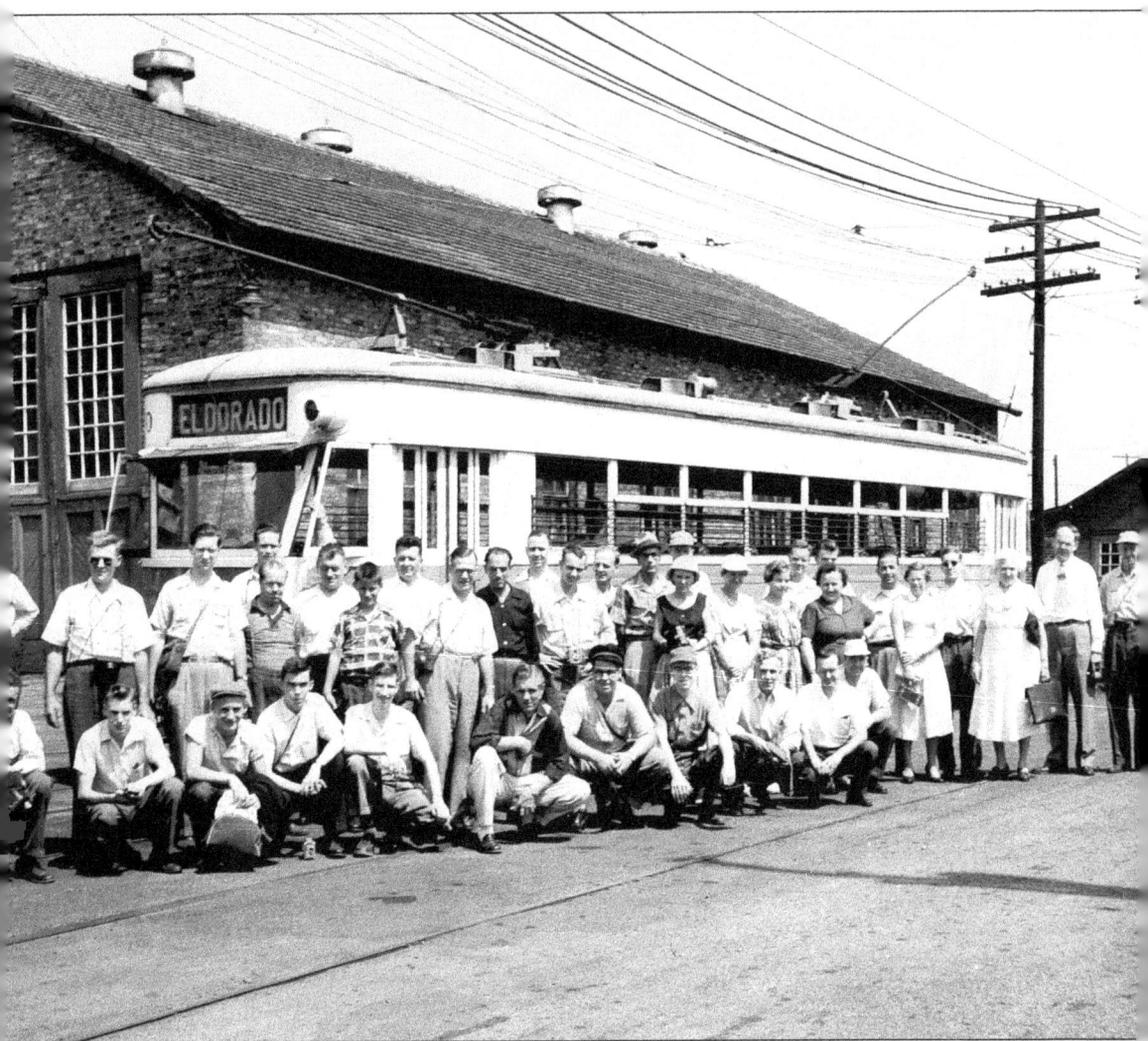

The Lehigh Valley Chapter of the National Railway Historical Society chartered an excursion on July 25, 1954, arranged by Gerhard Salomon. Seen with car No. 70 at the carbarn, from left to right, are the following: (kneeling) Thomas Ruddell, Richard Pearson, Larry Fisher, Andrew Maginnis, Gerard Deily, Kenneth Bogert, Walter Ensley, unidentified, Lloyd Allen, Ernest Kovacs, and Elwood McEllroy; (standing) motorman Wilbur Libold, Charles Kleivman, unidentified, Albert Remaley (front), two unidentified (behind), Charles Houser Sr. and son, Randolph Kulp, two unidentified, William Coe, unidentified, Edward Miller, Woodrow Eckert, Alma Eckert, two unidentified, Irene Kovacs, Elaine McEllroy, four unidentified, Margaret McEllroy, unidentified, Dolores Salomon (née Rautter), Gary Dillon, Emma Salomon, Gerhard Salomon, and George Bosch.

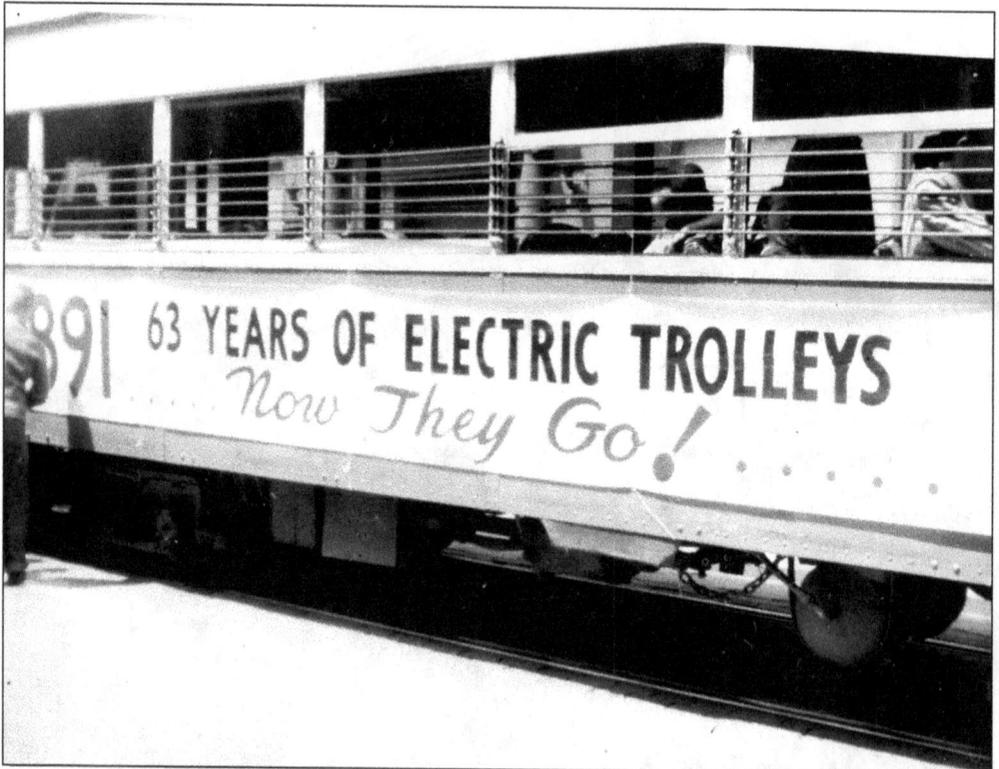

On August 7, 1954, five cars numbered 51, 56, 70, 72, and 73 were selected to provide the last ride. The sign on the side of car No. 70 tells the sad story: "63 Years of Electric Trolleys, Now They Go!"

The ceremonial last ride of the Logan Valley lines was scheduled for August 7, 1954. Five hundred special tickets for the three remaining routes were issued that day. Included here are souvenir samples of car transfer tickets, usually issued when a passenger needed to transfer from one line to another.

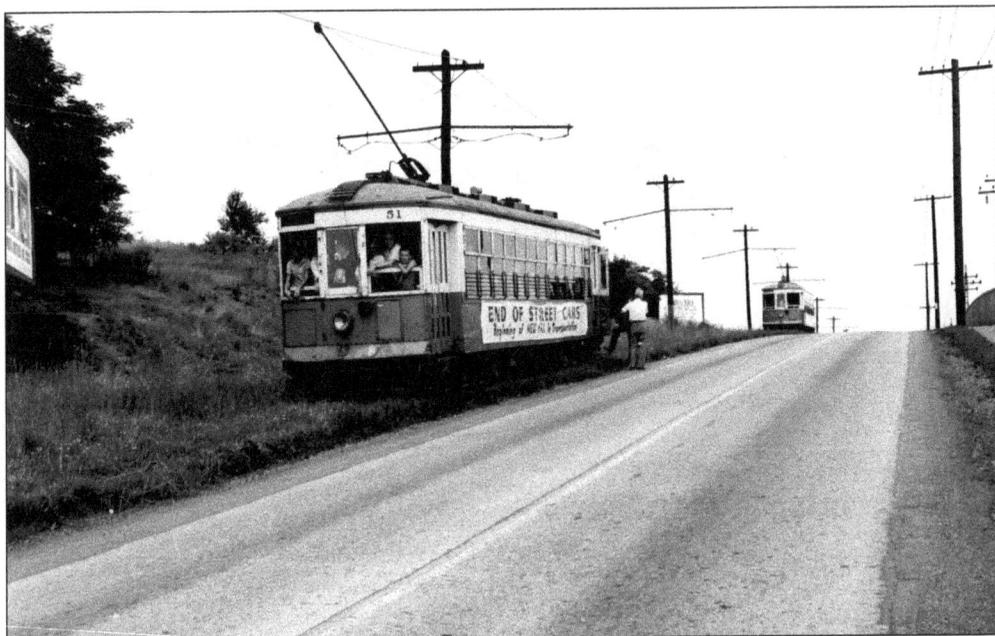

Car No. 51 had the honor of bringing up the rear of the five-car caravan. Its sign reads "End of Street Cars—Beginning a New Era in Transportation." No. 51 is seen here on Golf Hill approaching Juniata. Golf Hill is named for the former PRR Cricket Club, which, in an earlier time, was an athletic club for management officials and was replete with golf, tennis, and cricket.

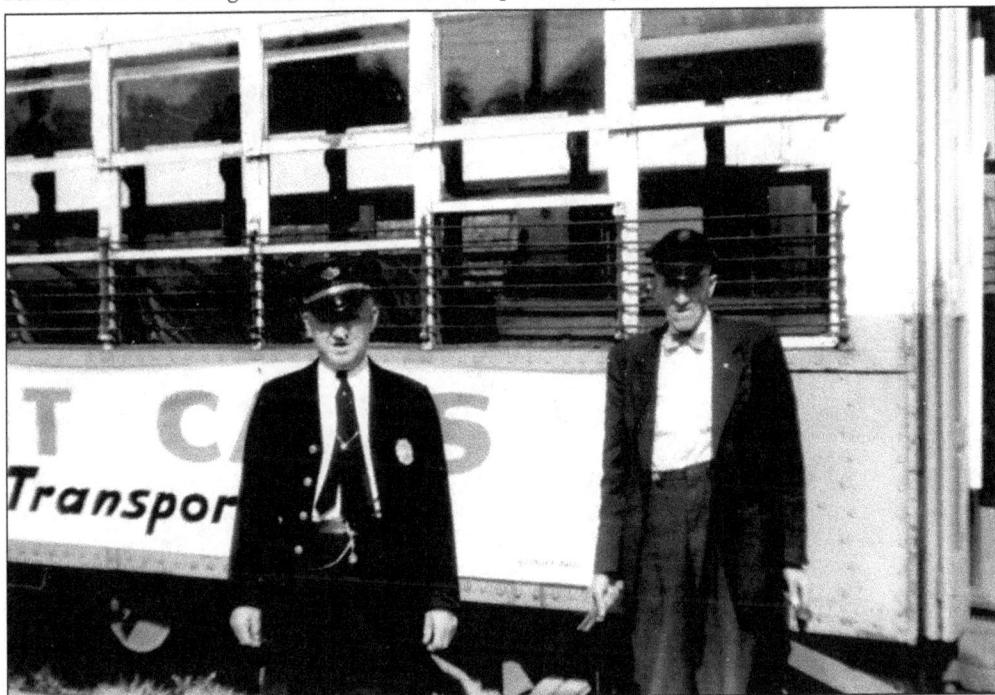

Five motormen retired on August 7, 1954, coinciding with the Logan Valley's last ride. One man was John C. Keatley (right), who had 49 years of service. The identity of the man on left is unknown.

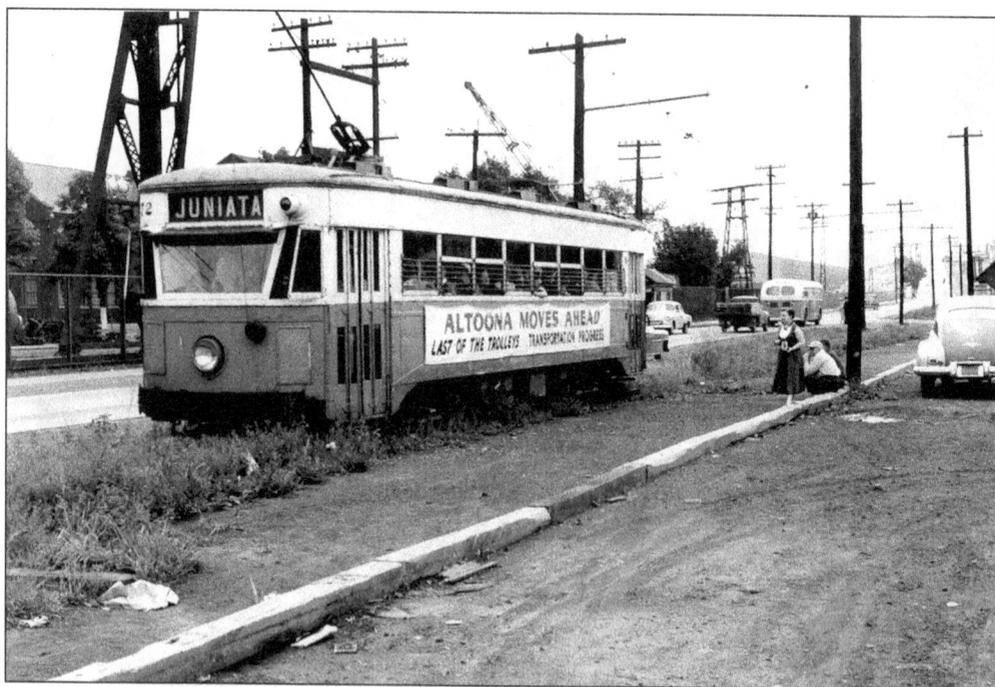

Car No. 72 waits in Juniata (opposite the PRR locomotive shops) as one of the new Logan Valley buses passes by.

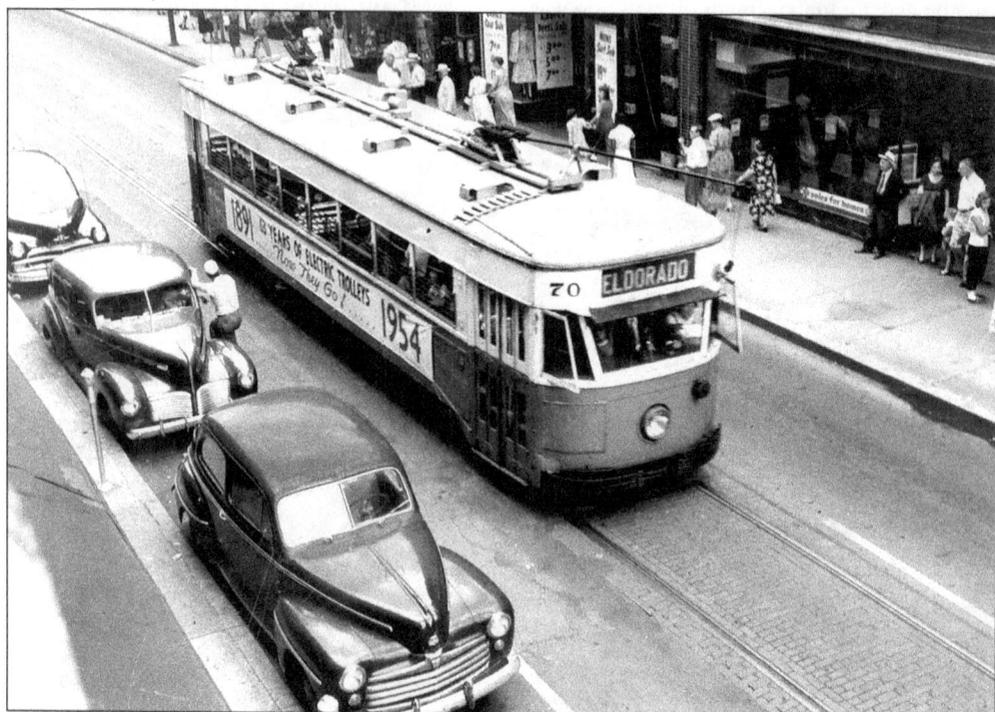

Car No. 70 travels the 1400 block of Eleventh Avenue downtown for the last time, August 7, 1954. Many of the people walking the streets and doing their shopping did not realize this was a historic day. Co-author David Seidel was among the riders as a high school student.

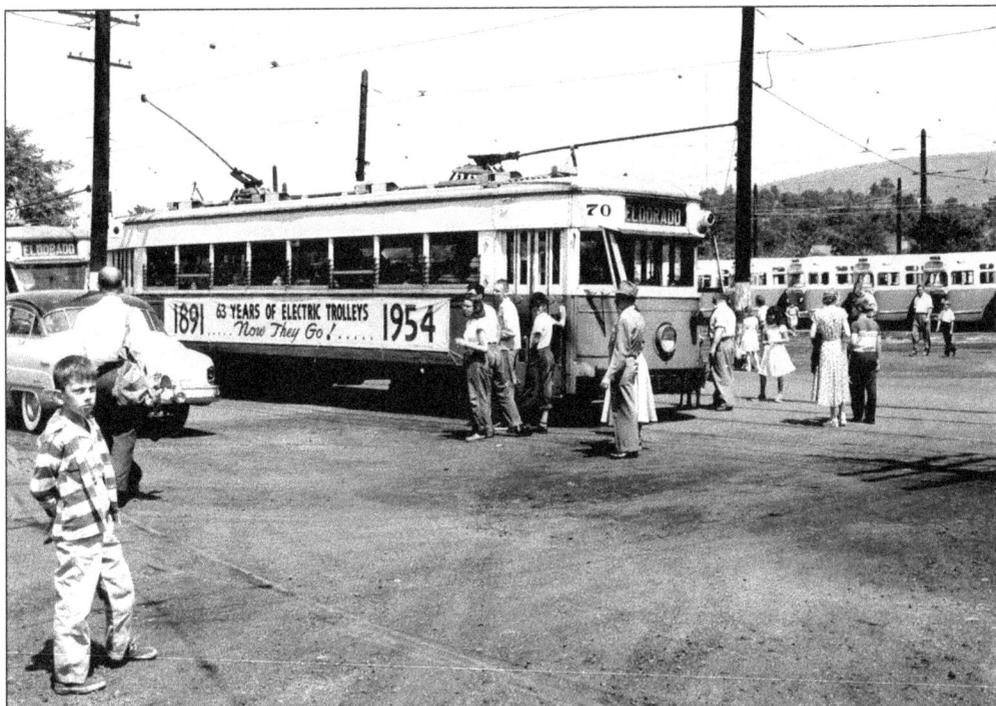

The last ride included a stop at the carbarn on the way to Eldorado to show the riders the brand new GM buses lined up in the yard area. These 10 new buses would replace all remaining streetcars. Note the 1950 Buick to the left.

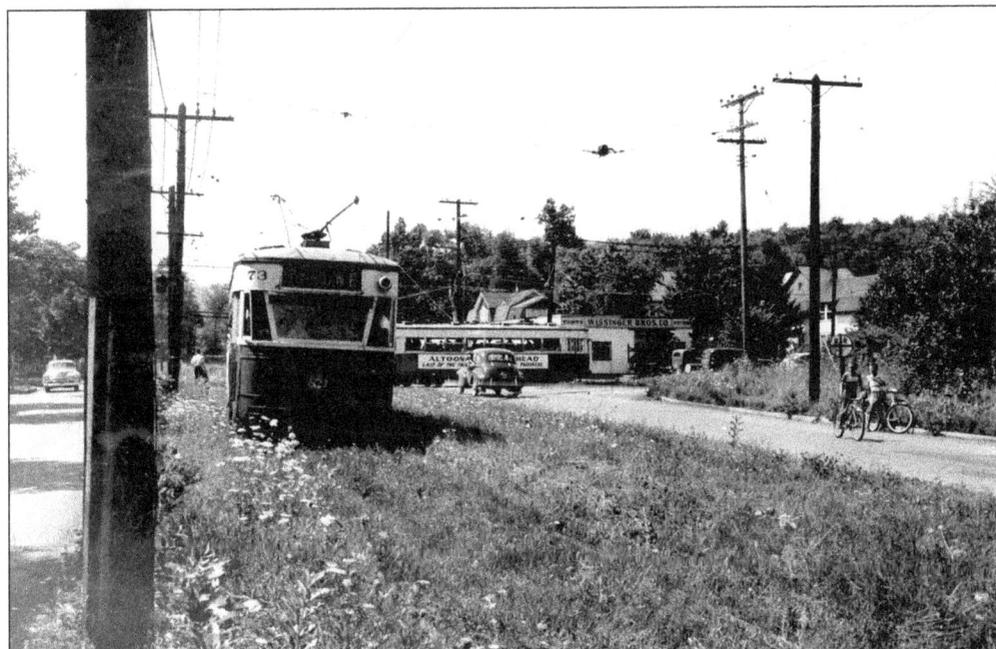

From the carbarn, the last ride cars went to Eldorado, reversed, and returned to the Eldorado and Hollidaysburg Junction to transfer to the Hollidaysburg line. This move required another reverse move through the switch to change from an east-west to a southbound direction.

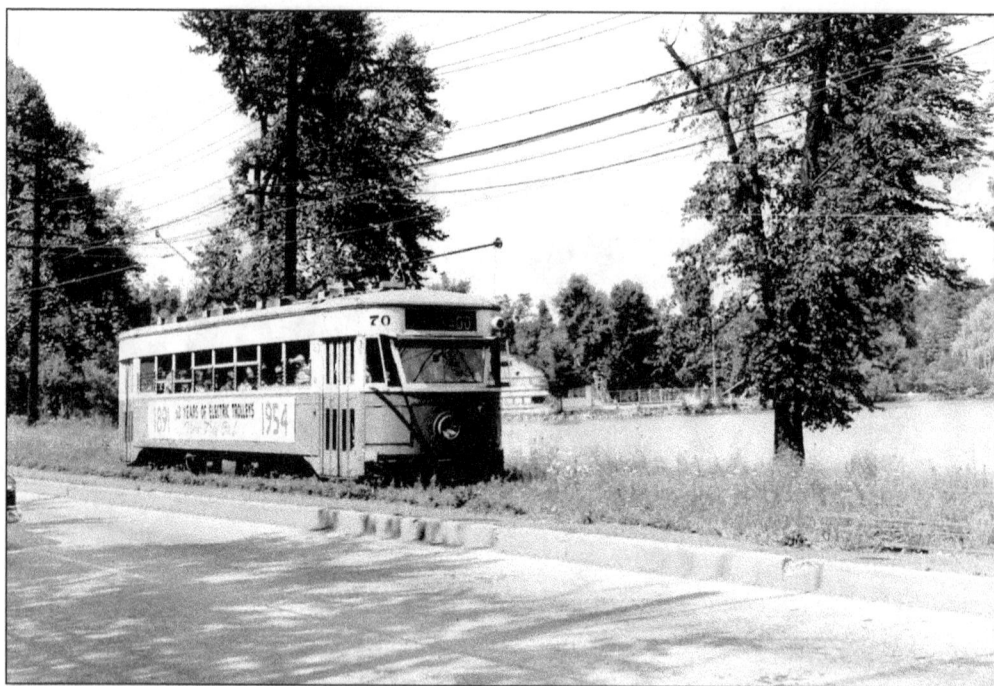

Car No. 70 passes Lakemont Park on August 7, 1954. In a short while, the reverse move by Lakemont Park would happen for the last time. It had been 18 years since Logan Valley sold the park. Logan Valley had also disposed of the electric distribution business of Home Electric Company in Tyrone. With the electric and trolley operations ended, Logan Valley would become a bus company.

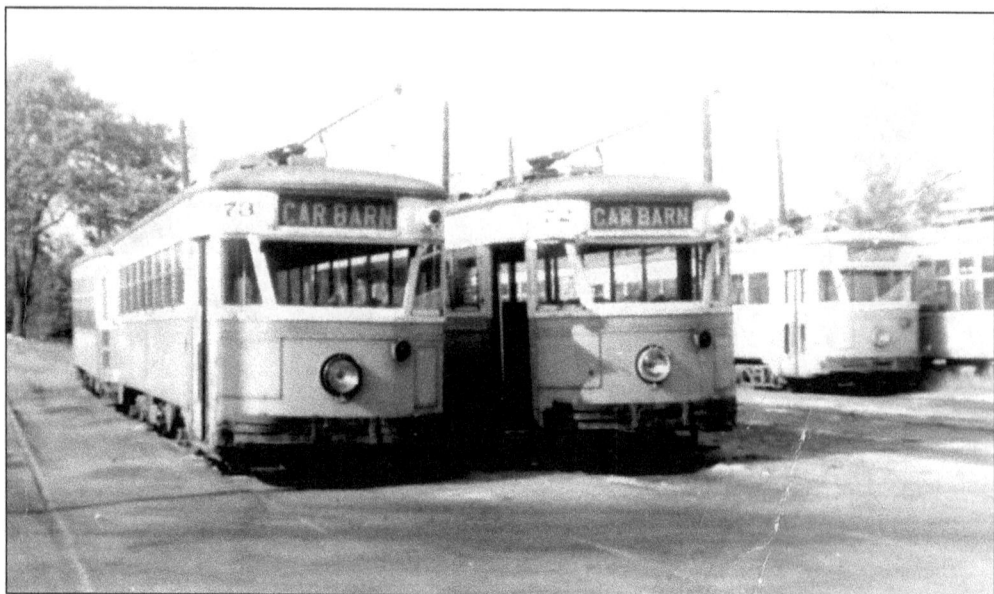

When the last ride was concluded, the streetcars returned to the carbarn to be retired. Rather than entering the barn, they remained outdoors, as the buses now claimed the bays. Many of the buildings on the north side of Fifth Avenue had been sold, and operations were consolidated into the old carbarn facility.

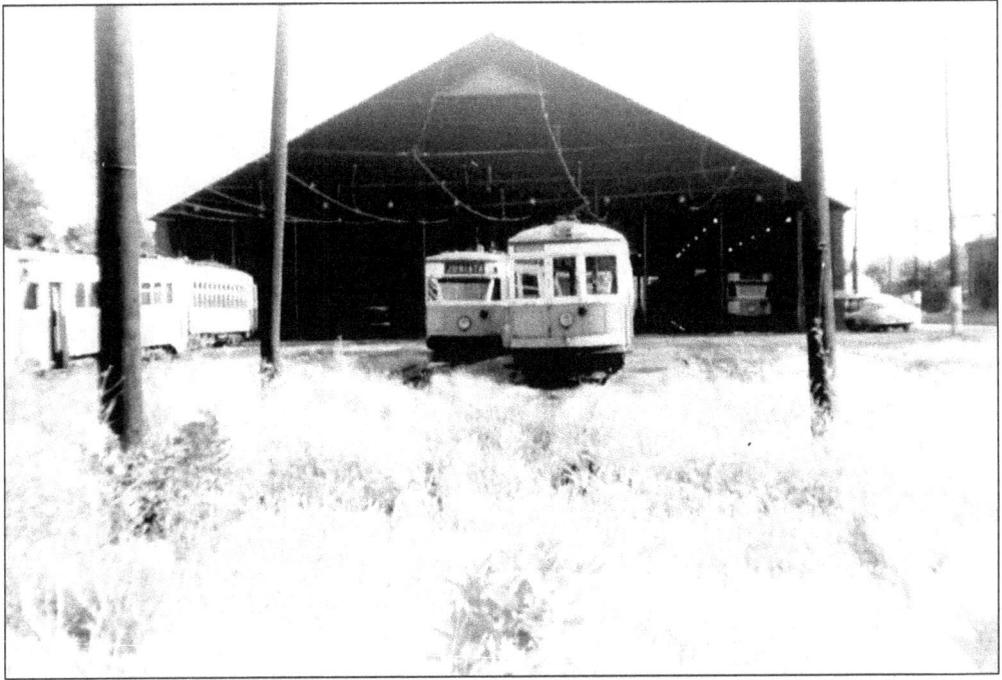

In this view, the streetcars are primarily outdoors. Weeds and grass replace visible ballasted trackage, and the end is near.

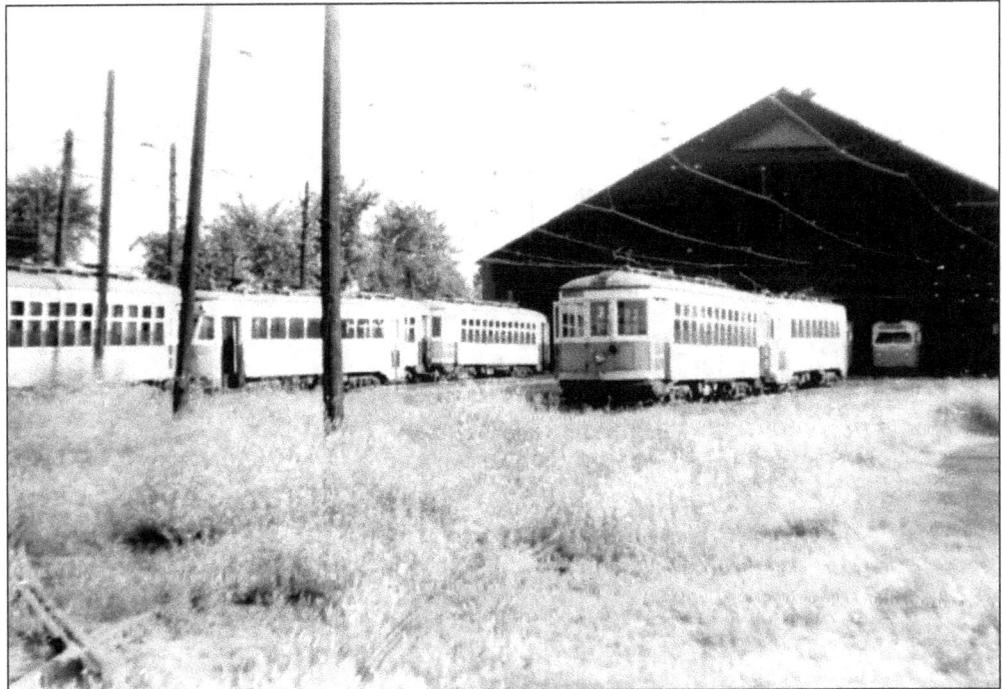

The Osgood-Bradley cars sit outdoors awaiting final disposition. Logan Valley hoped to sell the cars, but, in 1954, not many traction companies were still in operation nor was there a market for 25- to 30-year-old equipment.

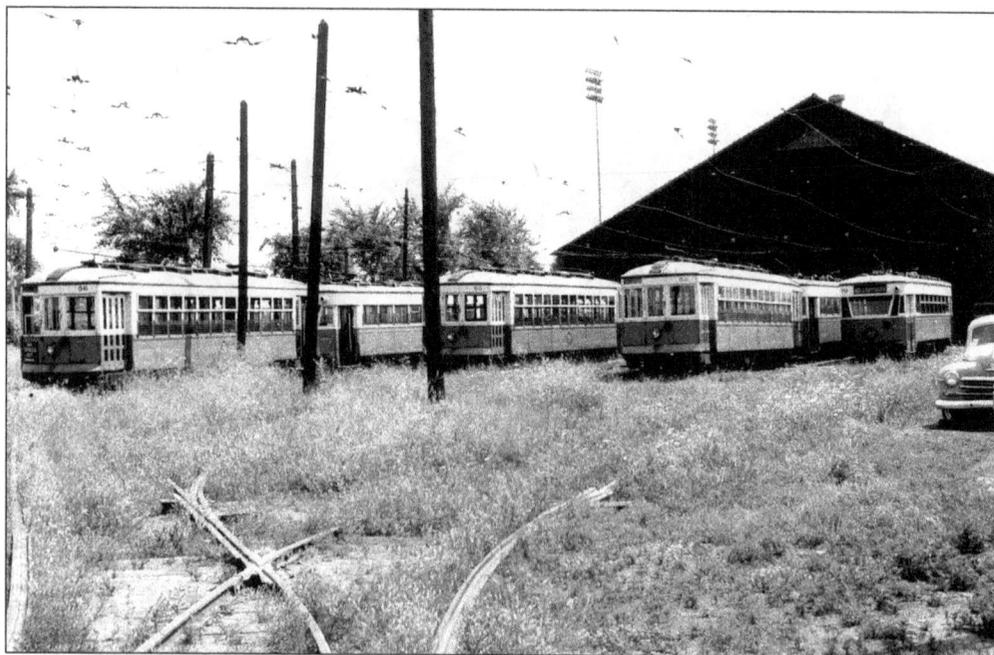

For six months in 1954, the trolley cars sat on the carbarn leads. There were no offers to purchase any of the cars for preservation purposes. Logan Valley was in need of money, and the cars, wire, and rails were valuable as scrap. So, by January 1955, their fate was sealed. A 1947 Plymouth can be seen on the right.

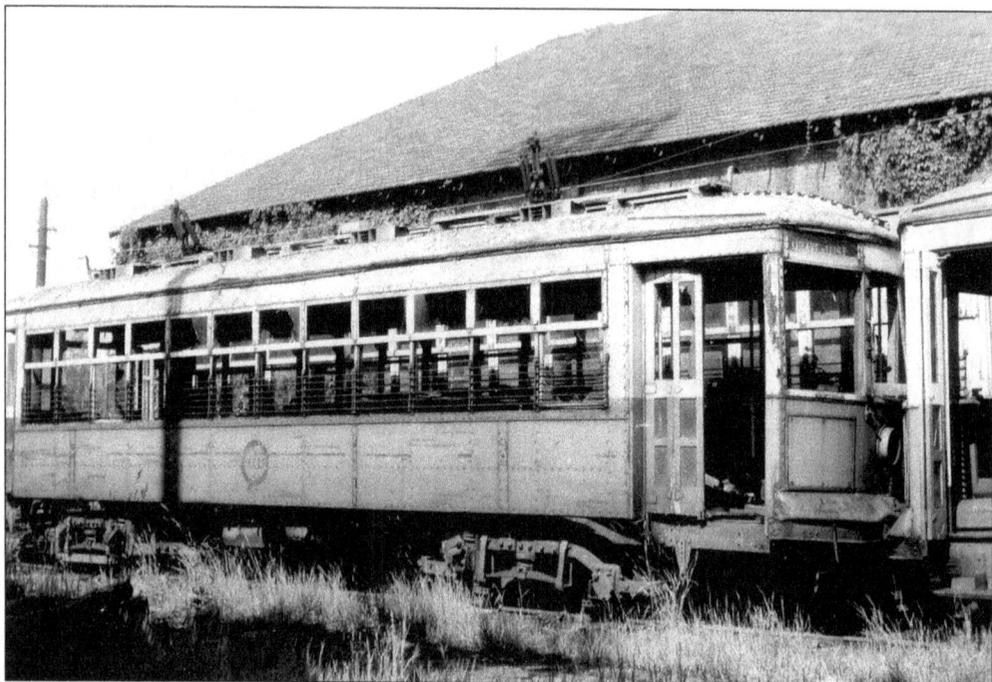

Workmen began stripping the cars in 1955. Shown here is car No. 61 with the poles and other items of value stripped away. The car also sits temporarily on truck wheel sets from another model, a 140-series Brill.

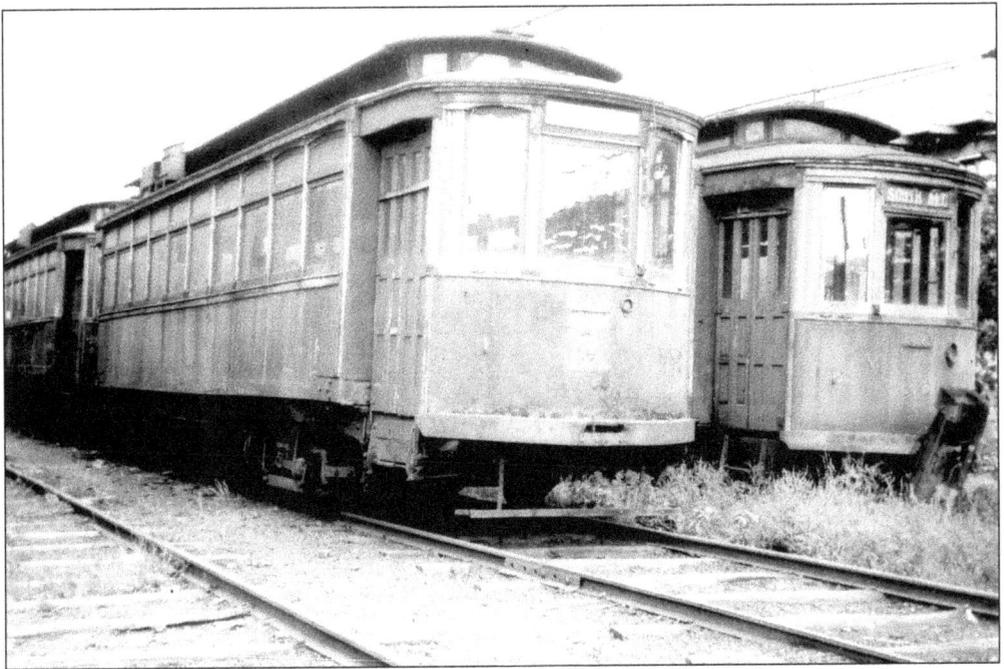

Cars No. 155 and No. 158 sit on the yard tracks near the barn, awaiting the scrappers, already stripped of headlights and other appliances.

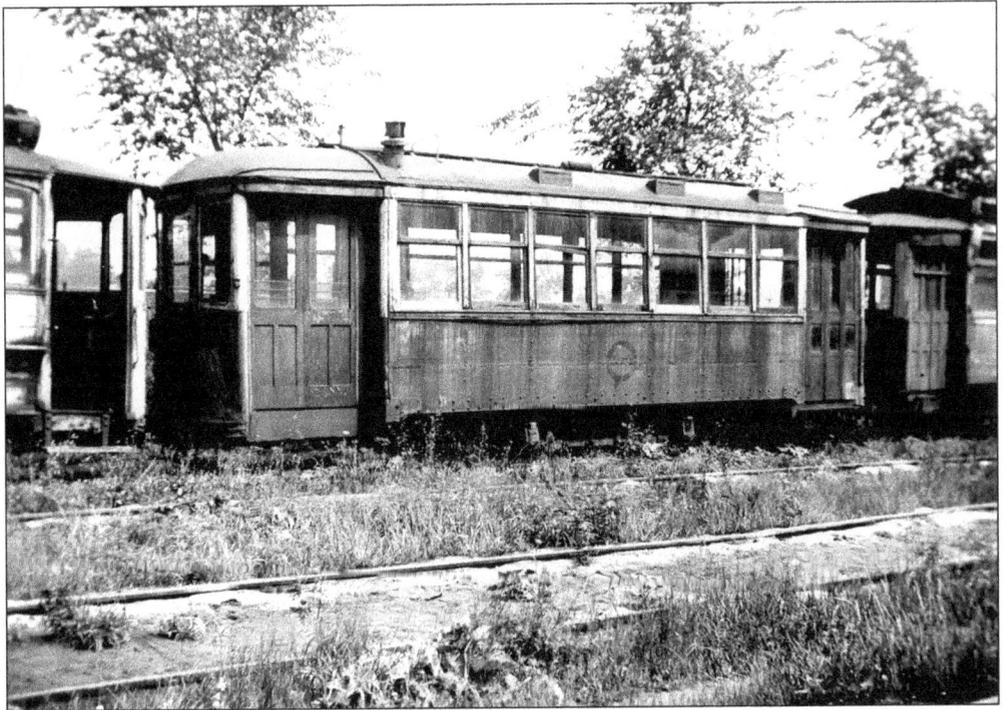

Car No. 139, a 1911 Cincinnati single-truck car, has lost its poles and awaits the scrappers. The same fate awaits all such rolling stock on Logan Valley property.

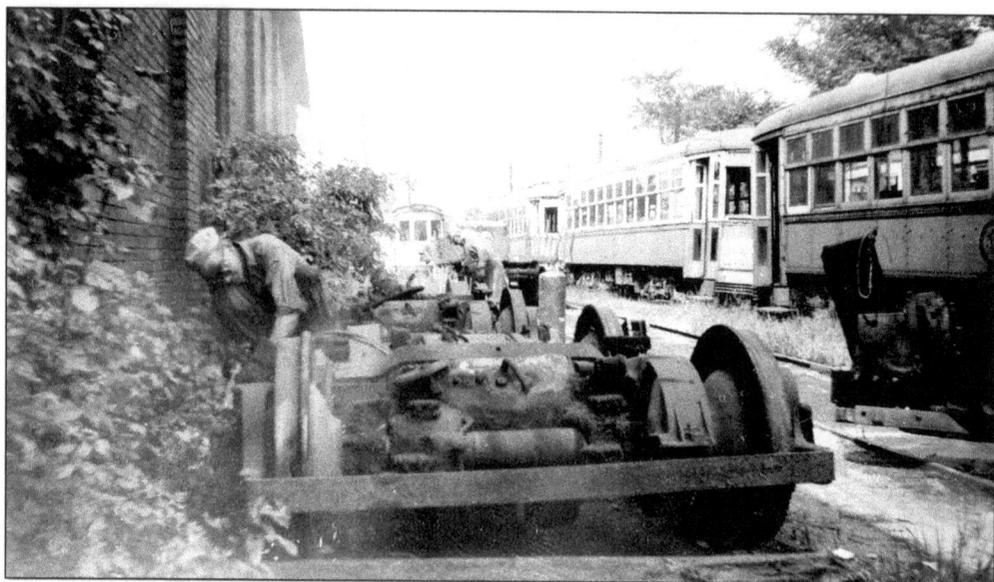

The workmen find a warm day in early 1955 to work outdoors, scrapping the trolley cars. In the rear is a 140-series car and to the right are cars No. 33 and No. 35 and the tip of snowplow No. 503. All met the scrapper's torch.

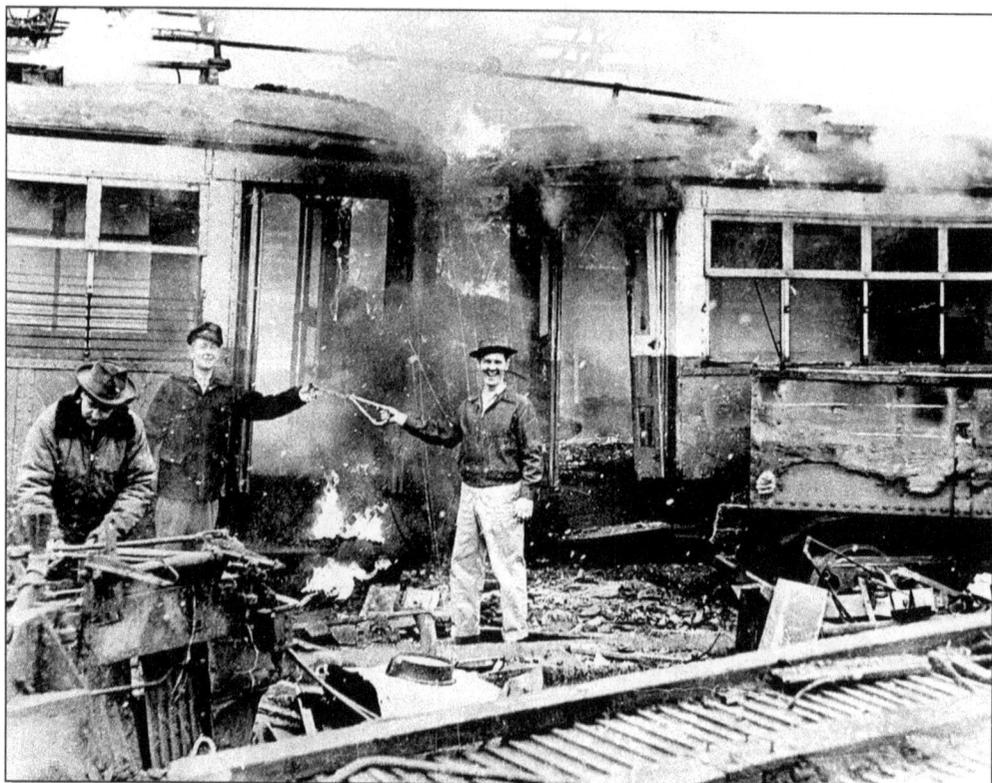

The final end was the fire. After most valuable items were removed, the car bodies were burned on the carbarn property. The remaining steel was then cut up for scrap. Every Logan Valley car met this end, and they were all gone by mid-1955. The identity of the workmen is unknown.

Eight

THE LOGAN VALLEY BUS COMPANY

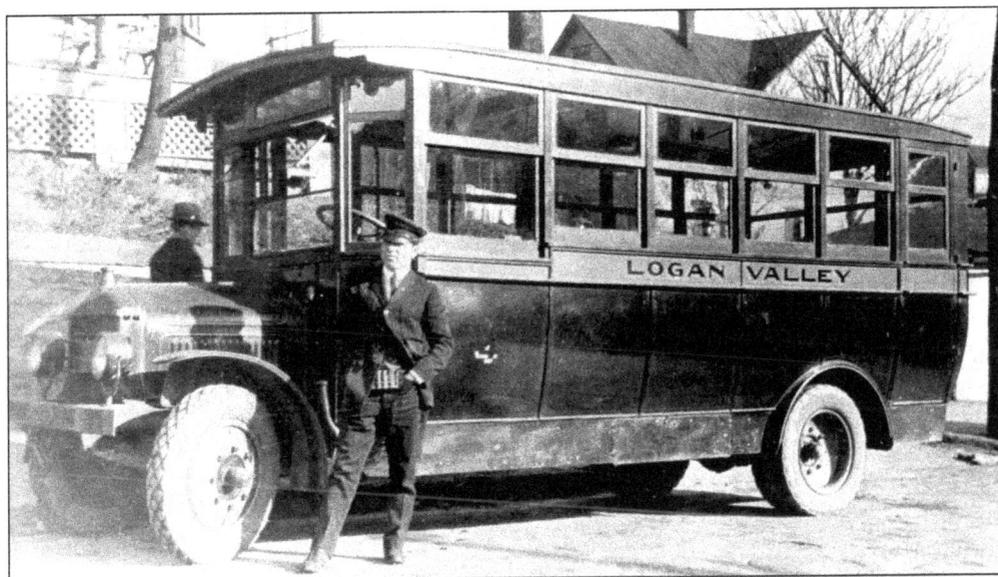

In 1923, Logan Valley started a subsidiary bus company to establish routes that would bring people to the trolley lines. It was cheaper than extending the rails and overhead wire. Service began on July 9, 1923, with 1923 Garford buses, represented by bus No. 4 here with Herman Darr, who was the first bus driver hired.

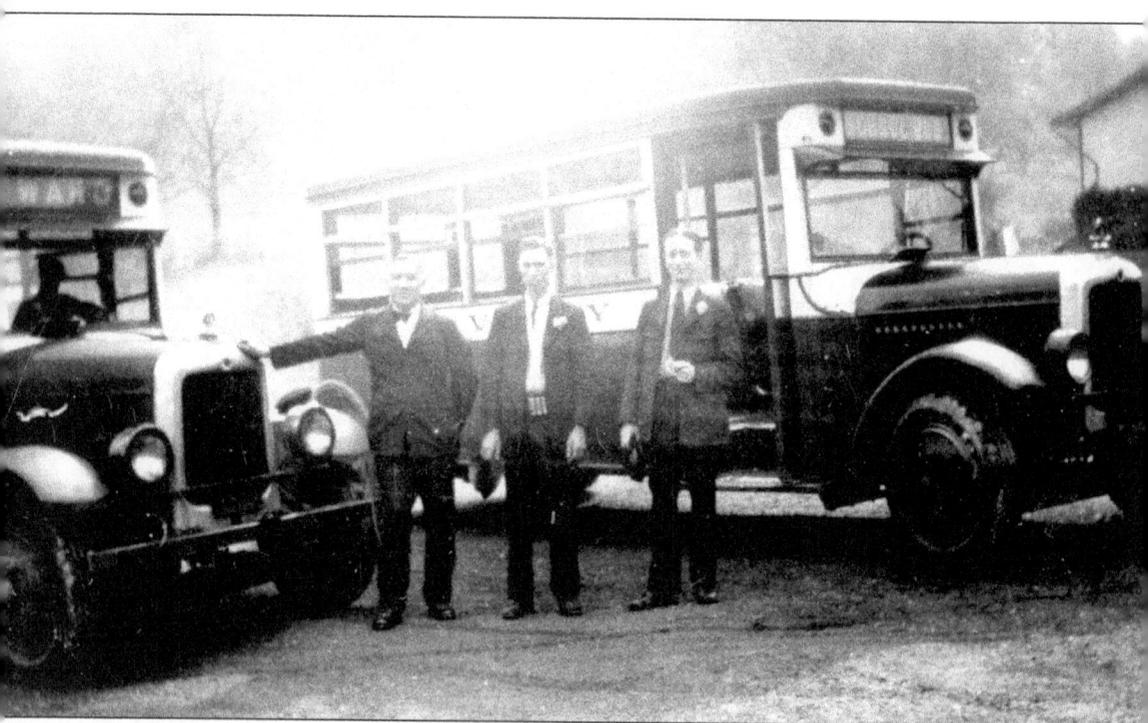

In 1926, Logan Valley purchased several Yellow Coach buses to add to the fleet. These were used to open up additional routes: Pleasant Valley, Greenwood, and Juniata Gap. Two of these buses are shown here with drivers Ed Green, Walter Wilson, and Ken McNelis, servicing the Juniata Gap line.

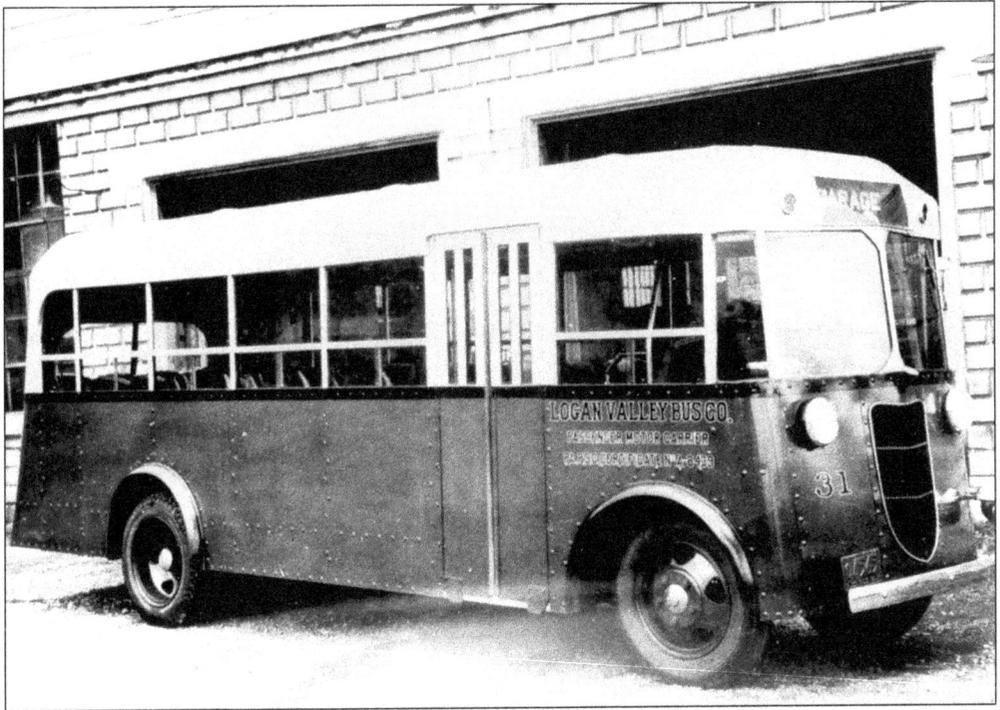

In 1934, Logan Valley was coming out of receivership and began to purchase small buses from Beaver Bus Company of New Brighton, Pennsylvania. These buses were built by hand on a Ford delivery truck chassis. The first one received was bus No. 31, seen here sitting in front of the new bus garage built in 1926. Prior to that, buses were kept inside the paint shop of the trolley complex.

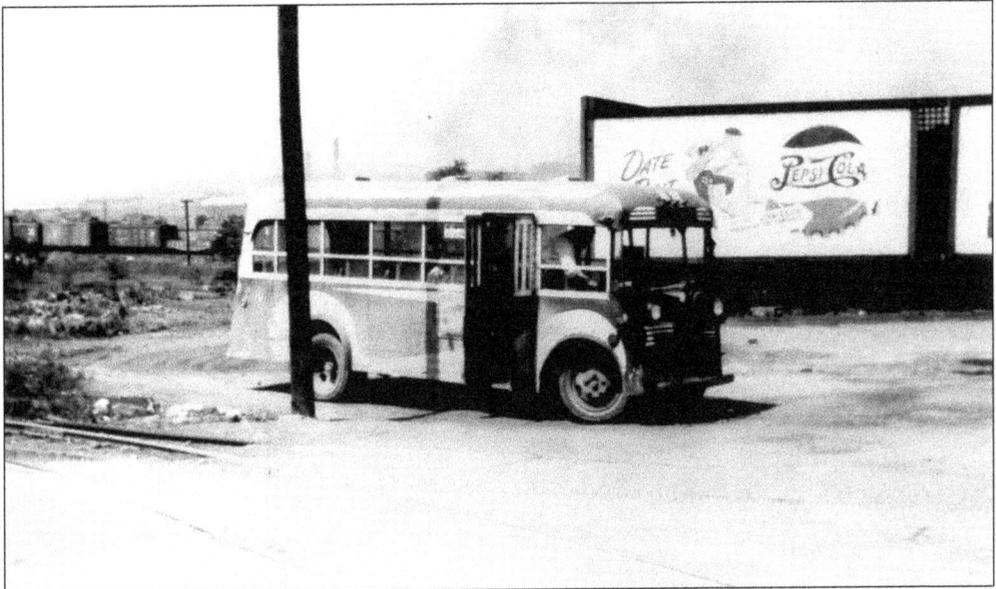

Another small Beaver bus is No. 36, purchased in 1936. On June 1, 1948, it waits at the end of Red Bridge in Juniata for the Juniata Shop shuttle trolley to cross the bridge. The PRR smoke hangs heavy in the background behind the vintage Pepsi sign.

The last of the small Beaver buses arrived on Logan Valley property in 1936. A Beaver model 101, it became bus No. 41 and sits at the gas refueling station located near the front of the new bus garage.

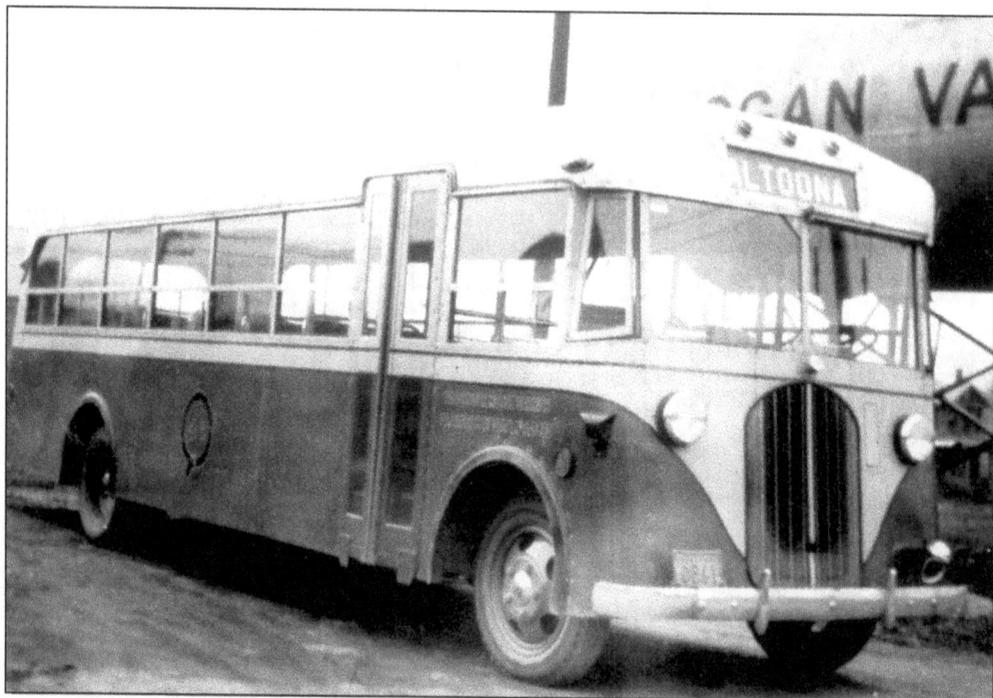

Also delivered in 1936 were several larger Beaver buses, model 102, designed to carry more passengers. They still had Ford engines but possessed a larger chassis. Bus No. 43 sits at the gas pumps along Sixth Avenue.

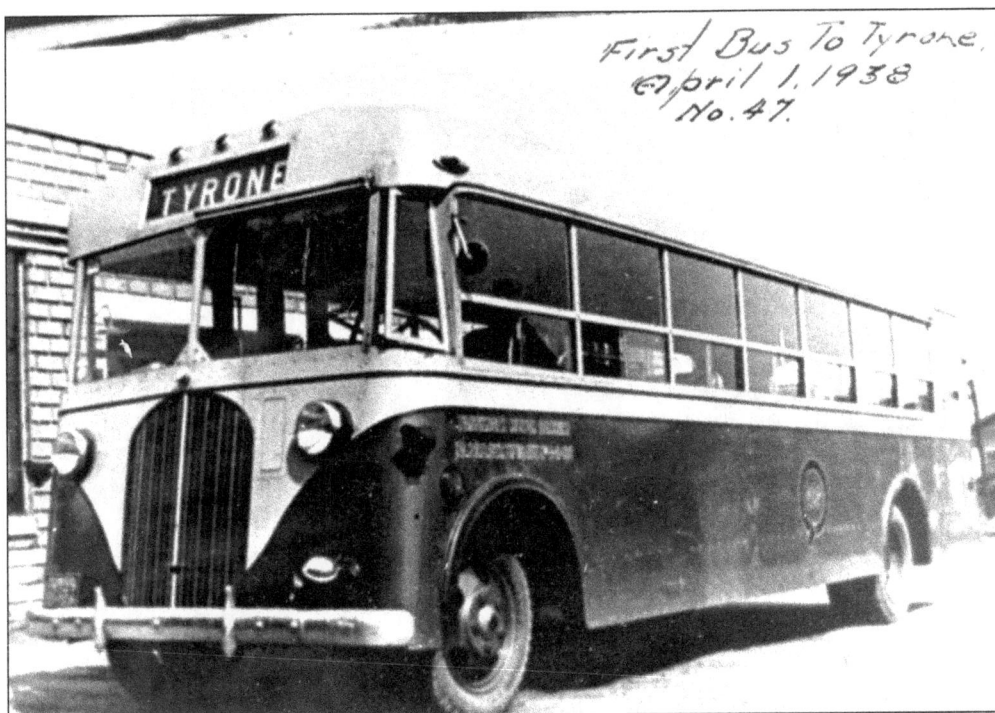

First Bus To Tyrone. April 1, 1938 No. 47.

The first trolley route taken over by buses was the Tyrone route. Spring floods washed out some of the trolley line, so buses replaced the trolleys on April 1, 1938. The first bus to Tyrone was No. 47, a Beaver bus purchased in July 1937.

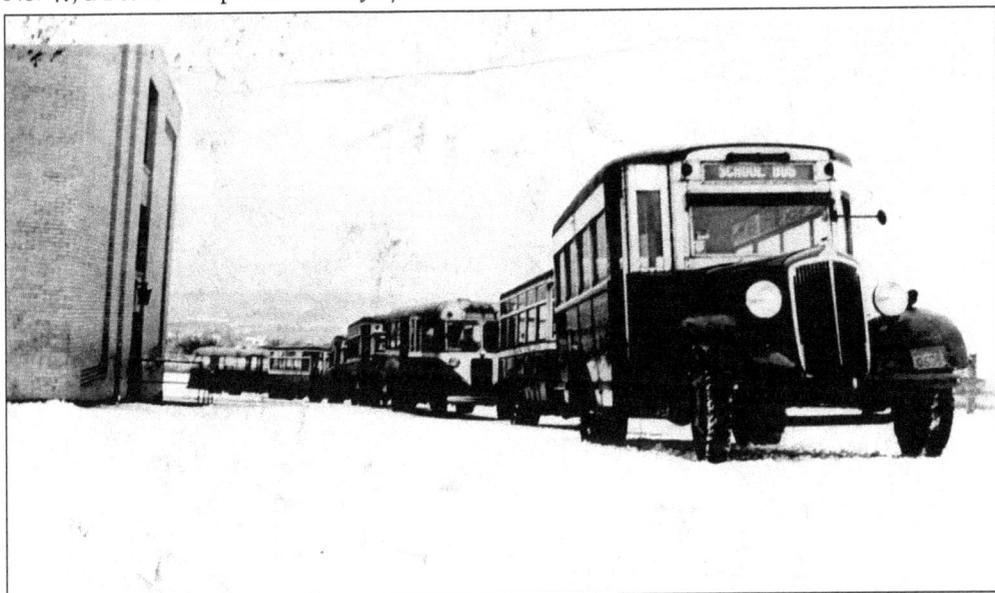

During World War II, Logan Valley found it could generate extra revenue by using their off-duty buses to transport school students during the daytime. This was done after transporting workers to the PRR and before the workers needed to return home. Here No. 30, a 1934 Reo-Fritz-John, leads four American Car and Foundry Company (ACF) and two Beavers waiting for kids at Edison School in Eldorado.

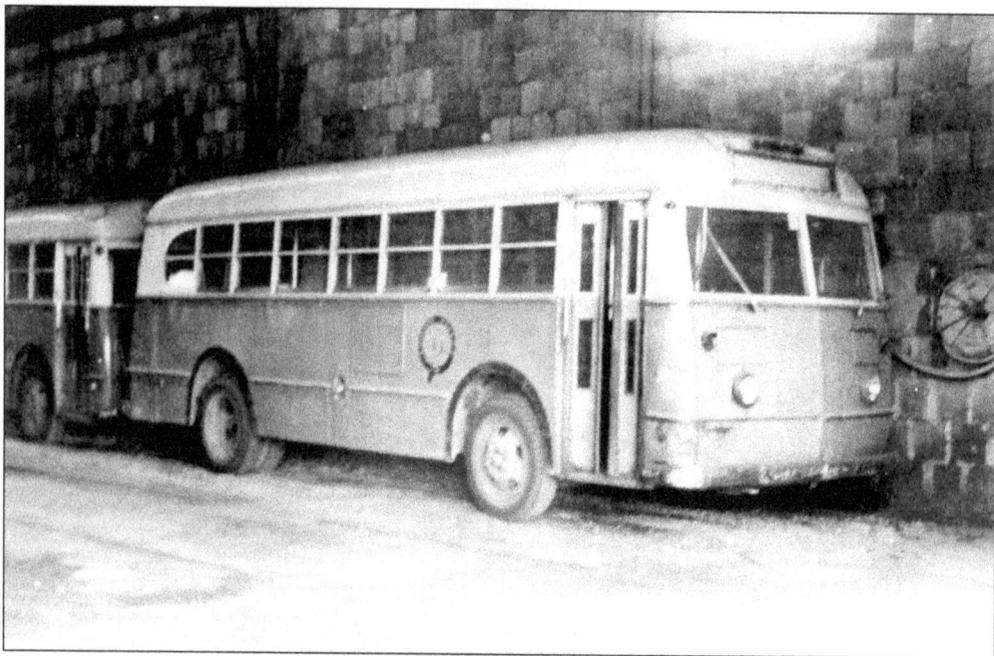

During the war years, Logan Valley was able to purchase new buses due to the need to transport workers to the PRR, a defense industry. From 1940 to 1944, fifteen new Ford Transit 09B buses were purchased. Bus No. 51, shown inside the old carbarn in August 1955, represents this type of bus.

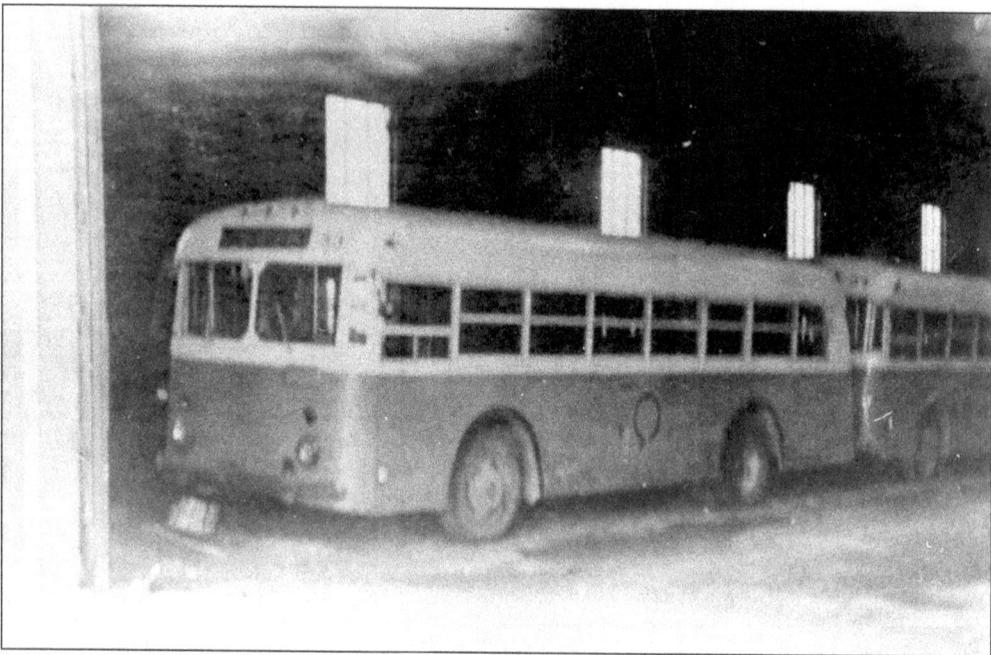

Three Beaver model 25 PT buses with Dodge engines were also purchased during the war years. They became numbers 52 through 54, and No. 53 sits inside the carbarn in this photograph. After the trolleys were discontinued, the buses were placed inside the carbarn and the bus garage was sold.

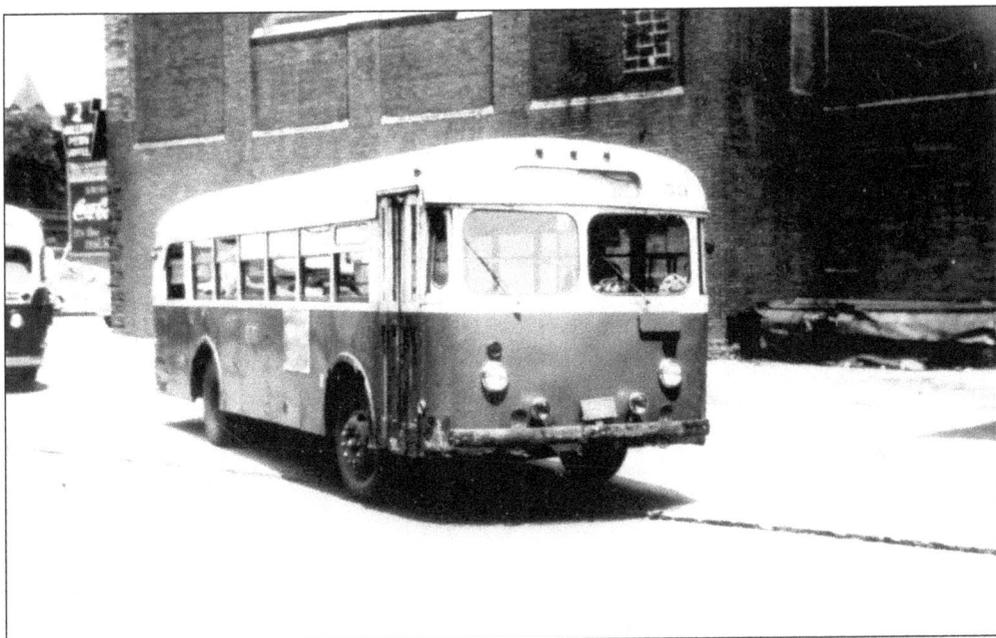

The two largest buses purchased during the war years were Beaver model 31 PT, which had international engines. They held numbers 59 and 60, and No. 59 is seen here at the bus terminal downtown at Eleventh Street and Twelfth Avenue.

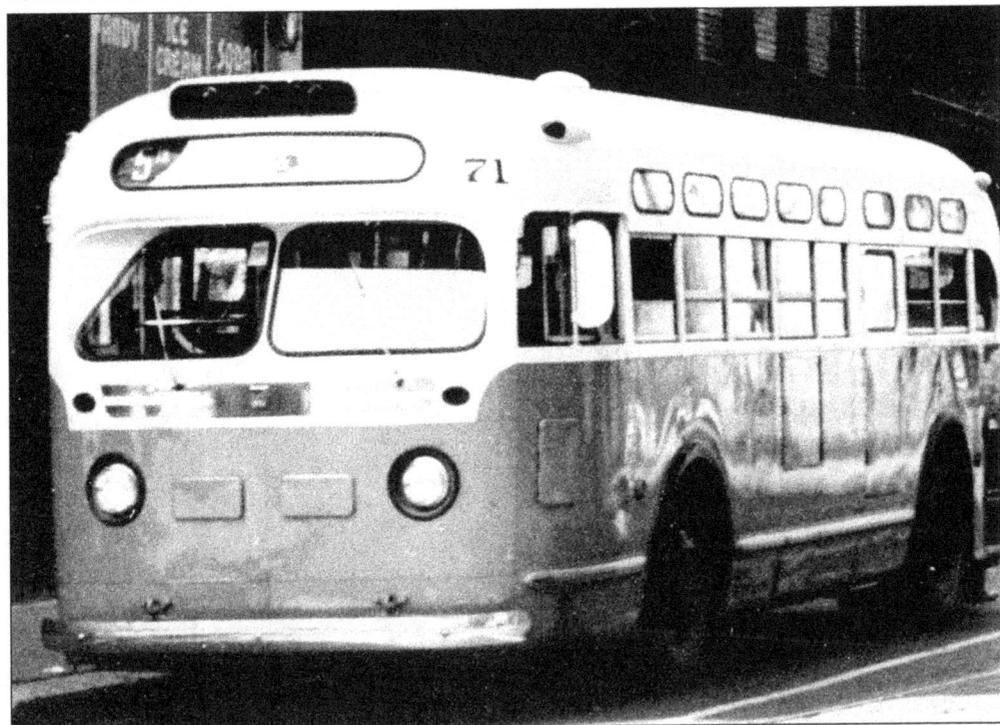

In 1947, Logan Valley began to purchase GM transit buses with diesel power. These buses had an exit door and were obtained with the thought of replacing the trolleys. The first was bus No. 71, a GM 3207 shown here at the downtown terminal, signed for 5th Ward and 18th Street.

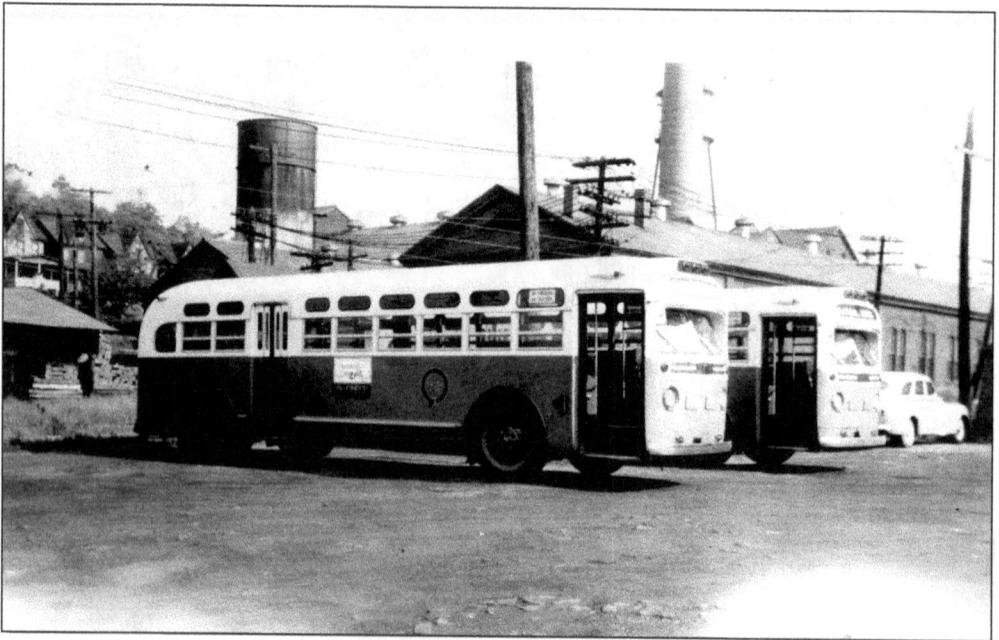

Also arriving in 1947 were buses No. 72 and No. 73, GM 3610s that were a window longer and carried more passengers. They sit behind the carbarn along Fifth Avenue in this scene. Ironically, the postwar years for the PRR was a major decline in employment, hence less riders for the Logan Valley, as steam technology faded and diesels arrived on the railroad. The diesel locomotive required less maintenance and thousands of workers were displaced from their jobs on the railroad.

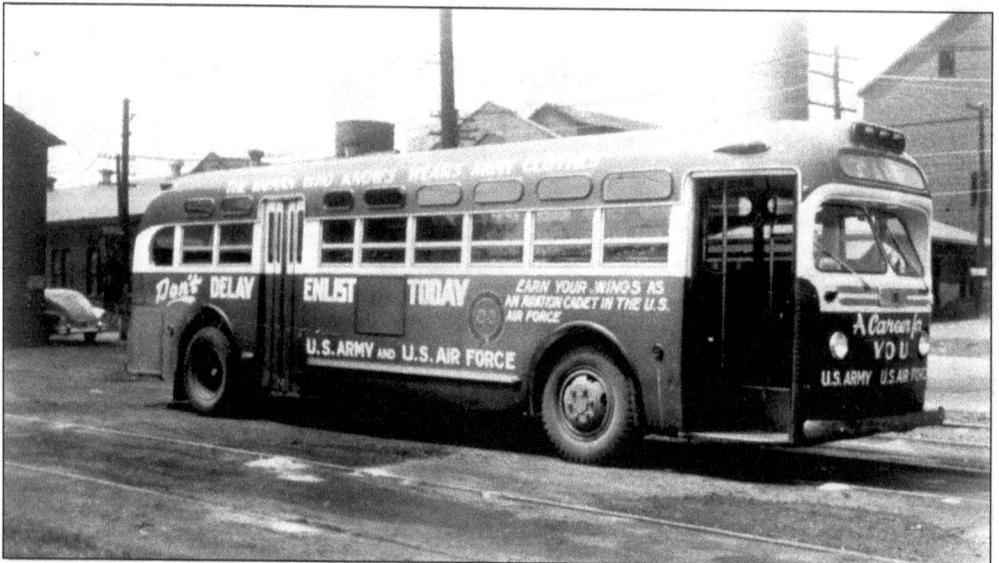

In 1948, fifteen additional GM 3610s arrived to replace older buses. By this time, buses were running the routes at night. Bus No. 83 from this group received a special paint job to help promote enlisting in the armed forces.

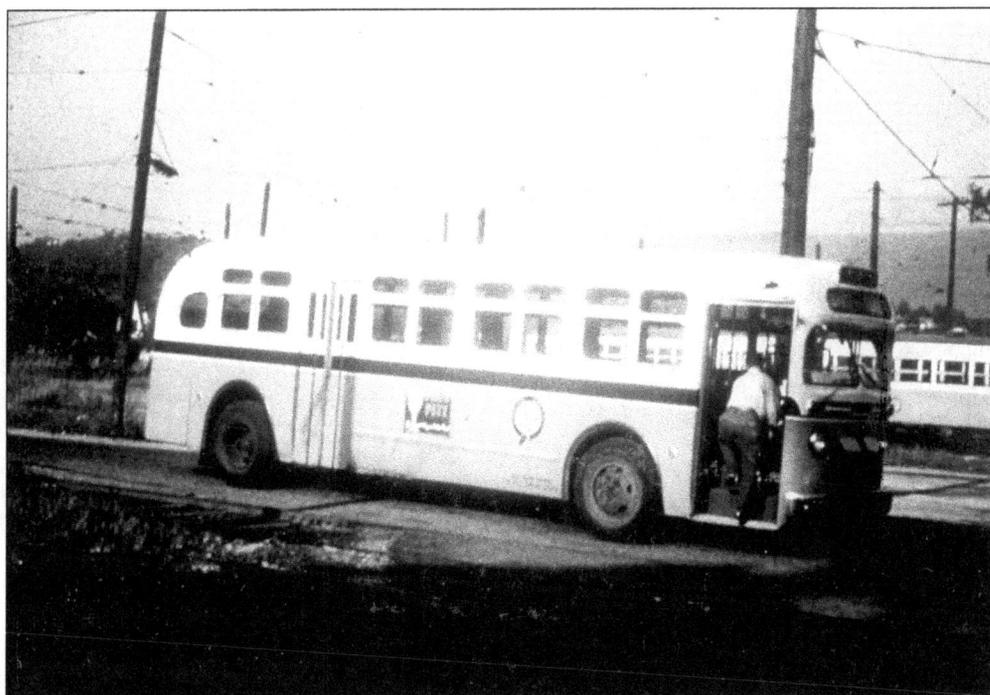

Thirteen more GM 3612 buses arrived from 1949 to 1951 to replace older buses and trolleys. For a while, the buses had a special paint scheme for Altoona's centennial celebration and featured a black stripe separating the ivory and orange paint line as shown on bus No. 99.

Ten additional GM 3714 buses arrived in 1954 when all remaining trolleys were retired. No. 102, seen here in Juniata, prepares to reverse direction to Eldorado via downtown. The PRR shops and yards are in the background.

Bus No. 106 services the Juniata-Eldorado route. It is shown at the Logan Valley office on Fifth Avenue near the carbarn, one of the stops on this route. Bus No. 106 operated until 1984, having the distinction of being the last Logan Valley bus to be retired.

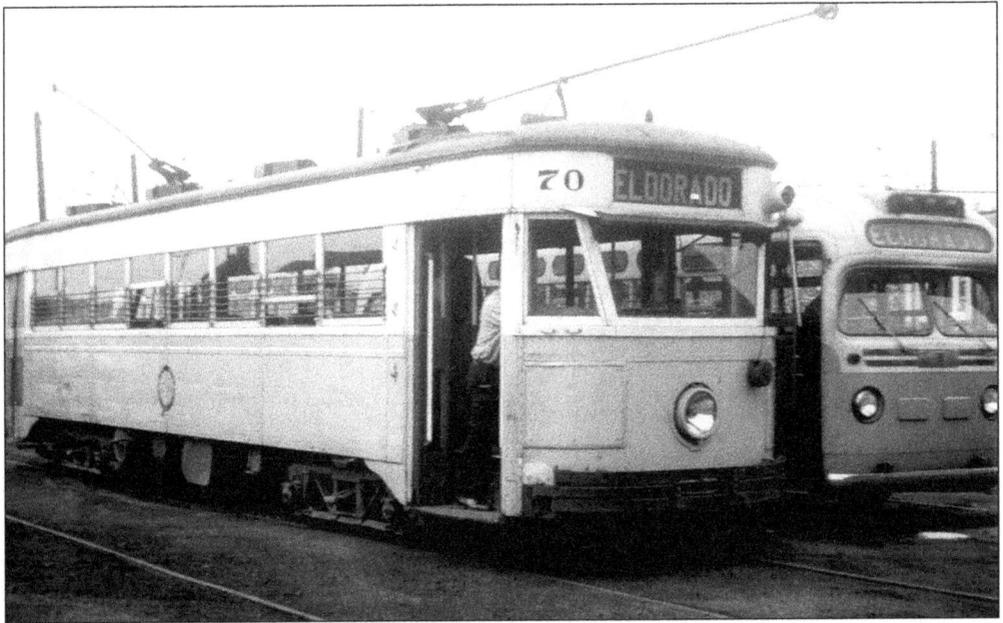

Osgood-Bradley car No. 70 and a GM bus share the Eldorado route. The buses ran at night and the trolleys in the daytime. This photograph, taken at the carbarn at dusk, depicts the changing of the guard.

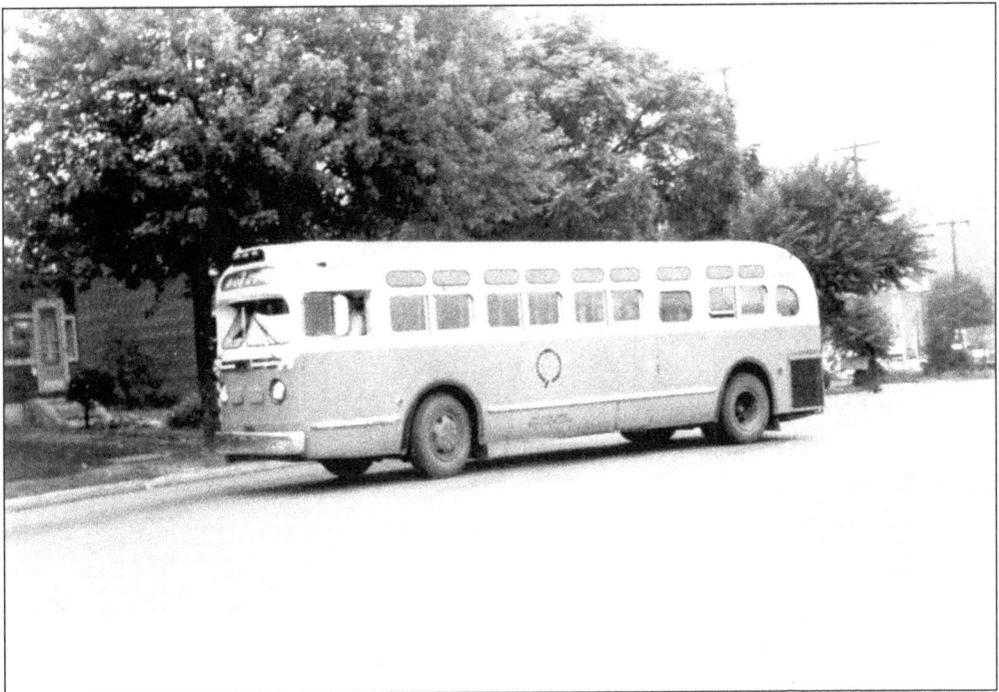

Logan Valley used only the GM buses after August 7, 1954. Here, bus No. 107 is leaving Hollidaysburg bound for Altoona in August 1959. Less than two months later, Logan Valley would be out of business.

After the trolleys were retired, Logan Valley rebuilt the carbarn into a bus garage and consolidated all operations into this one building. The front of the carbarn is closed in, except for a few doorways for the buses. Also gone are all tracks and overhead wire, but the Altoona and Logan Valley Electric Railway sign still hangs on the eave of the building.

Two doorways were cut into the back of the carbarn during the rebuild for bus entrances. This made the carbarn a drive-through building. No other traces of the electric railway system remain. Tracks and overhead wires have been removed and all trolley equipment has been scrapped.

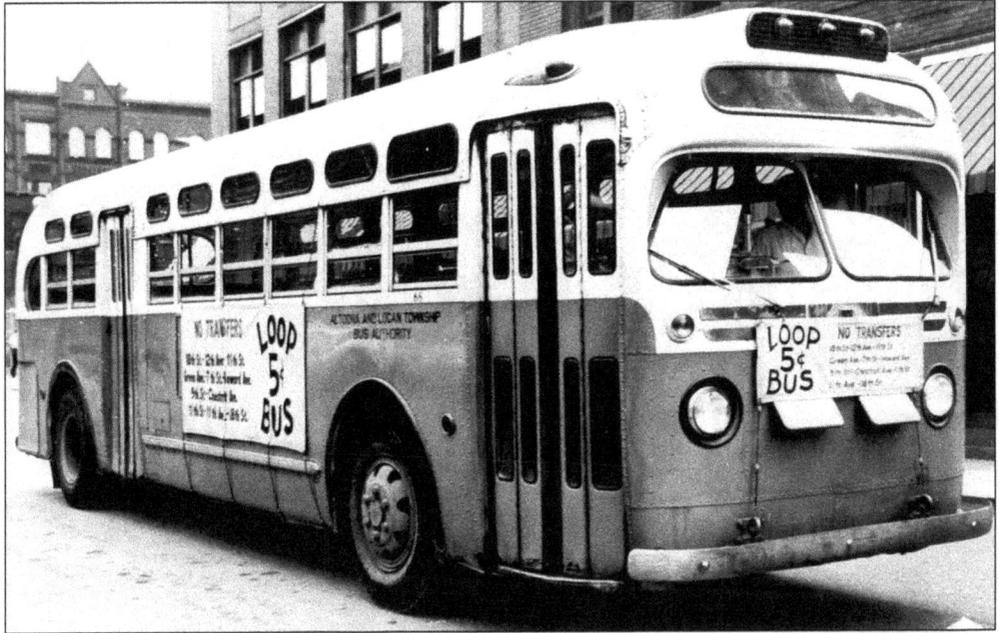

On November 1, 1959, Logan Valley went out of business and the very first bus authority in Pennsylvania was created. Named the Transportation and Motor Buses for Public Use Authority, it continued Logan Valley's operations. All buses had Logan Valley logos painted out and black lettering added over the front wheels, stating "Altoona and Logan Township Bus Authority." The Hollidaysburg and Tyrone routes were eliminated. Bus No. 88, shown here in downtown Altoona, exhibits the changes.

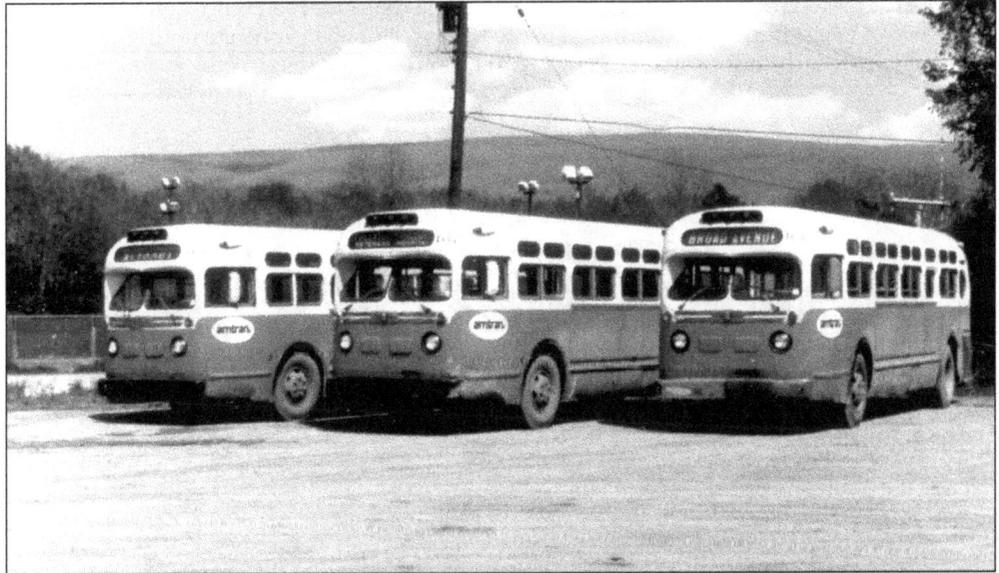

The old Logan Valley buses remained on city streets for many years in Logan Valley's ivory and orange colors. Almost half of the 41 GM buses were retired in 1968 when the bus authority purchased 17 new buses. The remaining GM buses continued until 1978 when the operating name was changed to Amtran (Altoona Metro Transit). Any remaining Logan Valley buses displayed the new Amtran decal, as shown here.

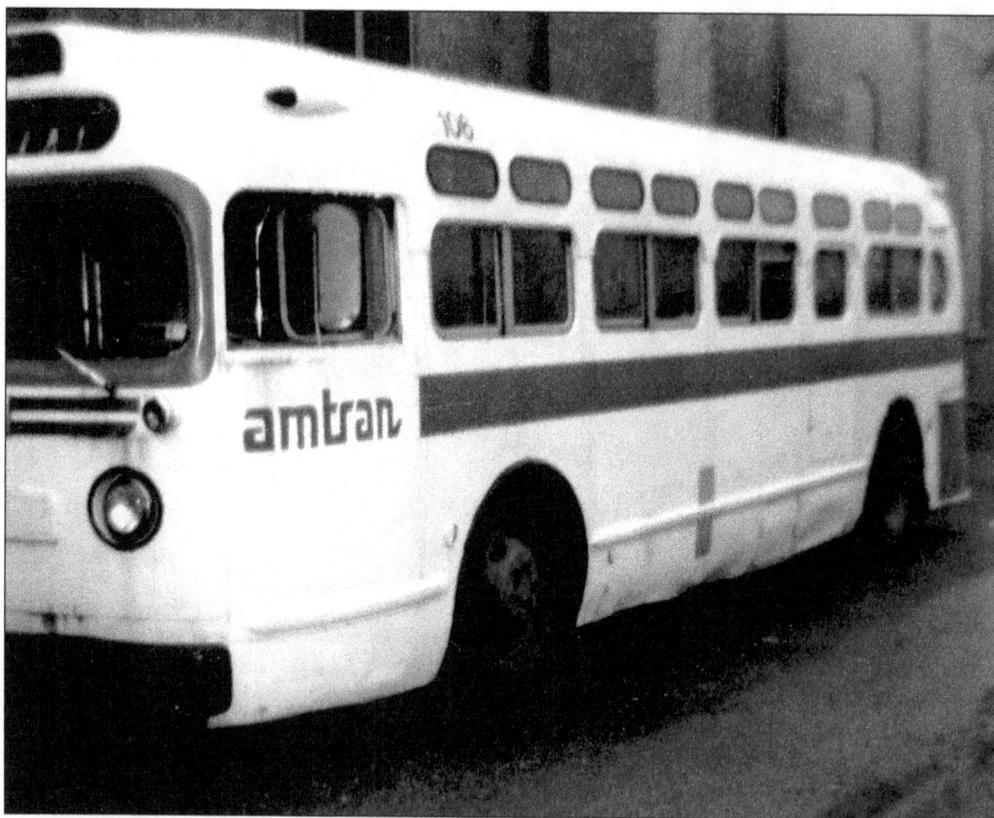

By 1980, only one Logan Valley bus was still operating. Bus No. 106 even received new paint (white with a green stripe and lettering). This 1954 bus continued to operate until 1983 when it was finally retired, the last remnant of Logan Valley in revenue service.

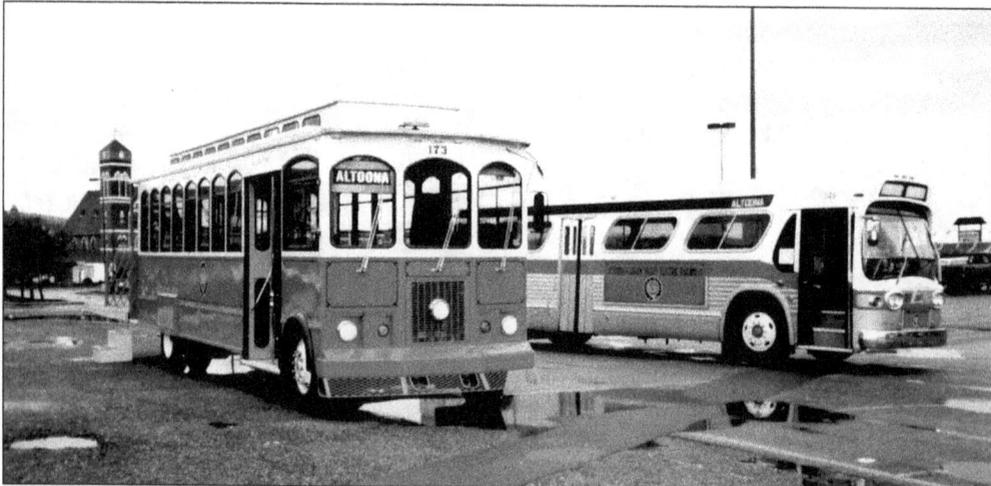

Amtran, as a tribute to Logan Valley's upcoming 100th anniversary of trolley service, placed two buses in service in 1990, painted in Logan Valley's colors of ivory and orange and lettered "Altoona and Logan Valley Electric Railway." Bus No. 149 (right) is a 1975 GM T6H 4523. It ran until its retirement in June 2001. Bus No. 173 (left) was a 1990 Spartan trolley bus that displayed Logan Valley colors until March 2003, when it was repainted green and white for Amtran.

Nine

PRESERVED MEMORIES

In 1991, on the 100th anniversary of Altoona's trolley system, the Horseshoe Curve Chapter of the National Railway Historical Society produced a video history of the Altoona streetcars. Shown here is the chapter committee presenting a copy to Amtran manager Phil Fry. From left to right are Dick Heiler, David W. Seidel, Phil Fry, and Leonard E. Alwine. The 1924 employee photograph hangs on the wall of Amtran's office in the background.

The 1902 carbarn sign is also preserved at Amtran's bus garage. This building is the former carbarn, modified from a peak-roof to a flat-roof format. The triangle previously adorned the peak-style roof.

The old trolley station at Lakemont Park was removed to make way for the Pennsylvania route 36 expansion project in the late 1950s. For almost 45 years, it lay behind the Leap-the-Dips roller coaster. This station was restored in the late 1990s to become the 18th hole at the Lakemont Park miniature golf attraction.

124

Logan Valley service truck No. 18, a 1946 Walter SnowFighter, was also purchased by the bus authority in 1959 and was relettered. It was retired in the mid-1980s and given to the Railroader's Memorial Museum in Altoona. Extended exposure to the outdoor elements and some minor vandalism occurred to the vehicle. The Horseshoe Curve Chapter of the National Railway Historical Society, acquired the truck in 1997 and started to restore it.

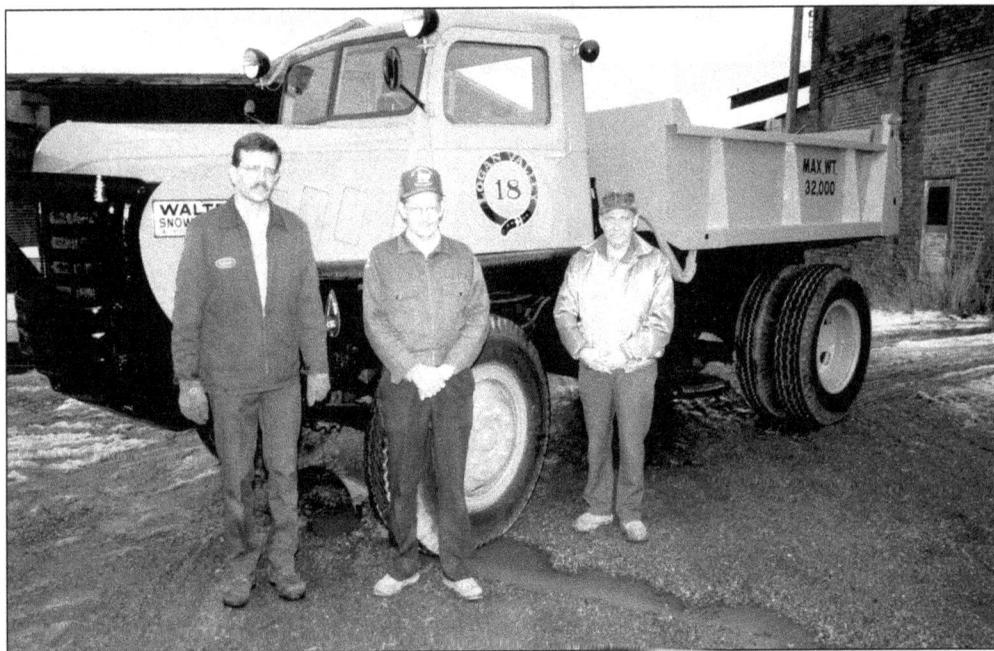

The committee who worked on the restoration of the truck is shown in December 1997. From left to right are Frank Givler (president, Horseshoe Curve Chapter, National Railway Historical Society), mechanical repairs; Joe Harella (vice president, Horseshoe Curve Chapter, National Railway Historical Society), interior and woodwork; and Leonard Alwine, body restoration. Commercial sources completed the repainting and lettering. The paint color is Logan Valley orange. Harella is also an employee of present-day Amtran as a bus driver.

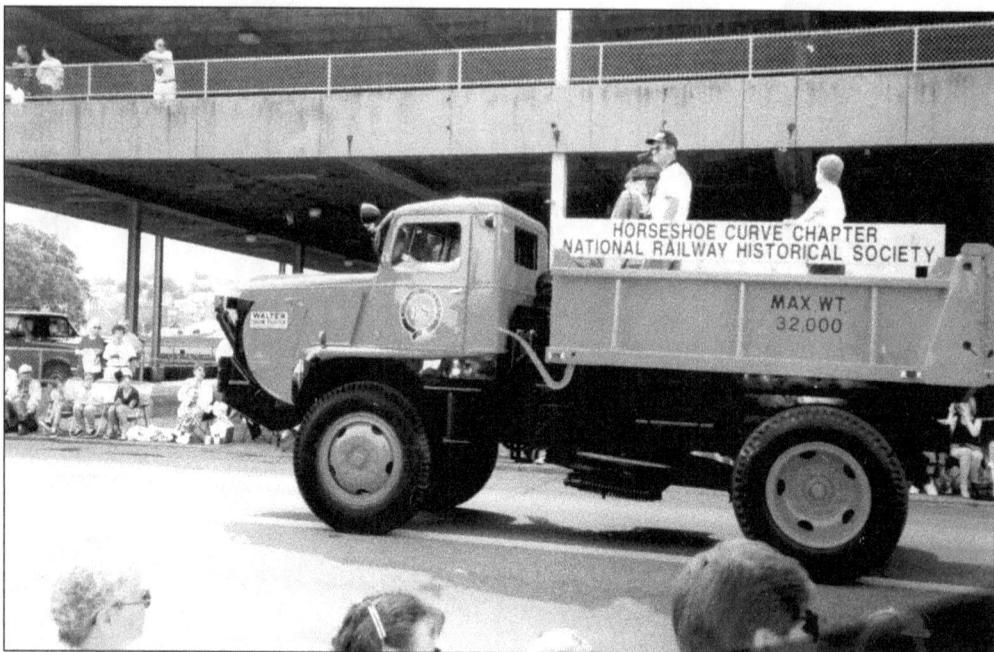

Service truck No. 18 returned to operational condition in time to make its debut in Altoona's sesquicentennial parade in May 1999. It is shown here at Twelfth Avenue near Thirteenth Street. The only known vehicle of the Altoona and Logan Valley Electric Railway to survive, it was applauded by local citizens as the parade passed.

One set of drive wheels from car No. 51 was saved from the scrapper's torch and has been exhibited on the portico of Baker Mansion since 1955. The mansion was home to the Elias Baker family and descendants, participants in the founding of the City and Park Railway and Lakemont Park. This wheel set was placed on exhibit at Amtran in 2004 (a long-term loan by Blair County Historical Society), and later mounted in a garden at the Amtran office to commemorate the 50th anniversary of the cessation of trolley operations.

On August 6, 2004, the 50th anniversary of the end of trolley operations, a special dedication was held for the return of trolley wheels from Osgood-Bradley car No. 51. Using Amtran's trolley bus as a podium, Leonard Alwine offers remarks for the dedication. The wheels are mounted in close proximity to a wheel storage area formerly used by the Altoona and Logan Valley Electric Railway.

The Blair County Historical Society chartered the trolley bus for the evening of August 6, 2004, to further commemorate the end of trolley operations 50 years prior. Two successive tours were offered of former trolley routes through the Llyswen residential area to Lakemont Park, with David Seidel narrating the journey.

Members of the Blair County Historical Society, in period dress, participate in the 50th anniversary trolley bus tours of Logan Valley routes through Llyswen and Lakemont Park on August 6, 2004. Pictured, from left to right, are Peggy Fields, Cindy Corle, Connie Baker, and Joan Thompson.

Crea Aikens, Amtran bus driver, drove trolley bus 173 for the 50th anniversary tours. Aikens is a long time employee of Amtran, serving the routes of Altoona and nearby communities, and held in high regard by the authors.

www.ingramcontent.com/pod-product-compliance
Lightning Source LLC
Chambersburg PA
CBHW080548110426
42813CB00006B/1247